Zull's Manual of Advanced Penmanship

Hull's Manual of Advanced Penmanship

Sull's Manual ~of~ Advanced Penmanship

An Instructional Guide to American Cursive, Ornamental Penmanship, and Flourishing

Michael R. Sull
MASTER PENMAN

Skyhorse Publishing

Skyhorse Publishing books may be purchased in bulk at special discounts for sales promotion, corporate gifts, fund-raising, or educational purposes. Special editions can also be created to specifications. For details, contact the Special Sales Department, Skyhorse Publishing, 307 West 36th Street, 11th Floor, New York, NY 10018 or info@skyhorsepublishing.com.

Skyhorse® and Skyhorse Publishing® are registered trademarks of Skyhorse Publishing, Inc.®, a Delaware corporation.

Visit our website at www.skyhorsepublishing.com.

10 9 8 7 6 5 4 3 2 1

Library of Congress Cataloging-in-Publication Data is available on file.

Cover design by David Ter-Avanesyan
Cover images by Michael R. Sull

Print ISBN: 978-1-5107-7347-9

Printed in China

To my beloved wife, Debra, and my daughter, Jennifer, I foremost dedicate this volume with my deepest affection and respect.

In addition, to my devoted associates of long standing: Cam Schutte, Allan Shinogle, and Hugh Scher, with whom I have shared many of my penmanship adventures, I furthermore dedicate this manual of instruction. Their faith in my efforts and their encouragement throughout my career have been pillars of strength I have rested upon countless times.

Also, for all my hopes of what this volume may represent to students everywhere, I am proud to acknowledge exceptional students: Heather Victoria Held, Kathy Meyers, Schin Loong, Fozzy C. Dayrit, Nina Tran, Frances Miller, Barbara Calzolari, Hong Nguyen, Kalo Chu, Michael Ward, and Martha Laurens. Through their own determination and passion for learning, they are among the finest instructors I have ever known. They are truly links of this generation to our Spencerian heritage of Penmanship.

We should always strive to see the best in our students' potential and guide them with integrity from our hearts. These individuals and others like them have touched the lives of countless students everywhere and are, surely, a model for us all.

To everyone I have mentioned, I am most indebted. Your belief in me, unparalleled assistance in so many ways, and your enthusiasm have made my own efforts possible, and my passion fulfilled.

Table of Contents

Foreword

There are hinge moments in life upon which the trajectory of your journey swings and sends you in an entirely new direction. The ancient Greeks called these moments "kairos," which they used to describe the perfect timing of necessary elements coinciding to create something new. One such moment came for me in college. On a fateful, sunny day in southern California at Biola University, I stopped by the campus mailbox on my way to class. As I found my box amid the matrix of others that filled the four-wall exterior of the small building, inserted my key, and gave it one simple quarter-turn, there was a seismic shift. Of course, I did not realize it at the time; for all I knew it was just another average day and this was just an ordinary mailbox, but for me, in that moment, it was transformed into Pandora's box or Alice's magic rabbit hole. The small aluminum door squeaked open and there laid a letter addressed to me in ornamental penmanship from none other than Master Penman, Michael R. Sull. From then on, I would be forever marked by the beautiful letterforms inscribed on that envelope. The rest, as they say, is history—but a history still being written. Since that fateful day some seventeen years ago, Michael R. Sull has been to me a mentor, a colleague, a fellow penman, and a true friend. Our friendship has continued to grow year after passing year along with our shared passion for American heritage handwriting and the propagation thereof.

From this prolific teacher who has shaped not only me but countless other penmen over the years comes another profound resource for those looking to grow in the fine art of penmanship. While many today practice this discipline, few have the ability to teach it and fewer still teach it as well as Michael R. Sull. He is a gifted instructor who has the rare ability of articulating the foundation of the letter forms, the execution of techniques, and identifying the nuances of each, which make the letters dance on the page with fluidity and dynamism. Whether in spoken word or in print, Sull provides the crucial knowledge he has long gained over the years to accelerate the learning of his students and help them acquire the skills necessary for mastery.

History First

Sull has dedicated his life not only to the practice of this artform, but also to the profound history that undergirds it. After his initial letter to me, Michael sent a copy of his Volume One book and instructed me specifically to read the rich history behind American heritage handwriting before I even picked up a pen myself. I am forever grateful for this level of instruction, for it gave me a deeper perspective of the grand

endeavor that I was undertaking and the profound pen strokes in which I was following. Sull is steadfast in this approach to learning. For him, history goes hand in hand with penmanship, or more appropriately, pen in hand, for the legacy of our forebearers which brought forth such beautiful forms and disciplines becomes the very implement by which we flourish today. History, for Sull, comes first. Michael R. Sull himself is a bridge to the past—a connection to the golden age of penmanship through his mentor who was the last of C. P. Zaner's students—that great teacher of teachers and Master Penman in the highest regard.

Crawl, Walk, Run

Over the forty-plus years of Michael's career and the many books he has written on penmanship, a common principle follows from his teaching, which finds its precedent in penmen past: perfect simplicity in order to master complexity. In this book, Sull builds upon his previous introductory works to lead the student higher and further in their penmanship journey. Within these pages will be shared the myriad of techniques to take your handwriting to the next level. Sull's writing style is defined by the unique combination of movements which has not only served him over the course of his career but was also the choice method of penmen through the ages. By the coordination of finger movement, wrist (muscular) movement, and whole arm movement, the versatility of the penman is expanded beyond what any individual movement on its own can bring to the page. Sull will define the movement and help the student learn to identify each and know when exactly to employ them through the course of writing. This book will certainly push the bounds of what you know and help you further hone your skills to gain those small, incremental improvements we all must fight for once we have reached a certain level of proficiency. The next leg of your penmanship journey starts here!

Flourishing Legacy

Like the individual strokes of a grand flourish are interwoven the individual legacies of all who have picked up the good pen. Each adds to the composition of the whole and contributes to the beauty and complexity that is the American heritage handwriting story. And the legacy of Michael R. Sull finds itself prime of place in this composition, with weight and grace defining the mark of his legacy. In spiraling sequence have grown from him the legacies of penmen unnumbered, and I am but one among them. Sull's love for the artform and his deep desire to see it live on has taken him around the world to share his passion with others. The wisdom he has gained is not kept to himself but shared lavishly with the penmanship community and beyond. Sull uses the pen as a tool of generosity—for all that comes from the pen is gratis—the profound gift of

connection. The written word takes on its highest form when it bears truth laced with beauty, made all the more meaningful when penned by a good heart and a skilled hand. With Sull, there is both. Whether he is demonstrating at a calligraphy conference, creating a certificate for an honoree, or writing a name card for a stranger at a pen show, I have seen his pen countless times in its highest employ: the service of others. In this latest book is yet another act of service and the furthering expression of Sull's legacy: advanced American penmanship. I encourage you, Dear Reader, to take it in for all that it is worth and for all that Sull has poured into it, if it is possible to do so. Learn not only from the words of these pages but also from the posture and spirit of generosity that brought them forth. Learn these lessons well so that you, too, can share them lavishly, and this grand flourish shall continue through you!

—Jake Weidmann
Master Penman

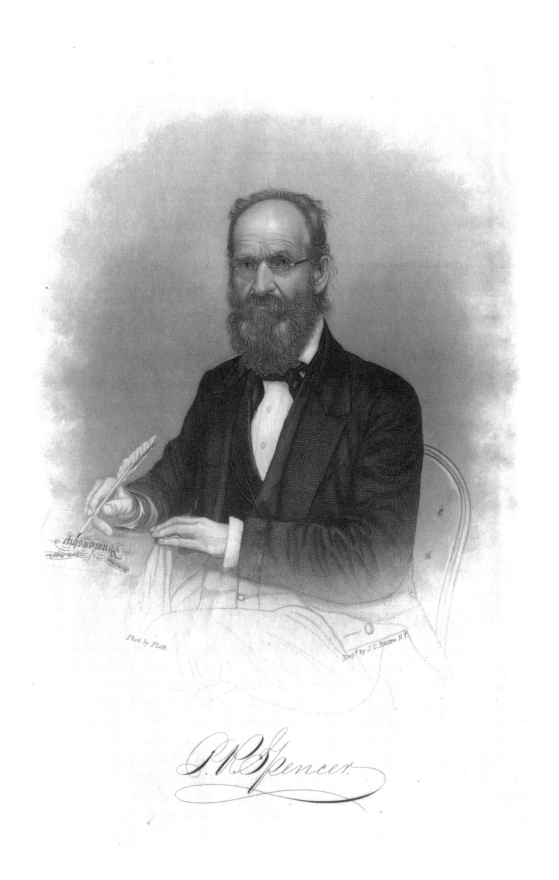

Phot. by Platte.　　　　　　　Eng'd by J.C. Buttre N.Y.

P.R.Spencer.

SPENCERIAN KEY

TO

PRACTICAL PENMANSHIP.

PREPARED FOR THE "SPENCERIAN AUTHORS"
BY
H. C. SPENCER.

" One ink-drop on a solitary thought
Hath moved the mind of millions."

PLATT R. SPENCER,

ORIGINATOR AND AUTHOR OF THE SPENCERIAN STYLE AND SYSTEM OF PENMANSHIP.

SUCCESSORS AND ASSOCIATE SPENCERIAN AUTHORS,

R. C. SPENCER,	P. R. SPENCER, Jr.,
H. C. SPENCER,	H. A. SPENCER,
L. P. SPENCER,	M. D. L. HAYES.

IVISON, BLAKEMAN, TAYLOR & CO.,
NEW YORK AND CHICAGO.
1877.

PREFACE.

PARENTS, teachers, and lovers of the art of writing, we submit this little volume to you and to the public generally, asking indulgence for its errors, and a generous consideration of its merits.

Preface

The first subject I would like to address is simple, but I consider it significant to the reader. What prompted me to write this book? The answer is simple, yet takes a bit of explaining.

For over forty years I have thoroughly enjoyed American penmanship. Even more, it has thrilled me to share its techniques with my students. From the very beginning of my career, I purposely chose to write with combination muscular movement, rather than the long-standing traditional method of whole arm movement dating to Platt Rogers Spencer in the 1820s. As the years passed and my own skill increased, I began to realize that I was becoming adept in using my finger, wrist, and forearm muscles; thus, I was benefitting from increased dexterity in the use my oblique penholder.

When penmen write using whole arm movement, they strive, through extreme diligence and practice, to control the most minute movements of those large muscles. In so doing, their goal is to write small-sized letterforms with the utmost precision at a high rate of speed. The best master writers succeeded in accomplishing this after many months, and even years of practice. Their skills were legendary, and the names of Zaner, Bloser, Madarasz, Courtney, Lupfer, and Flickinger, among many others, became synonymous with the very best penmanship made possible by the human hand.

At the beginning of the twentieth century, a major change took place that significantly altered the method of how Americans were taught to write. In an effort to help school children learn an easier way to write cursive, famed penman Austin Norman Palmer had an idea that changed everything. Whole arm movement requires that the forearm and wrist remain raised above the paper surface while writing. The primary objects that touch the paper during the process of writing are the pen point, the end portions of several fingers, and the heel of the hand immediately in front of the wrist. Maintaining your arm above the paper in this manner is fatiguing, especially for children. Palmer reasoned that if the forearm rested on the desk or writing surface with the elbow protruding approximately two inches beyond the edge of the desk, the large muscles of the upper arm wouldn't become fatigued. By using a combination of the forearm, wrist, and finger muscles to hold and manipulate the pen, greater dexterity would result in the action of writing. He labeled his development as Palmer method writing but, it was, in fact, combination muscular movement.

As the years continued to pass, I developed a fondness for ornamental penmanship and flourishing. Because I was formally trained in the art of engrossing for several years prior to becoming a penman, I enjoyed the accent techniques of filigree and line art in

designing elaborate certificates. These artistic styles are all rendered by using primarily finger movement. As I found pleasure in decorative writing, it became easy to combine the techniques of engrossing with ornamental penmanship and flourishing. The dexterity of my fingers enabled me to manipulate the pen in countless ways. It soon became apparent to my students that my penmanship had a look and a style they recognized as unique. My work did not mirror the elaborate styles of vintage whole arm penmanship but, instead, had an individual appearance all its own.

I loved teaching my favorite techniques to my students, and when they requested printed references to study, I began to write extensive handouts for them on all the "fancy" elements of penmanship of which I had become so fond. In addition, coupled with the specific requests I was receiving from private commissions, I developed many singular styles of my own. Some examples are Spencerian-styled monogram designs, methods to create the lavish penwork displayed in George Bickham's *The Universal Penman* (which I, in turn, titled Masterpiece Flourishing), and capital letters of complex design featuring multiple ovals and intersecting curves that my students refer to as super twisters.

Novelty styles of my own American Cursive Handwriting include puzzle writing, relay and connected writing, among others, and a form of layout arrangement called composition writing that is both purposeful and attractive. All these variations of writing danced off my pen. Soon I realized that none of these techniques, in the manner I wrote them, could be found in any former or existing publications. Thus, it was after many years, countless projects, numerous teaching assignments around the world, and admittedly my own age passing the seventy-year mark, I decided to put everything I did that is considered an advanced or unique manner of penmanship into one comprehensive volume.

All the past penmen, from Platt Rogers Spencer to my own mentors, Isaac Walden Bullock, David P. Fairbanks, and Paul H. O'Hara, will always be my Masters, for they reached the highest pinnacle of the very best skill levels that the human hand can achieve. My goal is to create the most comprehensive manual of advanced penmanship techniques in recent memory. I wish to provide explanations for all the methods that I use and enjoy whenever a pen is in my hand. If my students, regardless of where they live or what language they speak, can experience for themselves the joy that I feel and is always magical to me, I shall be justly served for the effort I have given to this endeavor.

I respectfully suggest to the reader that you should always have paper and a pencil or pen at hand while you study these pages. To my knowledge, this manual is the first of its kind. It not only features the widest range of subjects and applications of techniques, but it also presents everything in the physical method of combination muscular

movement. Your task is to study and practice, study and practice. Strive to actually see the negative spaces within each letter and composition, for they are truly as much of the design as the curves of ink that form their existence. Develop your skills to determine a visual balance in your written compositions. Then, too, don't be afraid to incorporate composition writing in your work, where capitalization is used as a pronounced manner of emphasis that can add prominence to key words in your text.

These and many more suggestions are waiting for you within the following pages. When you have achieved your skills in flourishing, your next challenge will perhaps be the most difficult of all: knowing when to stop.

For all of this I wish you unbridled success and a most magical time on your journey, as it still is to me.

Sources for Supplies

This list is brief, as I obtain all of my penmanship and art supplies from JohnNealBooks.com. You may certainly have your own favorite supply vendors or distributors who provide the tools and materials you need for personal, professional, and all other lettering needs. I can only say from personal experience that John Neal Books provides excellent products and customer service. I highly recommend them to you.

There is only one other unique product and supplier I wish to mention. For iridescent watercolors of exceptional quality and visual reflection of color, I heartily recommend KOUS iridescent and metallic watercolors. They are handmade and come available in a dry tablet or cake form. You simply add a few drops of water to the cake and then use an artist's brush to mix the color and lift it on the brush for painting or applying the color to your pen point. You won't be disappointed with the results. Visit their website at designkous.com.

Introduction

Before you view the pages that follow, I think it is only fair that I present an overview of what this work will offer, and what you can expect from the information contained within this publication. Here at the onset, I wish to state that the script styles in this manual are based on the casual parent-style of Spencerian penmanship. Thus, the shaded formal styles of engrosser's script and copperplate (English roundhand) are not included or referenced in this volume.

Like everything else in life, a person can usually succeed in any endeavor only if they study the subject at hand and diligently practice whatever techniques are involved. Then, once a person begins to feel somewhat comfortable with the techniques and gains an entry skill level, it is more important than ever to continue this effort every day. No Olympic athlete ever reached their degree of skill simply because they had a firm handshake or an engaging smile. They studied every aspect of their sport, practiced every day, and met every challenge. Although there is no penmanship Olympics, your road to become skilled in advanced penmanship requires the same Olympian effort, from you. When you finally reach your goal, chances are you will want to improve your skills even further. In this way, your journey will, and should be, a never-ending adventure, through which you will know the pride of accomplishment and understand the effort it took to reach every goal.

Although there are certainly many challenges waiting for you within the following pages, I want you to know one very important thing: Although every completed, complicated letter or flourish may look very intimidating at first glance, without exception they all begin with a single stroke of the pen. And if you can do that first stroke, with practice you will be able to do the strokes that follow. Whoever you are, wherever you live, I know you can do this! You are now my student, so never forget that your own belief in yourself is the very foundation of this, your new penmanship education. With this in mind, let us begin. . . .

Advanced penmanship means various things to various people. For myself, the following comments describe how I feel about this, and in turn, what subjects I have included in this book.

Today, whenever a pen with a pointed nib (as opposed to a broad pen writing instrument) is in my hand, I categorize the term "spontaneously written penmanship" as encompassing three related disciplines. These are American Cursive Handwriting, Spencerian script, and the aspect of non-lettering penmanship called flourishing. This means that, with few exceptions such as retouched shading, Masterpiece Flourishing,

and monogram design, all strokes are made in their entirety, from beginning to end, in one continuous movement. In this one movement, the pen point never leaves the paper. A letter or flourished pattern may be composed of several strokes, but each mark of ink on your paper is made as described in one single, continuous movement. Designed styles such as monograms are usually not created by individual pen strokes. Instead, they are typically formed by either drawing the outline of the letter and filling in said outline with ink or by using the pointed pen with ink to trace over a penciled outline. Thus, completed monograms are usually drawn, not written. A spontaneously written letter such as a capital F, however, is made by writing three individual pen strokes. These are written normally in sequence: the base portion of the capital stem, the following compound curve which serves as the carved crossbar at the top of the letter, and the small, short stroke that crosses the capital stem approximately halfway up the letter's height.

I am mentioning these factors because I don't want any of my students or readers to be deceived. It is a common occurrence that when a student sees either the original or printed work of a lettering artist such as a monogram or complex letter, the following can take place: The design is so impressive that, coupled with any positive reputation the artist may have, the student quickly thinks that said artist is amazing in their ability to create such a beautiful element in a freehand manner with a pen. And because of this train of thought, upon seeing beautiful monograms, students often give up before they even begin to study because they feel such incredible "freehand artistry" is beyond any skill they may hope to achieve. So now, as you begin your journey, please believe me when I say this: *You can do every technique which I have included in this book.* I will explain everything in detail, step by step. And if I suggest, for instance, that to balance the shading of a capital J after you have written the letter, you now lift the pen and then carefully go backward and retrace the left side of the letter's large loop with a bit of pressure, do not say "that's cheating" or think of it as contradictory advice. It is simply my advice of a shading technique that can be infinitely helpful to add a sense of weight to any hairline in a letter or flourished stroke and therefore effect a visual appearance of balance to your design. This technique can also be used to add colored shades to any portion of a monoline (unshaded) letter or flourish. It is a wonderful way to add iridescent gold shades anywhere you wish, and it always works.

In the chapters that follow, I will offer accent techniques such as spiraling and foliation using a variety of penpoints. To achieve such techniques, it will be best to have more than one oblique holder with a different point in each flange. I will also explain the related subjects of filigree and decorative linework, for these are certainly advanced techniques of non-lettering penmanship. They are superb in adding

beauty to a composition, filling in negative spaces, and adding a visual sense of texture to your design. As elements of spontaneous offhand flourishing, along with pattern design and decorative accent work, these glorious methods of ornamentation are waiting for you in this unique volume. For readers who seek focused instruction on specific topics such as super twister capitals, composition writing, extending and sequencing curvature, superscription, monogram design, and the benefits of understanding negative space considerations, the explanations of these subjects are only pages away.

In chapter one, I will dwell at length upon advanced techniques of American Cursive Handwriting. This most practical style of visible language is of especially high value in the current renaissance of interest in penmanship. Never think of this subject as "no big deal; it's only handwriting." American Cursive Handwriting is your voice on paper; your magic carpet of communication to another human soul. I will discuss the particulars of this writing method from the basis of letterform to several varieties of ornamentation. Then, for your own enjoyment (and perhaps the bewilderment of the person to whom you are writing), I will describe the details of ten forms of novelty styles using American Cursive Handwriting. Your correspondence written in backwards writing, running handwriting, relay writing, connected writing, puzzle writing, and landscape writing, among others, will faithfully present your message to your recipient, and dutifully challenge them in their efforts to read and understand what you say. Regardless of what you may define as your present degree of skill, the contents of this manual will undoubtedly raise your abilities to a significant extent when earnestly practiced with diligence and serious intent. There is a great deal of material here for your attention.

Study each chapter at a comfortable pace that will allow your mind to retain the methods of technique that are presented. The largest and strongest tree in the forest never reached its size because it was told to grow faster. The only way to become adept at the skills described herein is to take your time and read and reread each section carefully, taking notes in your own journal as you move along. Do not let yourself become discouraged if any topic becomes difficult to master. Simply put in more effort to practice again and again, just as I and all the penmen who came before me did. None of us would ever give up. More than forty years ago my own mentor, Master Penman O'Hara, told me never to listen to anybody who had any discouraging remarks to say about my efforts or my goals. You must believe in yourself despite what anyone else may say. As for all the people who do encourage you, listen to what they say, and value their comments, for they surely believe in you. There is no time frame or deadline when you must be a master of any of the presented techniques. I also believe in you, and if any of the topics are of special interest in your eyes, focus your efforts on that

subject first. Although I have presented the subjects in the order shown in the table of contents, do not feel that you must devote your attention strictly in that sequence. If you are enthused in a subject and study that topic first, your progress and success will enable you to gain self-confidence and encourage you to approach your next subject with enthusiasm.

I sincerely thank you for believing in my abilities to help you learn, and in trusting me to guide you along the way. My best wishes for success are with you always as we proceed.

The action of personally modifying Spencerian script by the penman who is actually doing the writing is an idea that was embraced by Platt Rogers Spencer himself. We are doing that at this time by creating elevated, advanced forms of Spencerian-based penmanship. I have included professor Spencer's comments on variety of style and shading because his explanations are enlightening. They are directly reproduced from the volume *Spencerian*, published by his sons in 1877. I respectfully offer them to you.

CHAPTER XII.

VARIETY OF STYLE.

WERE all the fleecy, golden, shifting clouds taken from the vault of heaven, leaving only one unchanging blue, were all the roses, lilies, and violets taken from the gardens, leaving only their carpet of green, we should weary of gazing upon earth and sky. The tastes of even a single individual may vary at different periods of life, or under various circumstances, while different minds require an almost infinite variety from which to choose what is most pleasing. The constant succession of new ideas and developments in science, and the ever-changing forms in art, render their study irresistibly fascinating to their devotees, and attractive even to those who only stand in the vestibule, and but half comprehend their meaning.

In presenting definite rules for the proper formation of letters, it is not designed to confine the skill and ingenuity of the writer within narrow limits, nor to prevent the exercise of peculiar tastes. We desire, rather, to encourage individuality of style, so far as it may be consistent with propriety, and will, in this chapter, make some suggestions in regard to the changes of which different letters are susceptible, while their proper form is carefully preserved.

The originator of this system, possessing a love for the beautiful, and a power of invention rarely equaled, was enabled to construct upon the basis of the principles he established, a greater variety of graceful and beautiful forms than would have been possible for a mind less exquisitely organized to design, or a hand less accurately trained to execute. The genius which would have made him a master in any department of art, was directed to penmanship.

97

Chapter 1: American Cursive Handwriting

In the early years of my career when I was trying to reintroduce our American heritage of Penmanship, I was often told by the directors of several calligraphy conferences, "That's just American cowboy lettering! The way Americans write isn't a style—there's no discipline to it!" I became so frustrated that in 1987 I organized my own program to teach Spencerian. I called it the Spencerian Saga and chose as its location on the shore of Lake Erie a wonderful facility (where Platt Rogers Spencer actually lived, worked, and taught). This program was successful right from the start. I directed this teaching event for twenty-six years, then trained my accomplished protege, Master Penman Harvest Crittenden, to carry on "the Saga" as its new director. We all saw the consistency of letter spacing in the consistency of the rolling waves, the essence of curvature and movement in the wind, the clouds, and the circling gulls overhead. We saw variety in the flowers, and colors of the sunsets, and contrast in the stars at night in the heavens above. We saw beauty everywhere.

I mention all of this because my experiences in teaching through the years instilled in me, as well as in my students, the wisdom of professor P. R. Spencer in choosing nature as the living heartbeat through which our handwriting flows. It is these thoughts that will allow your handwriting to reach untold heights of expression through your pen, for the same attributes of nature and penmanship are inherent in you.

As you progress through this manual, keep in mind that the three chapters of American Cursive Handwriting, Ornamental Penmanship, and Flourishing are all based on Spencerian script. Therefore, the same governing principles apply: curvature, movement, variety, and contrast. With these thoughts ever present as we learn the enclosed techniques for advanced penmanship, the best place to start our journey is here, with American Cursive Handwriting.

Basic Understanding

American Cursive Handwriting is the name I gave to this compilation of the various traditional forms of American Handwriting, all of which are based on the parent style known as Palmer method writing. (For complete self-study curriculums on American Cursive Handwriting, please refer to my previous works in the appendices.) This is a spontaneous form of handwriting that allows the writer to personalize their penmanship in many ways. Among these are the degree of slant, size of the letters (both capitals and lowercase), letter spacing, speed of writing, and creative artistry. Nonetheless, the primary golden rules of Spencerian penmanship should always apply: Letter slant and letter angle must be consistent among themselves, and the speed of writing should be at

a comfortable pace for the writer. That is, not so slow that the writer *draws* the letters, and not so fast that your hand does not allow itself enough time to finish writing one letter before it begins moving to write the next letter. Above all, your handwriting must be legible. Given these precepts, always remember that American Cursive Handwriting is basically a simplified, or "naked" form of Spencerian script. It is sometimes easier to think of it in reverse: It is a monoline form of Spencerian without any shades and without any extra curves, loops, or ovals except for any structural components that are necessary for legibility. Practically speaking, American cursive lowercase letters are nearly an identical monoline equivalent of Spencerian lowercase, while American cursive capitals are usually much simpler in form than Spencerian capitals. American cursive has far fewer alternative letterforms than Spencerian.

Additional Thoughts to Guide You

Because all three subjects in this manual are *informal* styles of vintage penmanship, you are perfectly free to substitute, interchange, combine, or modify the use of these forms. One of the easiest ways of "fancying up" a signature or correspondence letter is to use Spencerian or ornamental capitals with American cursive lowercase. The capitals would still be monoline in weight, but if you wish to add shades, once you've written a name or the salutation of a letter, simply go back over portions of the letter with your pen to draw in artificial shades.

An additional technique is to use your fountain pen or other convenient writing tool to write your correspondence all in Spencerian ornamental handwriting. Your communication would still be in a monoline format, but very vintage and quite attractive in appearance. For the most part, all the advanced techniques in the Ornamental Penmanship chapter that follow will work for American cursive, except that the results will always be monoline in appearance.

Tools and Materials

Pens and Pencils

Virtually all writing instruments that are considered to be convenient and widely obtainable such as ballpoint pens, various fine-pointed markers, fountain pens, rollerball pens, gel writers, and pencils are satisfactory for writing in a cursive style. For artistic and personal creativity, I would suggest the following:

- *Fountain pens:* Any quality brand of these pens will serve you well. If you purchase an inexpensive model that cannot be refilled with ink, once the pen's ink supply is empty, you can still write simply by dipping the point in a container of ink. You will have to dip the pen often, but this is a minor inconvenience. This is actually a good

way to use different colors of ink. After the point has used up the ink of one color, clean the point with water, blot it with a paper towel, and dip it into an ink bottle of a different color. If you have more than one refillable fountain pen, fill each one with a different color of ink.

- *Gel writers:* These are available in a wide variety of colored inks. Try metallic, iridescent, and those that write with a glitter tone of color. These produce lines and letters that sparkle for a dazzling appearance to your writing.
- *Colored pencils:* It is not recommended to write entire correspondence letters in pencil since you will need to sharpen your pencil often. For significant or dramatic words in your writing, there are pencils that feature two or more different colors in the lead. By rolling your thumb slightly as you write, the colors change as you proceed. This is one way to produce rainbow writing. Besides enjoying this technique for your own use, such writing is a fun method to demonstrate cursive in the teaching of handwriting to children. Such specialty colored pens are easily found in most art, hobby, and craft stores.

Inks

If you are using fountain pens, it is always fun to keep a supply of different colored inks on hand. There are fountain pen inks available that contain fine particles of mica in many colors. A quality ink of English manufacture known as "Diamine," among other brands, offers such sparkle ink in many colors. You must agitate the ink by shaking the bottle before filling your pen so that the mica particles will be held in suspension in the ink. It is also important to clean your pen after your writing is completed by emptying any remaining ink in the pen back into the bottle you filled the pen from, then flushing the point in water.

There are also iridescent fountain pen inks available. These create a beautiful, shimmering effect in your writing. As with the sparkle inks, clean your pen in the manner just described once your writing is completed. For information and availability of these specialty inks, the Internet or a local pen store are great resources. If you have the opportunity to attend a fountain pen show, you can usually find exhibit vendors who sell such inks on site. For information on this resource, look up "Pen shows" on the internet.

Other Materials

Papers: It is always fun to write on colored papers and, in particular, dark colored papers. Color gel writers, and particularly the sparkle gel writers, are especially dramatic in appearance when written on such papers. These papers are usually available at office supply stores, hobby, craft, and art stores.

With all these thoughts and resources in mind, the following information is reprinted from my previous volume, *The Art of Cursive Penmanship.*

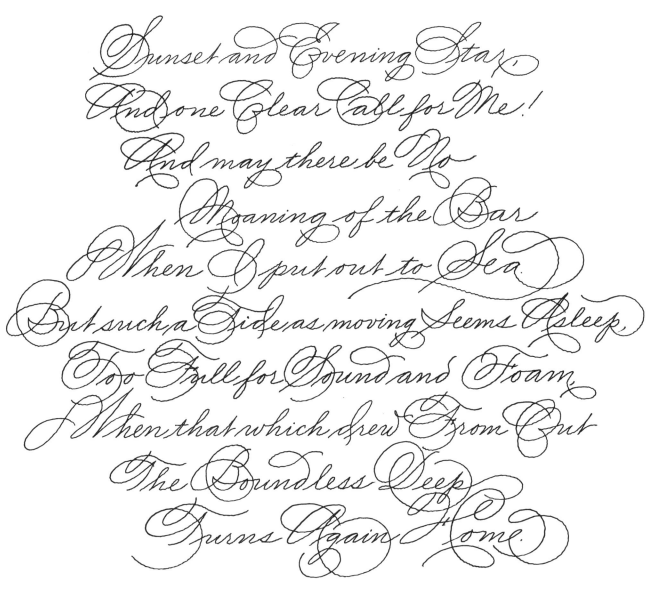

Sunset and Evening Star,
And one Clear Call for Me!
And may there be No
Moaning of the Bar
When I put out to Sea.
But such a Tide, as moving Seems Asleep,
Too Full for Sound and Foam,
When that which drew From Out
The Boundless Deep
Turns Again Home.

-from Alfred, Lord Tennyson; Crossing the Bar

At this point, much of what has been covered in this book focuses on the fundamentals of handwriting. These basics of cursive penmanship are essential, but there is also great enjoyment to be found in creating "extras" to ornament your writing. The following techniques are not difficult to master and can be very effective in adding emphasis to the content of your text, personalization to the recipient, and individuality to your own style of penmanship. In short, they're fun and serve to animate your writing in the same way that your voice and facial expressions add context to words when you speak.

1. Embellish Capital Letters

The purpose of capital letters can be summed up in one word: "Emphasis." More specifically, when capitals are used (most often as the first letter in a word), they infer a sense of respect, identity, importance, and recognition to the word itself, and to the meaning of the word as well. I like to think of capitals as a sort of "automatic device" to add significance to any word. And, although we normally use capitals only to begin a sentence or to identify a proper noun such as a name, there is no law or rule that states we are limited to these two options. So, in the same fashion as when a person raises his or her voice to emphasize various words in speech, I capitalize any word that I wish to emphasize in my penmanship. The use of additional capitals not only gives more visual importance to the words and sentences, but they can make your normal handwriting appear more ornate and elegant.

Another easy way to use capitals is to make them more decorative or larger than normal. You shouldn't do this to all your capitals; if you did, then all the capitals would be competing for attention to the reader's eye. Choose the words carefully—capitalization is a powerful tool, and too many capitals can cancel out the image of any word as being special. Another idea is that any capital letter can be made to look fancier by adding one or more large ovals as an entrance or exit stroke in a fashion similar to nineteenth-century Spencerian script. Again, you must be cautious not to overdo this technique or your letters will become a hodge-podge of lines and curves that look like spaghetti. Note the examples beginning on the next page. This is by no means a complete list, but there are plenty here to get you started.

Note: The capitals are shown with a lowercase "a" following them to indicate where the lowercase letters should begin when writing the rest of a word. Also, many capitals share similar elements of form with other letters, such as P, B, R; U, V Y; M, N; O, QU; F, T; among others. Thus, various beginning and ending curves can be used for many capitals of such similar form.

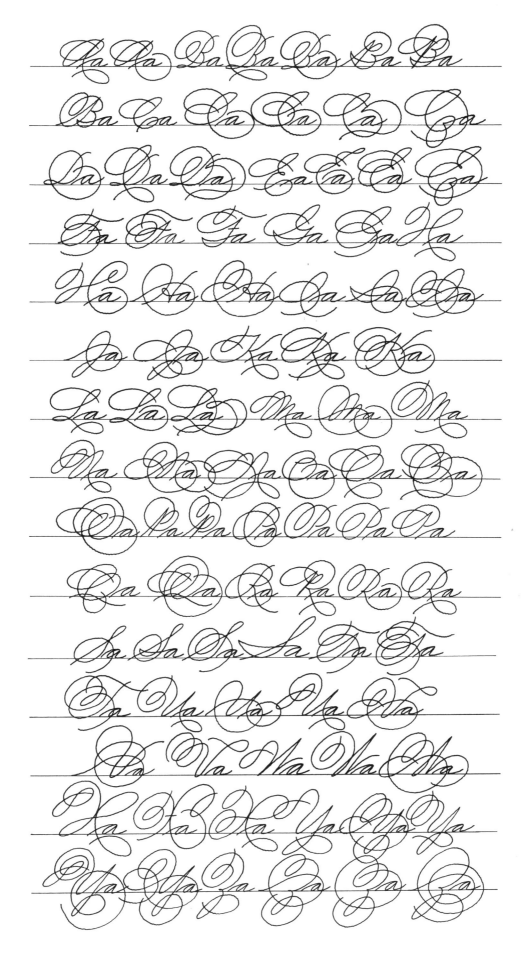

6

2. Flourish Lowercase Letters

Add flourishes to lowercase ascenders and descenders of the "loop letters," such as b,d,f,g,h,j,k,l,p,q,y, and z. Also, add "ending flourishes" to the last letter of the last word of a sentence or paragraph. This type of flourishing is quick and easy; you simply extend the ending stroke of the last letter into a curved oval. Again—be careful not to overdo it! The ending strokes can be quite short or of a greater length. The rule of thumb here is that the flourish itself should not be longer, taller, or wider than the word it originates from.

ending. evermore. forever.

tomorrow. garden. beautiful.

adventure. singing. sincerely.

future. again. rest.

In Conclusion

Handwriting can be so personal, so intimate or commanding, and so very much fun. The words written by your hand give you an almost physical presence to the recipient as they are being read. Your penmanship can make distances disappear between two people, and bring the shared thoughts together as if they were whispered in each other's ear. Treasure your ability to write and write well; it is as much a part of you as your own voice. And like your voice, your handwriting will be an identity of who you are.

Novelty Forms of Writing

The various techniques that remain in this section are presented for your sheer enjoyment as the writer, and for the fun, confusion, bewilderment, and surprise of the recipient who receives correspondence and must read what you wrote. Some of the novelty styles are easy to write and read. Some take extra time and patience on your part to prepare or design before you actually write your correspondence. Some you must judge for yourself if, instead of writing the entire missive in a specific technique, you decide to only write a portion of your social correspondence in the novelty style. I can say from experience that although these styles are all fun to use in your effort to write such correspondence, the greatest enjoyment is to hear the reaction from your recipient once they receive your letter in the mail!

Composition Writing

This writing style is further explained in the Ornamental Penmanship chapter (page 19) but simply described, it is this: In addition to capitalizing all proper nouns and the first word of every sentence, the writer also capitalizes every word they consider to be of significant importance to the content of the text. The result of such capitalization is positive in three distinct ways:

1. With so many more capitals appearing than in normal use, the written text does indeed appear to be of a more unified composition than simply a collection of related sentences.
2. The abundance of well-written capitals gives the completed composition a more attractive appearance.
3. When read either orally or by thought, the capitalizations add inflections of significance to the words and the overall context of meaning as if the composition was spoken aloud. As an example, in normal usage, the following text boasts only nine capital letters, underlined as shown:

<u>M</u>ary and <u>I</u> went shopping last weekend and saw an amazing presentation given by the sales representative from a <u>S</u>porting <u>G</u>oods department store. <u>A</u> crowd had gathered, for he was demonstrating the newest model of a name brand trampoline for home indoor use. <u>W</u>hen he was finished speaking, he asked if anyone had any questions. <u>A</u> woman in front of us who was holding her child's hand looked at him and asked, "<u>D</u>o you have any children in your home?" <u>T</u>hat is when the other parents who were present began laughing!

When written in composition writing, the text has a much different appearance and boasts fifty-two capital letters.

[Handwritten cursive text:]

Mary and I went Shopping Last Weekend and Saw an Amazing Presentation given by the Sales Representative from a Sporting Goods department Store. A Crowd had Gathered, for he Was Demonstrating the Newest Model of a Name Brand Trampoline for Indoor home Use. When he was Finished Speaking, he Asked if Anyone had Any Questions. A Woman in front of us who Was Holding her Child's Hand looked at him and Asked, "Do You have Any Children in Your Home?" That's When the Other Parents who were Present Began Laughing!

Notice that if you only read the capitalized words, you can easily understand the significance or meaning of the composition:

Mary I Shopping Last Weekend Saw Amazing Presentation Sales Representative Sporting Goods Store. A Crowd Gathered Was Demonstrating Newest Model Name Brand Trampoline Indoor Use. When Finished Speaking, Asked Anyone Any Questions. A Woman Was Holding Child's Hand Asked Do You Any Children Your Home? That's When Other Parents Present Began Laughing!

The words you choose to capitalize may be different than mine. It is a personal decision. However, please observe that except for the first letter of the first word in each sentence and the pronoun "I," the words I capitalized do convey the composition's meaning. Try it yourself the next time you write any body of text, such as a paragraph. Your writing will never look the same!

Running Handwriting

This novelty style of writing does not have to be preplanned. The writer usually decides which word or words to write in running hand just moments before the pen touches the paper. A person can certainly consider this ahead of time if they want to create a rough draft of text prior to writing the final text. Simply increase the letter spacing between each letter in a word by at least twice the distance of your normal letter spacing. You do not need to measure this distance; you judge the width of your increased letter spacing visually, by eye. It is important, however, that within a single word or group of words, your wider letter spacing should be consistent so that the letters in the word visually appear to be spaced evenly. The result is that whatever word or text you write in this manner will look like it is stretched out. The effect gained is that the "reading rhythm" of the person who silently reads your correspondence will be momentarily unsettling or confounding as your written running hand greets their eyesight. Another way of expressing the moment is that the pace at which a person is reading hits a visual snag because suddenly, a selected word or phrase in running hand does not have the same visual identity as all the other words written on the same sheet of paper. Your word or phrase is still spelled correctly, but it appears like it was written in someone else's handwriting. You will probably not wish to write an entire correspondence letter this way, for if you do, your letter will take at least twice as many sheets of paper to carry your message; however, it is a fun way to add a somewhat legible surprise to anyone reading your handwriting.

RUNNINGHAND WRITING

Runninghand is a good way to tell someone "I love you very, very much!"

Connected Writing

This one is a great deal of fun for the writer and can be a most perplexing exercise for the reader because you are interfering with the foremost Golden Rule of Handwriting: legibility.

Every day, when people read newspapers, publications, and even handwriting, no one gives thought to how important it is that words you read in a body of text are separated from each other by an open space. We have mentioned letter spacing, but legibility also relies on *word spacing*. If you remove the space between words, all the words written on a single line run together. In cursive handwriting, all words are connected, or joined, to each other. This means that if your stationery paper is perhaps eight inches wide, each line of writing can look like a single word that is eight inches wide. You can modify this somewhat by using capitals and punctuation, but if you really want to confuse the recipient of your handwritten note, disregard capitals and all punctuation. It is amazing but true; as educated adults, we depend every day on our ability to recognize letters written in a specific sequence in a finite arrangement and spaced apart from other letters in a sequence of a defined arrangement. Take away those little innocent spaces between words and join all letters in cursive handwriting, and what you are trying to read looks like another language. You must try this! Write one or two lines in this way, then stop and put your pen down. Don't look at your paper for an hour or two, then look afresh at what you have written. Not very easy to read, is it? And you know what you wrote! Note: Writing in all lowercase letters where every letter is connected might not be the best way to send a get-well message to a friend (or to anybody).

Connected writing
penmanship is the intimate expression of
human emotion transferred from thought
to paper it is our individuality that can be
read everywhere for all time and it is a power
that defines who we are the sharing of thoughts
and emotions through your own written word
is the most personal and highest distinction
of visible language its appearance is a
window to the human heart and allows us
a glimpse of the writer's soul.
— an example quickly written

Rainbow Writing

Rainbow writing was mentioned earlier in the context of using colored pencils that feature writing "lead" composed of more than a single color of pigment. As a novelty form of handwriting for the purpose of writing social correspondence, quotations, poetry, or passages from scripture, rainbow writing refers to writing in various colors using suitable instruments such as fountain pens, gel writers, or even roller ball pens. There are no rules in this category. An easy way to add interest and beauty to handwriting is simply to use color as a tool to help express your thoughts on paper. The simplest method is to write entire words or sentences in a single color, then use a writing tool with a different color of ink to write proceeding words, sentences, or even paragraphs, stanzas, or verse. Another method that is somewhat more time consuming is to change colors within a word itself. To add a touch of the unusual or dramatic to rainbow writing, select different colored papers to write on. If you enjoy using gel writers with colored, sparkling, or shimmering ink, by all means try your rainbow writing on dark hues of paper. I take three or four different colored sheets of paper that are the same size and cut them in half. This gives me smaller paper sizes to write on. For a two-page correspondence letter of normal-sized paper, I can now write the same social letter on four half-sized sheets, with each sheet being a different color of paper. For seasonal-themed correspondence, use ink colors appropriate to the season or holiday to write your letters. Each of these suggestions can add fun for both the writer and the recipient.

Cross Writing

In mid-nineteenth-century America, paper for social correspondence was a somewhat costly commodity. For pioneer families living in very rural areas and in regions west of the Mississippi River, north to the Dakotas and Montana, and further west past the Continental Divide, "store-bought paper" of good quality for writing with quill pen and ink was a rarity and difficult to obtain. Consequently, civil communication with loved ones and between families was often achieved by "doubling up" on a single piece of precious paper. This was done by writing in the customary direction, from left to right on the front side of the paper, while the paper itself was in standard vertical format (known as "portrait" position with the long vertical length from top to bottom and the narrower width of the sheet measured horizontally). Once the front of the paper sheet was fully written, the writer then rotated the paper ninety degrees, thus placing the paper sheet in the sideways or "landscape" position. In this manner the writing would be resumed as these early American correspondents now wrote *across* the length of paper, directly over their previous writing when the paper was in the "portrait" form of reference. By this method and continuing the same way on the reverse side of the page, one could essentially write four one-sided correspondence letters on a single sheet

of paper, front and back. Known as cross writing, the penmanship remained legible because our eyesight has been trained since youth to focus on lines of letters and words from left to right, not up and down. Thus, as we focus our sight from letter to letter and word to word in a left to right direction, handwriting that crosses the writing at a ninety-degree angle does not interfere or normally disrupt the legibility of what we are reading. Many of our pioneer scribes contributed to the ease of visual legibility for their intended recipient by writing across the previous penmanship in a different color of ink from which they used to write in the portrait position. It was not uncommon for the first writing on the page to be written in black ink and the second page of writing to be written directly on top of and across the black penmanship in a brown or deep red color of ink. It is very rare for social correspondence to be written this way today, but you most definitely can. It will surely foster both comment and interest from your reader. Like our hardy forebears, I recommend you use two different colors of ink to make this easier for your recipient to read.

February
6, 2023

Dear Nietha,

I know this is a strange looking letter but I'm having fun learning new ways to use handwriting. This style is called Cross Writing, and I think you can see why. As you are reading this from left to right, disregard and ignore the vertical lines of handwriting. There are other forms of handwriting that I'm anxious to try, so keep an eye

To help scribe your cross writing lines at ninety-degree intersections, see the Cross Writing Guide Sheet on page 200. I encourage you to photocopy this guide sheet and position it underneath a sheet of your stationery paper. Then, with either a strong lamplight shining down upon these two sheets of paper or by using a light table or light pad beneath your two sheets of paper, you should easily be able to see the guidelines through your writing paper. Simply write with your paper in the portrait position using the guidelines as your reference. Once your writing ceases at the bottom of the sheet, rotate your paper and guide sheet combination ninety degrees; using a different ink color, continue writing on your paper in the landscape position. I recommend that you do such cross writing only on one side of a sheet of stationery paper. It would be much too confusing to continue on the back side of the same sheet of paper after you have fully cross-written on the front side.

Landscape Writing

Landscape writing is a very simple technique that only involves turning the paper sideways ninety degrees from the standard portrait position. What was the longest length of the paper's dimension from top to bottom of the sheet in portrait position is now the longest dimension from left to right of the sheet in landscape position. The only noticeable characteristics of writing on the paper now turned sideways is that when a recipient receives your correspondence letter in the mail, it looks and reads a bit differently than all social mail traditionally received. If you wish for your correspondence to become more unusual, try the following suggestions.

If possible, obtain long-length paper at a stationer's retail or office supply store. Carefully cut the paper into strips of its longest length, but no more than two inches or five centimeters in width. Write your correspondence letter on these with your line spacing no more than three-eighths of an inch or seven millimeters apart. This will certainly make your letters stand out from anyone else's. For an even higher level of making your own social mail stand out in a positive way, purchase some lovely, patterned paper that is of a good quality to write on, such as marbled paper or a colored smooth art paper such as Canford, Canson, or Ingres. Cut that into long, narrow strips and write your letters on these. Your recipient will be flattered that you took the time to make their letter so special. Using colored inks or specialty markers will make your handwriting even more exceptional.

Baseline Writing

With baseline writing and the remaining novelty styles, we begin to take liberties with the patience of your carefully crafted correspondence recipients. Think of the course of a river or roadway that gets you to where you wish to go, but twists and turns in every

and any direction along the way. Here is the way to proceed: On a clean sheet of paper, take a fine-pointed marker and begin drawing a curving line that changes direction, even crossing over itself once or twice, and covers much of the area, or expanse, of the sheet. It can end, or stop, anywhere you wish, but ultimately your closing signature will follow immediately, so you must leave room for this. Thus, there will only be one long, curving line on your paper. This becomes your baseline to write your correspondence. I prefer to write this long line in either a fine red or blue ink. This adds some color to your correspondence unless you choose to use different or various ink colors for your writing. This will, of course, make your correspondence quite special, indeed. When your writing is going to cross over a previous section of the curving baseline upon which you have already written, you can either stop your writing just before you cross your previous writing, and begin again immediately past your previous writing, or you can simply continue writing through your previous writing. Since such crossing will only involve a minimum of letters crossing over each other, the context of the words written on both lines should easily allow both lines to be read by the receiver. The fun part is that you will have to constantly turn your paper to write on the curving lines, but your recipient will as well, in order to read what you have written. Note the following example:

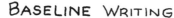

BASELINE WRITING

Relay Writing

In a relay race, one runner runs in one direction, touches the hand of his or her teammate, and then the teammate runs in the opposite direction, back to the point where the first teammate began running from. Therefore, you will have a constant change of direction or movement for each teammate's cycle of running in the race. You can do something similar when you write a letter to a good friend. Begin your letter after your greeting or salutation; continue writing on the first line until you reach the margin on the right. Now, turn your paper upside down and write on the second line. When you are finished writing on that line, turn your paper upside down again and begin writing on the third line. Continue in this manner, even continuing a second sheet of paper if your letter takes more than a single sheet of paper to complete. When your recipient receives your letter, they will also have to continuously turn the paper upside down to read it. This can be a lot of fun if the recipient is patient or your best friend!

RELAY WRITING

Dear Elizabeth,

Mark and Lucy said they would meet me for tea after they finish their classes for the day. I hope you can join us to make our foursome complete at the music festival this-coming summer. I hope so much that you will be with me and join us later this afternoon. Please say "Yes!" and come with me to the festival!

Fondly,

William

Backwards Writing

This and the remaining novelty style can surely test the patience or strength of a friendship. Backwards writing is simply that: writing the letters of a word in reverse order. Spelling must still be correct and both capitalization and punctuation should still be used. Although it will take you an extra amount of planning and time to write the letter, your recipient will take even longer to read what you have written.

Since handwriting is meant to be a spontaneous activity, backwards writing will seldom allow this to be so. I consider this to be a great deal of fun to do once in a while when I plan to have the time to do it. I first write out the letter to my friend. For backwards writing correspondence, I rarely go beyond one page in length. Next, I take a new sheet of stationery and I slowly look at the draft of the letter I have written. Then, I carefully rewrite each word backwards in reverse order on the nice stationery paper. In this manner, a simple sentence such as "I was thinking of you today and hope you are well" becomes "I saw gnikniht fo uoy yadot dna epoh uoy era llew." Try it!

Of course, you could write your backwards writing letter in relay writing, cross writing, or any of the other varieties. Even you might not have the patience to do this, and you must be kind to your friend! The following example will give you an idea of how this would appear as a short letter.

BACKWARDS WRITING - SDRAWKCAB GNITIRW

raeD nimajneB,
*tahW a lufrednow emit I dah yadretsey
gnitisiv eht wen ecneicS muesuM! knahT
uoy rof gnitivni em ot eb htiw uoy dna
gnirahs ruo emit rehtegot. I kool drawrof
ot ruo txen erutnevda rehtegot noos!*
ruoY dneirf
adnam

Puzzle Writing

This is my all-time favorite. In puzzle writing, the writer composes a nice correspondence letter to someone they know. Once the draft of the letter is completed, the writer divides the letter into separate sections, such as breaking the text between two paragraphs. Write each section on a separate sheet of paper. Both sheets should be on the same, identical paper stock, and written with the same pen.

For a more challenging technique, write two separate, completely different letters on different subjects. Both letters, however, should consist of the same number of sheets of paper and must be written on the same type of stationery paper. There should be an even number of pages—half the total for each separate letter. Next, lay them on top of each other so that all the pages line up nicely. Keep the papers held tightly together with the hand or clasped together with several paper clips. Take scissors and cut the sheets into puzzle-sized pieces. Thus, if the total number of pages of paper is four sheets, each puzzle will consist of four pieces of paper, all the same size and cut up exactly alike. The cutting should be done in all directions. It is best if the cuts themselves all feature curved edges. They do not have to be as intricately shaped as jigsaw puzzle pieces, but you should use your creativity to cut the pieces into many different shapes.

Once the cutting process is completed, put all the puzzle pieces into a bowl and, with your fingers, mix them all up so that there is no easy way of telling which piece is from which letter. Then, carefully put them all into a single envelope and mail it. When the recipient receives the envelope in the mail, they must put the pieces together, thus solving the puzzle so that the correspondence can be read. It certainly will be an item of correspondence remembered for a long time.

Summing It Up

The information, comments, and techniques contained in this first chapter should help you and the receiver of your social communication view cursive writing in perhaps a more interesting and personal way. It is my hope that they will provide more fun and enjoyment for your efforts at correspondence writing, and perhaps prompt or at least encourage your recipients to try the techniques themselves in their own letter writing activity. Someday, you might even open an envelope addressed to yourself that will be filled with puzzle pieces!

Chapter 2: Ornamental Penmanship

All the techniques that follow encompass curvature, negative space, visual balance, and methods of line extension. Always keep in mind that any curve can be extended or "stretched" to a longer length. Lengthened curves can spiral within a letter such as in super twisters, or exit a letter, change their direction of movement, and become access patterns such as off-hand flourishing designs of cartouches, scroll, or plumes. In your ability to use and manipulate curves, it is important to remember what I refer to as the golden rule of ornamental penmanship: any curved line within or exiting a letter can be extended into accent or designed flourishes as long as it does not decrease the legibility of any letter or word.

Gaining thorough knowledge of standard and alternate letterforms for both lowercase and capitals, plus the magic ingredients of mastering the manipulation of both curvature and negative space—these are the key factors. If, through diligent study and practice, a person can achieve a high degree of proficiency in these concepts, then a world of endless possibilities opens up for the penmanship artist. The skill to overlap, intersect, and parallel curves, as well as determining balance in a composition, creating varying degrees of contrast, and imbuing your work with a visual sense of emotion—these become the hallmarks of superior ability in the realm of ornamental penmanship.

In this chapter, I will focus on how to dexterously use curvature with letterforms and flourishing. I will explain the spiraling letters that my students refer to as super twisters; the methods of artistically flourishing letters and compositions; how to interweave and compound capitals into monograms; and effective methods used to create the extensive patterns for Masterpiece Flourishing.

As we commence our study, we must focus on the best ideas from which all curved items flow. With so many applications of artistic handwriting originating from traditional Spencerian letterforms, it is important to remember that the pathway to

ornamental penmanship is a journey guided almost entirely by the factors of curvature and negative space. These two elements of spontaneous writing are featured prominently throughout this book. Students must always strive to recognize these aspects in every letter and flourish. It will soon become apparent that the extension of curved lines from the entry and ending strokes can create letters, spirals, additional ovals, and other flourishes. As we begin this journey, it is prudent to review the fundamentals of Spencerian script. Our understanding of the fundamental concepts that follow will be key factors in our ability to modify or manipulate this vintage style of handwriting into the more complex forms of ornamental penmanship.

Foundational Elements of Advanced Penmanship

The key factor in improving your penmanship skills and knowing how to expand traditional or basic Spencerian capitals into the more complex capitals of ornamental penmanship lies in your understanding of the following concepts:

Curvature: The ability to write smooth, curving lines of any length, direction, and degree of curvature is the result of using the best muscles in finger, hand, arm, or in combination whose range of motion will be most efficient in moving the pen to achieve the best result. It is pretty easy to move these three muscles one at a time, but for writing ornamental penmanship, the most effective skill is to easily move from one muscle group to another or move from one muscle group to using two or even three muscle groups in combination while writing. In writing capitals (and in flourishing) where you are overlapping and spiraling ovals, combined muscle use is essential. In upstrokes when writing capitals and in making long downstrokes, strive to use arm movements instead of wrist or finger movements. It is also helpful to write at least one Cross-Drill Exercises (page 196) each day to help you develop your muscle memory of moving using finger muscles and then switching to arm movement, back and forth, while writing.

Negative Space: This is open or empty white space surrounding or within all your writing. In other words, it is the entire non-ink area within or around your strokes, letters, and flourishes. The subject of negative space is mentioned frequently throughout the techniques that are explained in this chapter. Pay careful attention to all references of negative space considerations, for the integrity of every letter, word, and written design is always a combination of inked strokes and negative space.

Line Quality: Every line you write should be as opaque and smooth as possible. With few exceptions, such as the truncated ascenders of the lowercase d and t, all shaded strokes should transition gracefully from a hairline into the smooth swell of the shade

and then gracefully taper back down to a hairline. "Finishing shades," such as at the end of a capital stem, and "continuing shades," where the end of the shade becomes a hairline that continues into an oval or flourish (such as in spiraling), must be opaque and smooth in visual sight. Several factors can affect this besides your own muscular movement. They are:

Ink: Must be in solution and thoroughly stirred or mildly shaken before use. Also, it is a good habit not to use any iron gall ink that is more than one year old. After one year, iron gall ink that remains in the bottle is usually quite acidic and will corrode penpoints in a short period of time. This will cause your point to scratch the paper surface while writing, producing uneven lines. Also, over time the acidic ink will make the penpoint more brittle, which can cause an uneven movement of the pen tips as you write. If any ink is too thick, it will cause the ink to have a high viscosity and prevent the penpoint from releasing ink in a consistent manner on upstrokes. (Please refer to my handout on McCaffery's Ink on page 195.)

Condition of Pen Point: Always check the quality of your penpoint before writing. The point should be free of dried ink residue and the point itself should not feel as sharp as a needle. Points that have corroded to any noticeable degree should be discarded and replaced with a new point.

Paper Surface: Smooth papers usually give the best results of line quality. Textured or soft, fibrous papers will seldom allow the ink to be deposited and dry evenly. Such papers as Niddigen, Frankfort, Mulberrry, handmade, cotton, and laid are very interesting to write on, but should be used only after the penman has achieved a very high level of skill and is comfortable writing on a variety of paper surfaces. Writing on such soft papers requires a person to exert a lighter-than-normal amount of pressure when producing upstrokes so that your point will not catch or snag on the surface texture of the paper. Be careful when choosing to write on such papers.

Non-Lettering Ornamentation

Most calligraphy classes focus on techniques to achieve good letter forms. While this is of primary importance, writing complex ornamental capitals frequently involves either beginning or ending non-lettering strokes that make the capital appear more artistic, exotic, or complex. The factors of curvature, line quality, balance, and other aspects previously discussed still apply, but for non-lettering strokes, legibility is not a factor. In truth, you are simply making patterns, but in doing so, the patterns of the negative spaces around and in between every line are as visually important as the lines themselves.

In any flourished design, the negative spaces form a pattern that is a significant portion of the overall composition.

Balance

In a calligraphic or written composition, balance infers that any single portion of the design does not look any heavier, darker (with an overabundance of shaded strokes), or more complex than any other portion of the design, It is common for a short text, such as a name, title, or caption to appear unbalanced when it is first written, but it is easy to achieve balance simply by adding non-lettering strokes, patterns, or small flourished designs to the unbalanced portions of the text.

Spontaneity and Movement

In penmanship, these two concepts are inseparable. Spencerian and American cursive were created as forms of handwriting. In calligraphic terms, these are properly considered to be an informal hand rather than a formal style such as copperplate or engrosser's script.

As informal styles, Spencerian and American cursive are meant to be written spontaneously, without the prewriting of layouts, rough designs, and preliminary drafts. The spontaneity of writing is precisely why one person's Spencerian or American cursive seldom looks exactly like anyone else's. There are similarities, to be sure—basic letter forms, consistent slant, and letter spacing—but this is the very nature of spontaneously written style. Spontaneous writing should be carried out at a comfortable speed, similar to the comfortable speed at which we speak to one another. If one writes too slowly, they are drawing the letters rather than writing them. If one writes too quickly, they are not allowing their hand enough time to write the accepted shape of the letter. While learning how to make complex capitals, it is fine for a person to initially trace the letters in an effort to learn the shapes of the curves and sequence in which they are written. After much practice, when the muscle memory is achieved, all letters should be comfortably written without any tracing, drawing, or hesitation. A spontaneously written composition looks naturally graceful, while a traced or drawn letter tends to appear vertical and stiff.

In achieving this quality of writing, I recommend not wearing bulky long-sleeve shirts, blouses, or sweaters. The cuffs of such garments at the wrist often become an uncomfortable thickness of material that can interfere with the easy and comfortable movement of your wrist and arm as you write.

Designing Text Layouts

It is always desirable to write your letters and words in the spontaneous motion just described. However, in the effort to write a poem, quotation, or excerpt from scripture,

it is frequently desirable for your completed work to have a pleasing appearance as an entire body of text (with or without added flourishes). The most common examples of this are often the way that sentiments appear in the text on greeting cards. Besides the emotional meaning of the text, the position of the words, the choices for capitalization, the way the sentiment of words and sentences are divided and placed into lines, and the size and prominent shading of any letters for visual emphasis are decided and designed by the calligrapher or penman. Therefore, the effort of achieving the desired final appearance of a body of work is not the result of a quick, spontaneous movement of the pen. It is a combined effort of thought and practiced writing of the text into lines of specific words chosen to produce the completed appearance desired by the pen artist.

Capital Transition: Basic to Ornamental Forms

The primary strokes of all capital letters are curves. For the standard letterforms of capitals, many of these curves take on a commonly accepted shape and all are of an average length for the completed size of the finished letter. Once these curves form the legible and traditional appearance of the letter, they simply end. Examples of this are evident in the shaded curve that functions as the crossbar at the top of a capital T and F.

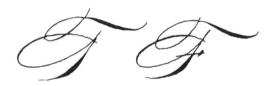

If the writer continues and extends the curves further, the capital letter can still retain its legibility, yet become visually more complex and ornamental. The trick to doing this successfully is being able to envision not only the placement of additional curves and shades, but to also envision the size and placement of the enlarged negative spaces. You must be able to "see" what is not there—the empty, negative spaces—and envision how large they must be to gracefully contain the additional lines and curves you are making. Invariably, when writing ornamental capitals, these letters must be written larger than the size of standard capitals to properly accommodate the additional lines, spaces, and empty (negative) spaces they will contain. The secret to doing this well is practicing ornamental penmanship on a daily basis to acquire muscle memory necessary for writing curves and shades at a large scale in a comfortable manner. Such large capitals often look more balanced in proportion to the lowercase letters if the capitals are written on an imaginary baseline that is slightly below the lowercase baseline.

Imaginary Baseline

Remember, all hairlines, shaded strokes, and negative spaces must be balanced for a completed letter to appear distinctly legible, graceful, and attractive. A well-written ornamental capital should never have an assortment of lines or shades too close together. If this happens, the negative spaces between the lines will also become too narrow and congested to balance the lines and shades of the actual letter itself. You will end up with a hodgepodge of ink that looks like a tossed plate of spaghetti. Skillful capital letter flourishing takes place when any curve is made longer than necessary for the letter itself to be considered legible. Such longer curves typically extend into the negative space that surrounds the letter and can be of any length depending upon how much negative space exists. In this manner, additional non-legible strokes can be added near the flourished curve to help form a flourish pattern or design. Note the following examples.

To explain in detail the method I have found most useful, I offer the following information. We begin by understanding and identifying what I refer to as the reference curves and transition ovals in capital letters. This is important because these curves and ovals become the pathways to making capitals complex and ornamental. These decorative capitals will be larger than traditional capitals, and will serve as emphatic, and sometimes dramatic, portions of your text. This means that they can also occupy a larger, more predominant area of your final composition, which you must consider when planning your text layout.

Note: The rest of this manual is devoted to detailed information on the methods and techniques of flourishing. However, basic information on the flourishing of capital letters is presented below because ornamental capitals are, in truth, traditional capitals that have been flourished. Flourishing techniques are myriad in form and purpose. Simply put, the purpose here is to make traditional capitals fancier and more ornamental. It is for this reason that such information is included.

Line Spacing (Placement of Ornamental Capitals within a Body of Text)

It is creative and fun to write ornamental capitals. However, you should note the following:

The purpose of basic traditional capital letters is to affect an air of respect, prominence, and identity to words such as proper nouns, titles, and the first word in a sentence. Ornamental capitals do the same thing, but their decorative and embellished

24

appearance also accents the proper noun and/or context of the composition. You must be careful not to overuse ornamental capitals by writing them too frequently in the body of the text. An overabundance of ornamental capitals makes each one less visually prominent among all the other capitals that are similarly embellished. Pick and choose the best words to capitalize in this manner. If such ornamental capitals are written within the body of the text, it is helpful to realize that the overall composition will look its best if prior to actually doing the writing, you establish an increased distance of line spacing for your text or composition. As an example, if I am writing a quotation in which I use an ornamental capital to emphasize or dramatize the first word at the beginning of the text and use traditional capitals of standard size for any proper nouns within the composition, I normally have my baselines approximately half an inch or twelve millimeters apart. But if I wish to use ornamental capitals frequently throughout the composition, I establish my baselines to be anywhere from ⅝"–¾" or 12–18 millimeters apart. By increasing my line spacing in this fashion, my ornamental capitals will appear graceful rather than constrained in appearance or disproportionate to the lowercase.

In this example, the line spacing of five lines at the top writing is ⅜" apart the line spacing of the Composition Writing below is ⅝" apart.

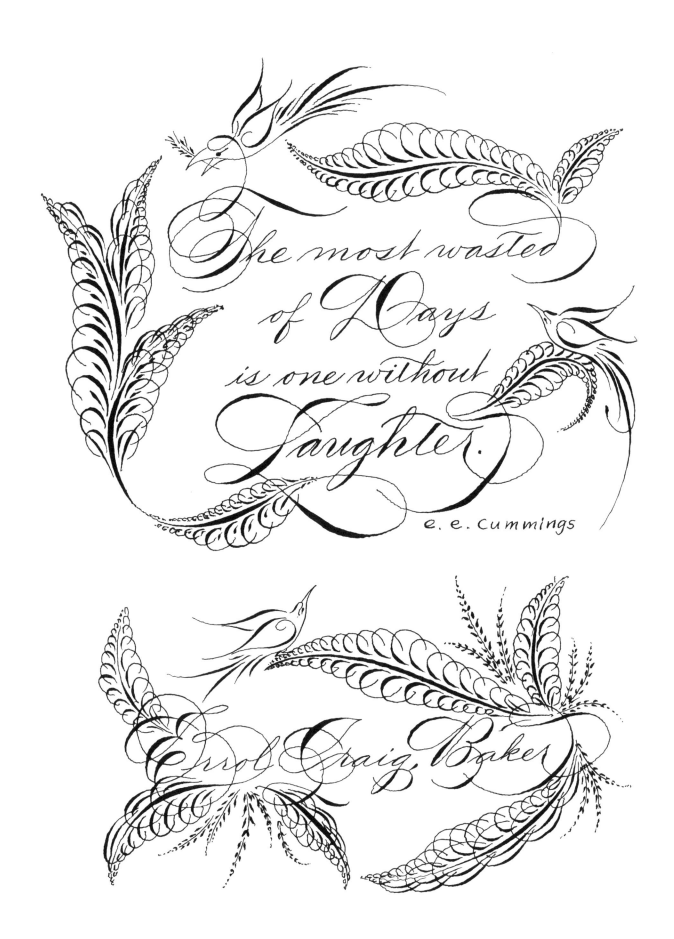

The most wasted
of Days
is one without
Laughter.

e. e. Cummings

Carol Craig Baker

Reference Curves and Transition Ovals in Capitals

The dotted lines in the following examples indicate the transition ovals, which are the reference curves that serve as the structural elements in a capital letter for extending, spiraling, overlapping, and/or intersecting additional curves of ovals.

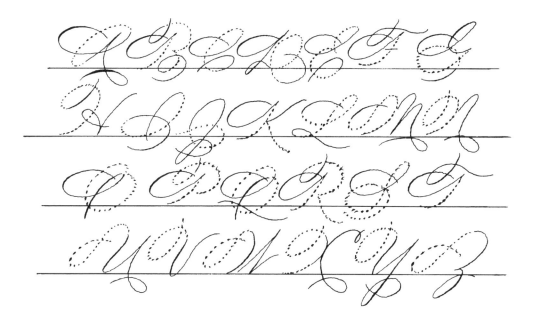

Examples of extending transition ovals into multiple spirals:

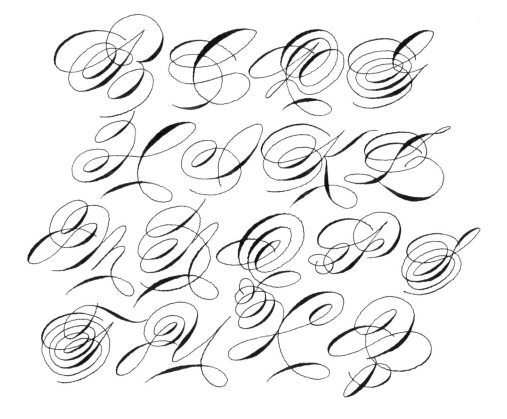

Ending strokes of capitals and lowercase can also serve as transition ovals. These strokes frequently become flourishes that serve to balance a name, title, etc.

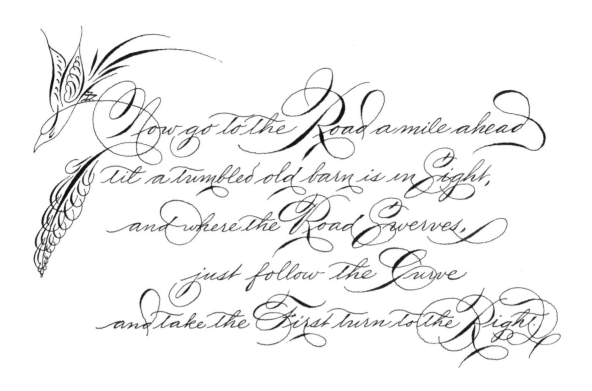

Flourishing Techniques for Ornamental Penmanship

Off-hand flourishing techniques have been very traditional and popular methods of non-lettering ornamentation for more than one hundred and fifty years. The resulting patterns of cartouches, plumes, quills, scrolls, birds, and title flourishing serve very well as stand-alone design elements to fill negative spaces within and around lettering compositions. However, in the complete absence of any lettering, flourishing by itself can produce artistic designs of beauty that are a joy to behold. Indeed, flourishing is not only a beautiful art form; it is also a compulsive activity, for it is usually very difficult to stop!

For all of us who enjoy this activity, it seems right to explain some additional techniques of how flourished designs can emerge and flow from individual letters into any area of negative space on your paper. It's all about focusing your attention to the beginning and/or ending strokes in a letter!

The first step is understanding that the flourished lines themselves, not the letter they will be emerging from, are simply extended curves that possess no legibility. In simple terms, flourishes are not letters, and therefore it is a fact that flourishes can have no top, bottom, or baseline to sit upon, and the size of the flourishes you make is only limited by the available negative space and, of course, your imagination!

To begin this new journey, think of your capitals not as letters, but as nothing more than a pattern of curves. In the designing of flourishes, I must also ask you to think of letters not as shaded strokes, but as a monoline arrangement of curves. Once you can envision this perspective, focus on the beginning stroke of the letter if you wish to enter the "letter" (monoline arrangement of curves) with a flourish, and the ending stroke that would traditionally be the terminus of the "letter." Note entry strokes (X) and ending strokes (Z) in the following examples:

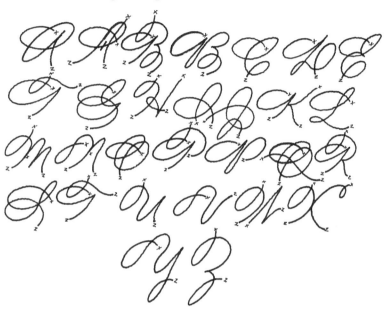

Now, consider the extended curves designated by the dotted lines. These samples show beginning and ending flourishes that I use all the time. Study these spirals and oval patterns. They can similarly be used on many capital letters.

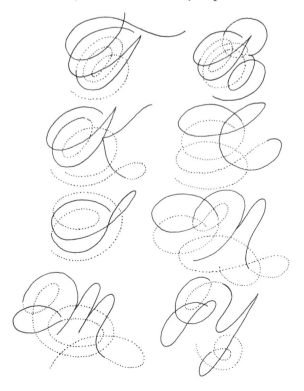

Once you have gained the ability to envision the basic extended curves such as those shown in the samples, it will become easier for you to imagine extending the curves and curved patterns even further. Thus, the curves in the legible capitals become reference curves, and the primary ovals serve as transition ovals, and are the basis for further flourishing of curves and patterns. Then, like water flowing around pebbles in a stream, you can create the flourishing designs that fill the negative spaces in the empty areas of the margin spaces you desire. Most often, these margin spaces will be to the top, bottom, left, and right of the lettering composition. The result is that you now have the ability to create the beautiful, flourished borders that can surround your penmanship composition, with portions of the flourishes actually flowing out of capitals or ending lowercase letters.

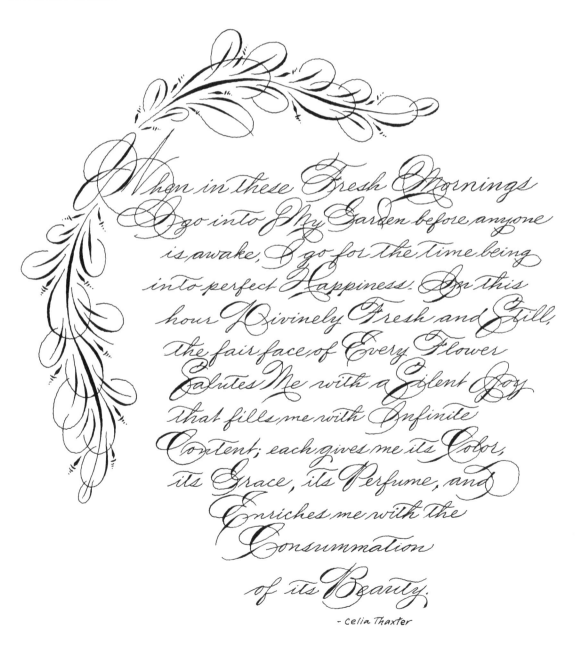

When in these Fresh Mornings I go into My Garden before anyone is awake, I go for the time being into perfect Happiness. In this hour Divinely Fresh and Still, the fair face of Every Flower Salutes Me with a Silent Joy that fills me with Infinite Content; each gives me its Color, its Grace, its Perfume, and Enriches me with the Consummation of its Beauty.

- Celia Thaxter

WHEN a knowledge of forms, and the power to execute them, are fully acquired, it is proper to enter upon the study of the rules pertaining to shade. When, therefore, anything which is useful, is at the same time made attractive, the mind is then ready to accept it, and apply it to practice.

The power of appreciating what is beautiful seems inherent in every mind, although tastes, within certain limitations, may differ in their requirements.

If we would have Penmanship both attractive and useful, and its study pleasing, we cannot depend entirely upon correctness of form for imparting to it these qualities.

Light letters, when properly formed, are in themselves beautiful; yet, when combined, as on the written page, they produce a monotonous effect.

To break up this monotony, and produce something which will please the eye, and gratify the taste, light and dark lines should be mingled, so as to present an agreeable contrast.

Shade, however, not being essential to form, may be used, or omitted, at the option of the writer. Many accountants and book-keepers prefer to write without shade, in order that they may more easily preserve the neat general appearance of their work, and, also, that they may more readily erase errors in words, letters, or figures.

Were all writing executed with heavy downward lines, as in the old-fashioned round hand, it would possess no more beauty than if the lines were uniformly light, since excess of shade as effectually destroys the contrast, as its entire omission.

It is the graceful blending of light and shade which gives life and beauty to the productions of the artist, and renders paintings fountains of delight, from which the eye of the beholder may drink, and never weary. And what is writing but the picture-work of thought.

The principles involved in the subject of shading are few, and their application depends mainly upon a right exercise of judgment and taste.

Excerpted from Platt Rogers Spencer's *Spencerian* (1877)

Shading of Letters

Inspired by the environment surrounding Lake Erie's shoreline, Platt Rogers Spencer based his entire system of writing on the four concepts that are universally found in nature. These are movement, curvature, variety, and contrast. Since all letters remain legible in a monoline form without shading, Spencer reasoned that the techniques of shading fell under the concepts of variety and contrast. In this way, shading was an *accent* rather than a *structure* of penmanship. Therefore, a penman or writer could acceptably shade any portion of any letter. In this way, shading became a prominent feature of handwriting with various degrees of appearance depending on the writer. Shading served as a tool of penmanship that could make any letter, word, portion of a sentence, or text more visually significant or dramatic. Shading could also render a text more masculine in appearance by making shades heavy and prominent, or more feminine by making shades delicate. It must be noted, however, that in traditional Spencerian penmanship, every capital should be written with at least one primary shade such as capital stem. Yet, even this discipline could be tempered with either a light or heavy shade.

Sidebar: Owing to the significance of the Industrial Revolution following the Civil War, professional penmanship training began to thrive in America during the last decade of the century. This was the era prior to the widespread use of typewriters in the 1920s. (My own mentor, Paul H. O'Hara, summed up the effect that the typewriter would have on the penmanship community by saying on several occasions, "That damn typewriter! It put us all out of work!")

During this Golden Age of Penmanship (1850–1925), the faster a person could write, the more marketable they became to secure employment. Colleges and business schools whose curriculums focused on penmanship studies began appearing by the score. Most prominent of these was the legendary Zanerian College of Penmanship that opened its doors in 1888. Mr. O'Hara was a student there from 1907–1908; his personal instructor was Professor Zaner. The stylized form of Spencerian writing taught there featured no shaded strokes at all and was known as "business writing." It was simply faster to write without shades, which allowed a person's "rate of writing" to be maximized.

The primary benefit in the decision of when to shade, the prominence of the shade (how light or heavy the shade should be), and how often to shade gave the writer the opportunity to develop his or her own individual appearance in their penmanship. This was a major benefit in allowing people, as long they maintained legibility in their handwriting, to be free from the former strict discipline of shading every letter, as in the English roundhand script of the eighteenth century. Therefore, throughout America, as a country founded on the principles of individuality, personal rights, and

freedoms, everyone could now learn the basics of handwriting in a form they desired. Coupled with such freedoms as a personal choice of letter spacing (all letters must be consistent in their letter spacing, yet a writer's letter spacing need not be the same as everyone else's) and specific letterform of capitals (refer to the next subject of alternate letterforms), people could write in their own way. This was a tremendous boon to the progression of literacy in the United States. Citizens who perhaps lacked the formal academic education of such vocations as the legal profession, clergy, medical fields, or government officials now felt that learning how to write, and thus to read as well, was within their grasp.

Alternate Letterforms

Like the aspects of variety in nature where there are many species of birds, flowers, trees, and animals within a specific genus of living organisms, Spencer taught that letters, especially capitals, need not be limited to only one reference of letterform. Decades later during the height of penmanship's Golden Age, skilled penmen expanded this philosophy further into the realm of ornamental penmanship. It certainly was never mandated that any penman was required to know or use any of the alternate letterforms, but it was often regarded as an indication of a person's skill if their writing exhibited a variety of the nonstandard letters in their work.

Legendary Master Penmen such as A. D. Taylor, C. P. Zaner, E. W. Bloser, Francis B. Courtney, and Louis Madarsasz, among many others, delighted students with a myriad of fanciful, complex, and elaborate versions of traditional capital letters. Today, such alternate forms are still considered as viable and accepted, although there are some examples whose popularity is so distant that they have become lost in time. These "lost letters" rarely appear in the work of present-day scribes, but many are now regarded as either archaic, antiquated, or simply obsolete. Sadly, some are not recognizable at all as being legible. With these thoughts in mind, I invite you to study and use any of the following examples. I offer these as the alternate letterforms that I use all the time in my work. I find them fun to write, for they do add a sense of enjoyment as I move my pen, and perhaps a touch of the unexpected to those who read my penmanship. Note that not all letters, especially lowercase, feature alternate letterforms, yet even standard forms can have a sense of variation by altering degrees of shading, or by the technique of spiraling where additional ovals are brought into many standard capitals.

Lowercase examples:

ALTERNATE LETTERFORMS EXAMPLES	
ꝺ ꝺ / *ꝺ ꝺ* / *ꝺ*	ended ended ended ended
	dedicate decided skedaddled
r	error error Territory corroborate
	current Tertiary farrier Terrier
t t / *t*	attempt attempt intermittent
	transatlantic Teakettle toast
l g / *j p* / *q y* / *z*	etiquette people grateful together
	yearling giggle defend azimuth
	drizzle jumping equal quantum
	require gypsy analyze symptom
s	This s differs from the similar form for the capital s in that this lowercase version has no top loop, no shade, and though taller than the short lowercase letters, is only as tall as the short-extended letters such as d and t. It is often challenging to use this in a word with a double s combination where both s's should be the same size and height, with letter spacing being consistent.
	exquisite sensation basis assay
	surprise quizzes osmosis seasons

34

Uppercase examples:

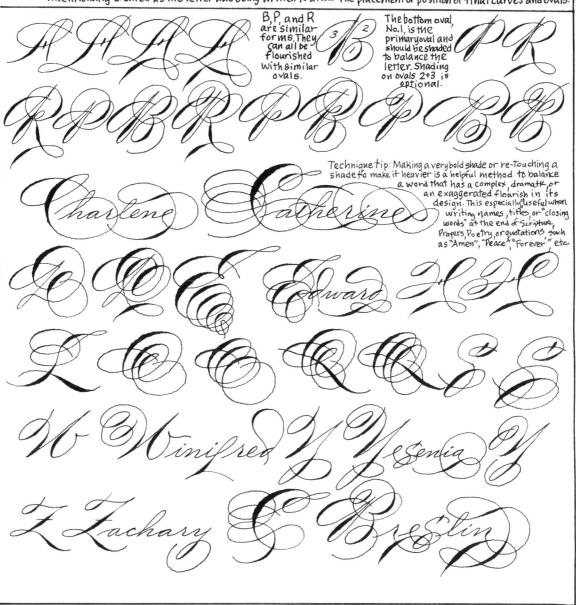

ALTERNATE LETTERFORMS
CAPITALS

Alternate letterforms are shown here for A, B, C, D, E, G, H, L, O, P, Q, R, S, W, Y, and Z. These forms differ from traditional Capitals in their structure, however slight that may be in shading. As with all Capitals, these forms can be embellished further into Ornamental Penmanship. Variations of these Alternate Capitals are shown below. Among them, look for variations in shade and oval placement, and always be mindful of the amount of negative space that was intentionally created as the letter was being written to allow the placement or position of final curves and ovals.

B, P, and R are similar forms. They can all be flourished with similar ovals.

The bottom oval, No. 1, is the primary oval and should be shaded to balance the letter. Shading on ovals 2+3 is optional.

Technique tip: Making a very bold shade or re-touching a shade to make it heavier is a helpful method to balance a word that has a complex, dramatic, or an exaggerated flourish in its design. This especially useful when writing names, titles or "closing words" at the end of Scripture, Prayers, Poetry, or quotations such as "Amen", "Peace", "Forever", etc.

35

Ornamental Capitals

Flourished Entry and Ending Strokes

Note: The small arrows in the following examples indicate the direction of the pen as it makes the forms.

Entry Strokes:

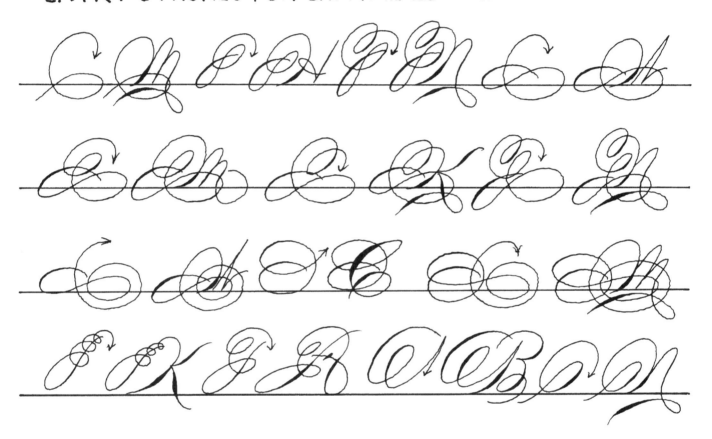

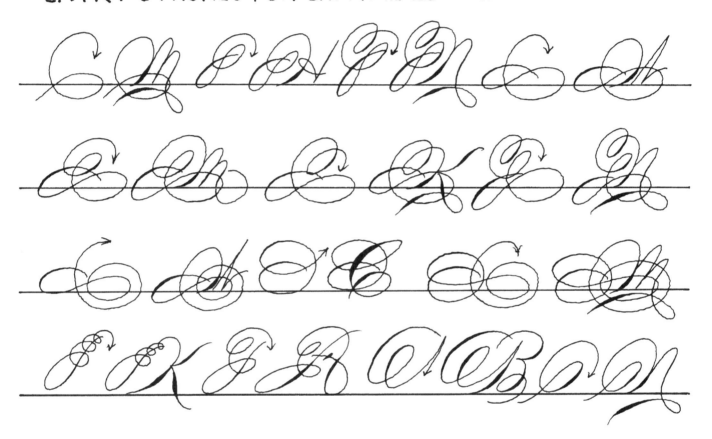

Ending Strokes:
Lowercase examples:

ENDING STROKES FOR LOWERCASE LETTERS

g g g sing g bring g

Notice the parallelism in the negative spaces

bring bring n n penman

penman penman penman

penman penman penman

penman penman penman

<u>Technique Tip</u>
It is often useful when writing the last word in a composition to write
the word with slightly increased letter spacing. This will allow
the linework of a complex ending flourish to pass through the
baseline in between the letters in a word. It is perfectly allowable,
however, for linework to pass through letters if it appears
to be the best way to cross through the baseline.

Capital examples:

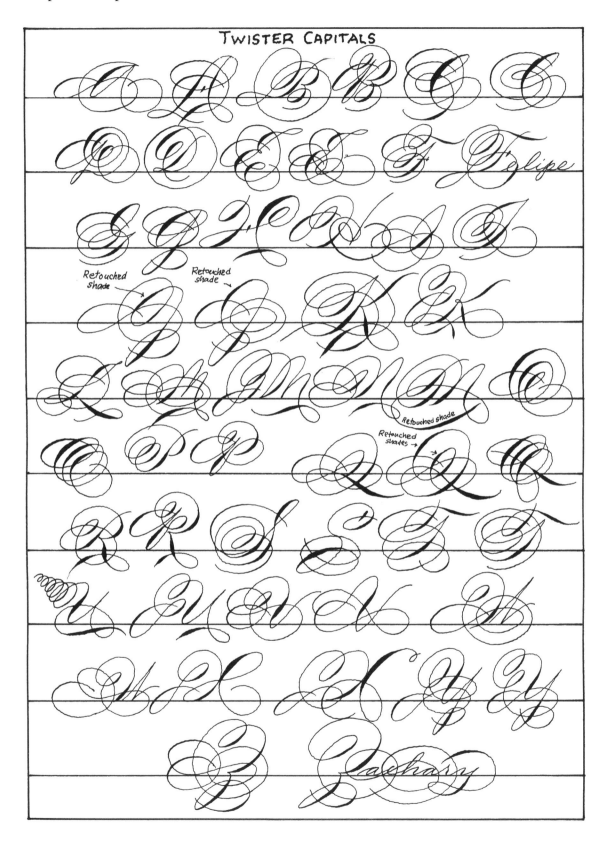

Compound Ending Flourishes: These are flourishes that begin with any of the examples shown, and extra non-legible curved strokes are added to produce a fuller, more decorative ending appearance.

Compound Ending Flourishes are best studied in the situation for which they are designed: as they are seen in visible language.

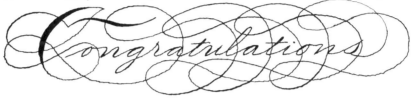

This flourished "Congratulations" was designed so that the flourish would flow uninterrupted from the Capital C to the ending s. The technique is fairly simple, going back and forth, again and again from above the letters to below the letters. The key is that the exit stroke from the Capital C needs to be going to the right, and thus be able to flow towards the final letters while making its loops above and below the lettering. Note the pattern of the negative shapes.

In this example, note which letters start the flourishing patterns.

Notice the patterns of the curves, negative spaces, and the sharp change of direction in the line work of "Homesville". The primary factor with all flourished penmanship is always Legibility-can the text be read easily? Let this factor guide you as you practice.

39

Ornamental Penmanship Techniques

The techniques and examples that follow represent the heart of this chapter. Your ability to become skilled in the subjects presented will only come after much study and practice. I recommend that you practice each subject in pencil first and continue practicing in pencil until your muscle memory allows you to perform each subject without hesitation. Take your time; above all, do not rush or become impatient with your efforts. Except for monogram design and Masterpiece Flourishing, which are meticulously designed and then carefully drawn, all the other subjects discussed here are intended to be written spontaneously. Even retouched shades and extended curves should be spontaneously penned, for the strokes that create them are not laboriously drawn but rather written with the same ease at which you make a letter appear on paper.

In addition, I encourage you to look over the subjects in this chapter, select the subject that interests you the most, and allow yourself to begin your study and practicing efforts with that subject first. Only twisters and super twisters are sequential in the sense that you really must understand and become skilled in writing twisters before you tackle the more complicated techniques of super twisters, but you can approach composition writing, superscription, and monogram design in any order that you desire; none are dependent upon each other. But above all, study, practice, don't rush, and then study and practice more and more.

Spatial Considerations and Manipulating Shaded Strokes and Flourishes

Spatial considerations and manipulating shaded strokes and flourishes will be pertinent to all techniques involved in ornamental penmanship. In a very real way, I consider this important information to be the secret ingredients of advanced penmanship by which a Master Penman can demonstrate complex examples of pen artistry and make it look easy.

Spatial Considerations

In succinct terms, spatial considerations imply that once you have decided what you want to write, you need to have a mental image of the negative spaces that can result when your pen begins writing. By being aware of the negative space possibilities, you can then write your letters or words in such a way to maximize the negative space areas. By doing this, the larger negative space areas will allow for additional curved lines to pass through these areas. This is how twisters, super twisters, and ornamental capitals are formed with the spiraling and layering of ovals. Note the following examples:

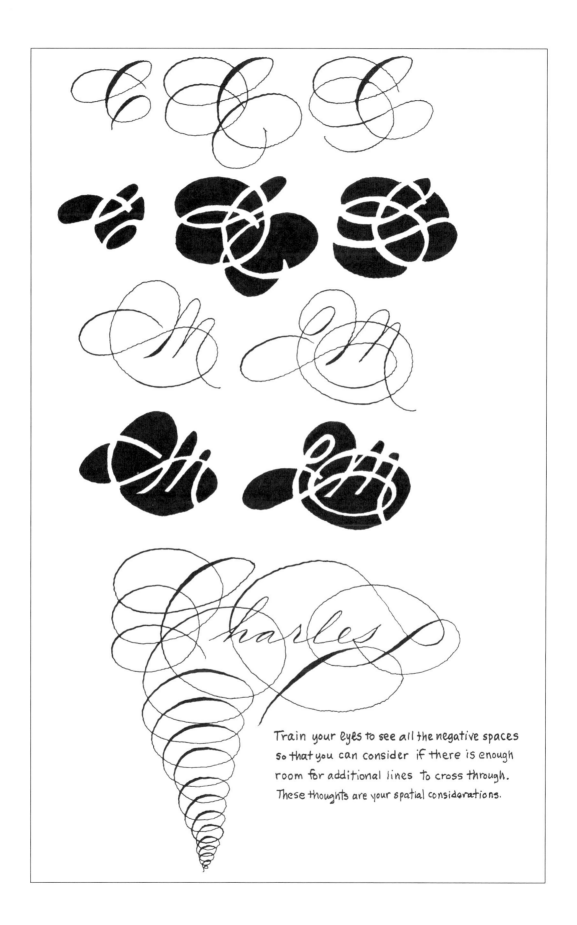

Train your eyes to see all the negative spaces so that you can consider if there is enough room for additional lines to cross through. These thoughts are your spatial considerations.

41

Manipulating Shaded Strokes and Flourishes

With this method, it is easy to produce shades and hairline curves that can add shades in portions of capitals that are traditionally written as hairlines. As an example, when writing a capital L, the ending stroke that forms the bottom leg of this letter is normally a hairline stroke, as the pen moves in a direction to the right:

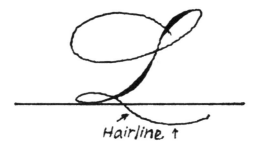

Hairline ↑

However, if we stop the movement of the pen at the moment the pen point touches but not crosses the capital stem stroke, then lift the pen and shift the position of the paper approximately 180 degrees, we can now touch the paper at the spot where our line will cross the capital stem and continue our final stroke. With the paper in the 180-degree position, we can make this the final leg of the L as a downstroke and do so as a strong shaded curve.

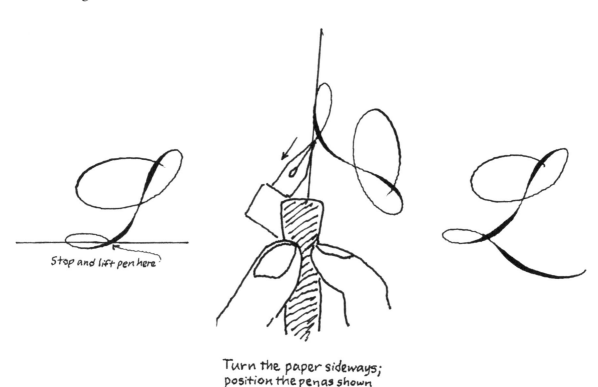

Stop and lift pen here

Turn the paper sideways; position the pen as shown and moving in direction of arrow, write shaded leg of the L

Once this letter is completed, turn the paper back to its normal writing position and continue writing your remaining text, whatever that might be. The important idea to remember is that we stopped and started our pen stroke directly on the spot where we would cross a previous line. This "crossing spot" is very useful in that it can usually hide any small degree of misalignment that we may make in our effort to put the point of our pen down exactly on the same spot we stopped and lifted the pen off the paper. Also, it allows us to make a shaded stroke in an area where we could only make a hairline stroke previously. If we were crossing a shaded stroke, this crossing spot would be even more forgiving of any misalignment. The following examples and notations are worth your study. Observe how this "stop and restart" of the pen and shifting of the paper position enables the writing of shaded flourish strokes as well. In the example of the capital J, after writing this letter in its standard form, we simply turn the paper inside and down (180 degrees), carefully place our pen point on the hairline indicated, then make a shaded stroke, the edge of which covers the hairline. This retouched shade makes the capital J visually more balanced.

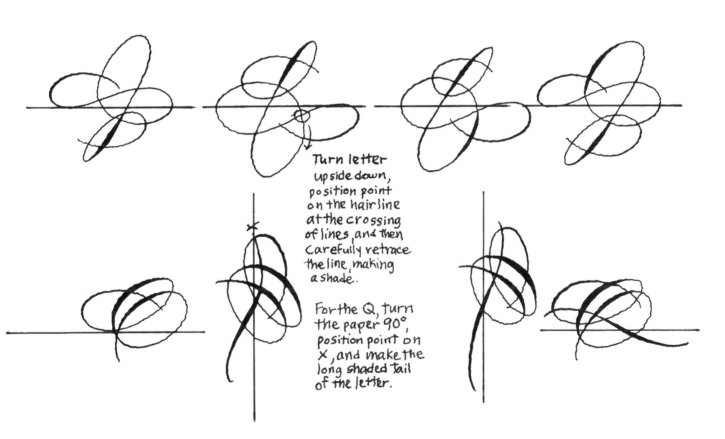

Turn letter upside down, position point on the hairline at the crossing of lines, and then carefully retrace the line, making a shade.

For the Q, turn the paper 90°, position point on X, and make the long shaded tail of the letter.

Twisters and Super Twisters

Twisters

"Twisters" are capitals in which the primary or major curves extend beyond the point of recognized legibility and continue into a spiraling pattern to form an additional one or two more ovals. Because a traditional capital will have at least one primary shade in its construction, the addition of one oval results in the twister capital having two shades. The addition of two ovals results in the capital having three shades. Note the following example:

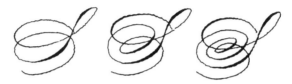

The word twister was coined in the late nineteenth century by legendary Master Penman Francis B. Courtney (1867–1952), whose skill and versatility were so unmatched that he was widely referred to as "The Pen Wizard." His twister examples were all achieved by a method I refer to as direct spiraling. This means that the ovals spiral *within* the letter, and because of this fact, each succeeding oval is smaller in size than the original oval used to form the traditional letter. In Courtney's publications from a century ago, he usually limited his twisters to possessing a total of three shades. The reason for this is that by the time a penman spirals two additional ovals within a letter, the last of these ovals is quite near the center of the first or primary oval. There is simply no more room to add another oval so, in a sense, a three-shaded twister is the practical limit for the resulting letter to be made nearly the same size as traditional letters. In making these additional ovals, you must maintain the same amount of negative space between each oval. This is the key factor in making all twister and super twister letters. Failing to maintain adequate space between each oval will result in the ovals and their shades being positioned too close together or lopsided and uneven. The letters will have a cramped, unsightly, and "heavy" appearance.

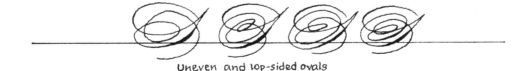

Uneven and lop-sided ovals

It is for this reason of proper spacing that most twisters tend to look best if they are written at a slightly larger size than traditional capitals. The larger size allows more room within the letter to afford adequate negative space between spiraling ovals.

Traditional size

Twister size

It must be pointed out that the natural shape of some letters prevents such letter-forms from having twister configurations. For example, the traditional capitals A and L do not have twister forms, however, there are super twister forms for them which will be explained in the following section.

It should also be noted that while a standard capital O is often written with two shaded ovals, it is the twister form that boasts three ovals with shades.

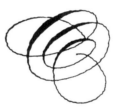

The following are all the standard twister forms of capitals that are frequently used by skilled penmen.

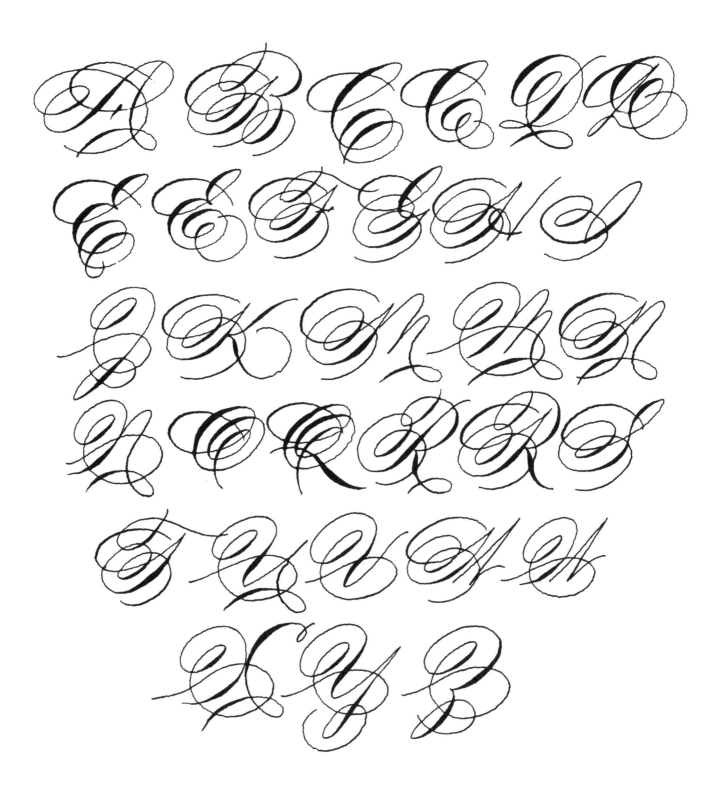

Super Twisters

Super twisters are capitals that feature ovals made by indirect spiraling or the overlapping of ovals formed both inside and outside of the basic letterform. Some super twisters may feature one or two shades, but such letters always feature additional parallel curves and negative spaces on both the inside and outside of the basic (traditional) letterform. The reason it is possible to make such letters is because many of the curves are, as mentioned, made *outside* of the letter, and therefore we are not limited to the inside space to make our additional curves, ovals, and shades. This feature of outside space also offers us a variety of stroke sequences, which further permits many additional forms of super twister versions of many letters.

At the end of this section are many examples of super twisters. Refer to these at any time to familiarize yourself with their shapes and shade portions of curves. Do not try to memorize all the possible spiraling combinations, for the variations are endless and often confusing. Remember, also, that the more complex the super twister letter is with multiple shades and additional curves crossing other curves, the more essential it is to make the letter a large size: only in this way can you maintain adequate negative space between spiraling ovals and shades to have the completed appearance look graceful and balanced.

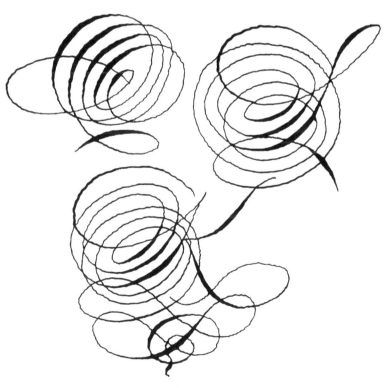

The network of open, negative spaces allows a Super Twister to "breathe."

Designing Super Twisters

To design and write such elaborate letters as super twisters, you must first be able to envision the letter you wish to create. Besides the overall shape of the letter, you must consider the placement and approximate size of all curves and negative spaces before your pen touches the paper. This will enable you to write so that the lines you create will be in the correct position to accommodate the ovals and shaded strokes you wish to produce. When I first began to develop these letters, I thought of how it all made sense to me. I did not wish to simply memorize any nice-looking letters I might happen to write. I wanted to understand how I could create such letters; the method or process that would enable me to write any super twister at any time without needing to resort to simply copying a reference example. The following is how I did it.

Begin by examining a traditional twister capital O:

Instead of focusing your attention on the actual lines, notice the relationship of negative space.

There are four curved negative spaces. The top two are parallel over-curves on the left side of the letter and the bottom two are parallel under-curves on the right side of the letter. These opposite curves allow the entire letter to be visually balanced. The opposite curves also appear to be at the same slant (letter angle) as any lowercase letters that would follow this capital O. Observe that the smallest shaded oval in the center is itself at the correct angle. All the curves and negative spaces on the left are basically a mirror image of the curves and spaces on the right. The only difference is that the curves on the left are downstrokes, capable of making shades, and the curves on the right are hairlines made by upstrokes.

The next step follows that if you wanted to create a letter with four shaded curves on the left and four parallel hairlines on the right, a similar mirror image to the initial capital O would take place. On a clean sheet of practice paper, take a pencil and draw the small central oval of your proposed letter. Then, sketch the number of curved parallel lines on the right that will represent the unshaded curves you desire to have in your finished letter.

For the completed letter to be visually balanced, the width of the negative spaces between the unshaded curves should be the same width as the central oval.

wider spacing

Therefore, if you desire to have four unshaded curves on the *right,* you must also have four parallel shaded curves on the left. Keep in mind that each shaded stroke on the left will have a slightly wider width (the width of the shade itself) than the hairline strokes on the right. With this in mind, sketch in the four shaded curve positions on the left with a slightly greater width between these curves than the spacing between the curve positions on the right.

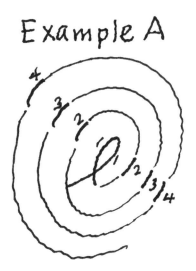

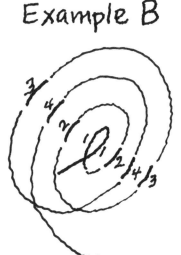

From this point on, put your pencil back on the leading curve of the center oval and go around and around the letter you are making in a sequence that will allow the spiraling of this line to go through each of the penciled curves in a continuous, spontaneous motion. There are two different ways you can do this. In Example A, the curve is going around in a spiral like a pinwheel.

No lines are crossing any other lines until you reach your ending stroke. There is nothing incorrect with this spiraling sequence. However, your finished letter, complete with shades, may tend to look more like a target than a capital letter. If you are just beginning to master this technique, I suggest that you consider following Example B. There is a bit more to remember here, but the crossing of lines at the bottom of the ovals gives the finished letter a more attractive and graceful appearance.

To help familiarize yourself with this sequence, I suggest that you redraw your sketch by starting with a straight, slanted line at your desired letter angle. Next, draw the small strokes that represent the positions of the four shaded curves on the left and the four unshaded curves on the right.

Now, using a pointed colored pencil or a fine-pointed colored marker such as a red Copic Multi Liner 0.03 or Pigma Micron 02, write the numbers shown in this example directly on top of the shaded curve positions. Now, go around with your pencil to cross each number in sequence.

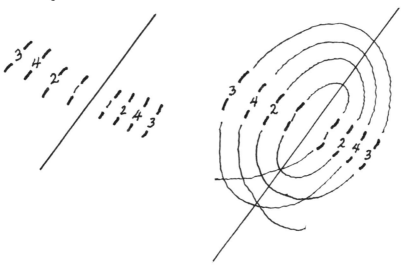

As you practice this form of a super twister over and over again, you will gain a thorough understanding of this type of spiraling and become familiar with the sequence of curves to follow. It should also be stated that other sequences and spiraling patterns certainly exist, and as your skill progresses, your enjoyment of this art will prompt and challenge you to learn a variety of super twisters. Here are two such examples for you to try. Follow the lines to determine the spiraling sequence.

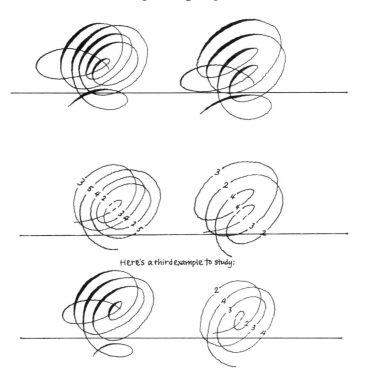

Here's a third example to study:

51

Letter Spacing

Spacing of lowercase letters immediately following super twisters and elaborate capitals can be tricky. Due to the extra ovals, hairlines, and flourished strokes on the right side of such ornamental majuscules, the first lowercase letter often looks best when a portion of the letter is written *within* the right side of the capital.

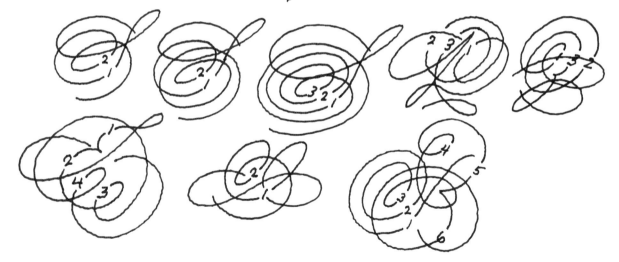

I am convinced that the secret to writing super twisters and all ornamental capitals is being able to envision the width and sequence of the necessary negative spaces that will be needed to create the number of shaded strokes you desire. As you imagine what your finished super twister letter will look like, focus your thoughts on the sequence of the curves that you write in the letter. The following examples show the sequence of curves as I would write them:

Numbers show sequence of shaded curves

52

Student Practice

Choose a word that you wish to capitalize with a super twister and, with a pencil, practice the spiraling sequence to make the letter. Continue practicing until you can make the letter spontaneously. Then, after you have written the letter with confidence, write the lowercase letters to complete the word. For a better visual effect, write that word in a sentence or body of text. This will allow you to see the prominence of your super twister and how its size and multi-curved appearance will make your writing appear more special, artistic, and often dramatic.

Now, choose another word and go through the complete exercise again. Strive to provide at least five different super twisters each day, and always train your eyes to see the negative spaces that you will need to accommodate all the curves and shades within a letter.

Combination Twisters

This large group of twisters involves a combination of direct spiraling, where we spiral within the letter, and indirect spiraling, where we spiral to the outside of the letter. I love using these letters, especially for names in signature writing, and for titles of textual pieces. All the letters in this group share a similar structure that is not as complex as the super twisters previously described. Combination twisters are easiest to use on capital stem letters. A standard stem letter has a pronounced curve and a single shade. A simple ornamental letter can be made by extending the ending stroke in either a layered oval or spiraling oval. To make a combination twister, we use the spiraling oval as our base design.

Making this spiraling and oval capital stem at a large size, I usually extend the capital stem into two ovals, purposely leaving wide spacing within the innermost oval.

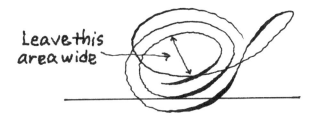

Then, instead of extending the spiral any further within the existing ovals I have just drawn, I make one final narrow oval that extends outside of the capital stem, curves around, and extends into and through the extra wide spacing that I allowed when I made my first two spiraled ovals within the capital stem.

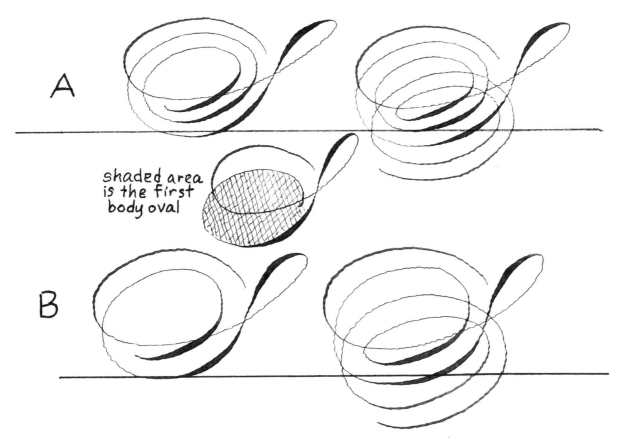

A

shaded area
is the first
body oval

B

Technique Notice that Example A has 3 parallel shades.
 Tip: Example B has 2 parallel shades. It all depends
 upon how many times you spiral around inside and within
 the first body oval before making the narrowest oval.

The trick to doing this well is to make sure you allow enough negative space within the inside oval so that there is enough room for your final curve to spiral to the right, outside the capital stem, then curve around the outside of the stem and cross back into the capital stem spirals, crossing between the left and right side curves of the inside oval. Note the examples that follow:

54

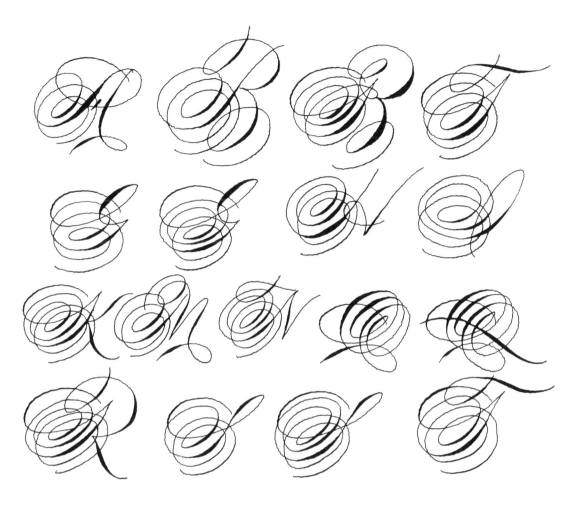

The complexity of the Super Twisters depends upon how many times you spiral within the letter.

Overdoing It

Once you become skilled at spiraling, I confess from personal experience that you almost feel you have superpowers as a penman. It becomes tempting to spiral every curve you write. Instead of making an O with four or five shades, you want to make one with six shades, or an S with "just one more oval" to its shapes. Those may be good academic exercises, but they generally result in letters that are too large to look balanced with adjacent lowercase, or else the additional spiraling detracts from the legibility of the word it appears in. I offer this hint of caution to consider as you practice daily and increase your prowess with a pen.

Other Ornamental Capitals

Twisters and super twisters are only two forms of pronounced capital letters, yet all ornamental capitals involve a combination of spiraling, duplicating ovals and shaded

strokes, and often elaborate entry and/or exit strokes. As previously mentioned, it is imperative that you train yourself to see "what's not there." You must see the negative spaces in your mind before your pen touches the paper. Only by doing this will you know how to properly write your initial curves, ovals, and shades so that there will be adequate space for additional curves and shades to fit between other curves and shades in your letter.

Perception of Negative Space

Study the following examples. For your own practice, write six super twisters lightly in pencil at a large size (approximately half an inch or one and a half centimeters in height). Now, take a sharp-pointed colored pencil or a fine-pointed colored marker and color in all the negative spaces. When you are finished, look at your work. Concentrate the focus of your vision on the negative areas in color. Practice this exercise with different super twisters each day. As you continue into the various ornamental capitals that follow, do this same exercise each day with as many capitals as you can.

Balance of Capitals in Ornamental Penmanship

At this point in our studies and prior to presenting the techniques and examples of other elaborate letters, it is prudent to remember that all ornamental capitals, including super twisters, need to be written at a large size—*at least* one and a half times larger than standard capitals. Such a large size can often cause conflicts with lowercase letters. Everything you write, all letters, needs to achieve a visual balance in your composition to appear graceful and easy to read. To help in this effort, I suggest the following considerations.

Because ornamental capitals are substantially larger than standard capitals and far larger than lowercase letters, I have found that ornamental capitals look best if they are written on an imaginary baseline that is a little lower or beneath the standard baseline you will use for your writing of words and text. I have developed a Guide Sheet for Ornamental Penmanship Capitals on page 202.

I must caution you not to get overzealous in your use of ornamental capitals. For the general writing of textual copy, poetry, quotations, verse, scripture, etc., the best place to use large capitals is in titles, the first letter of the first word used in a composition or paragraph, or perhaps the final word in a composition if that final word is dramatic in its meaning or reference to the text. All other capitals throughout the text should be of standard size and form. The use of too many large ornamental capitals within a text can make these letters look less special with less of a dramatic appearance. Also, extra-large or fancy capitals within a text will frequently bump into or overlap the neighboring lowercase letters.

Ornamental Variations of Capitals

In the examples that follow, note the spiral variations, the parallelism of lines, curves and shades, the placement of shades within the letters, and the notes about turning the paper position for the tail of the Q and the added shading to the top loop of the J.

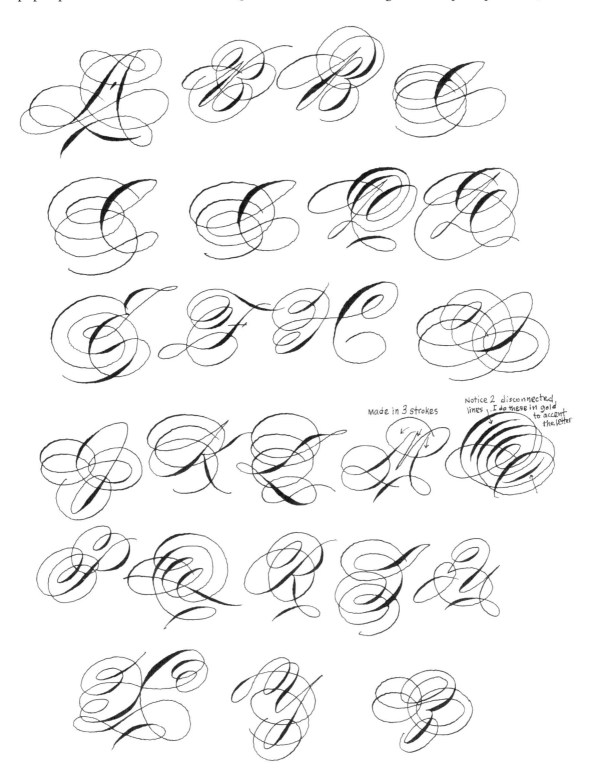

Made in 3 strokes

Notice 2 disconnected lines. I do these in gold to accent the letter

Extended Letter Flourishing

Definition: Any line that extends from a letter beyond the purpose of legibility is a flourish.

We have seen how traditional capital letters can be transformed into more complex forms of ornamental penmanship with extra curves, shades, and spirals. Such ornamentation, however, is a part of the letter itself. In this section, I will delve into how all letters, capital and lowercase, can be extended into flourishes, not to further ornament themselves, but to ornament and balance other areas within a body of text.

Traditional capitals have fairly standard entry and ending strokes. However, every entry and every ending stroke is a curved line. Because curved lines can be extended and bent in any direction, any extended entry and exit curve can easily be turned into any direction outside of the body of text to begin creating a flourish or accent design.

Traditional letterforms with an assortment of entry and exit strokes

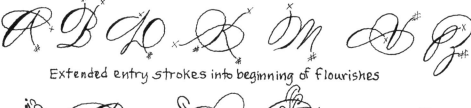

Extended entry strokes into beginning of flourishes

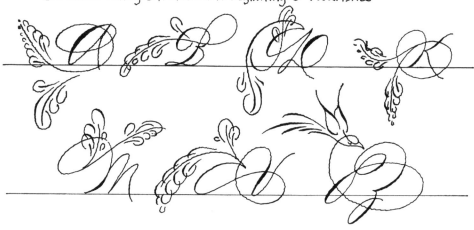

Exit strokes can be extended the same way

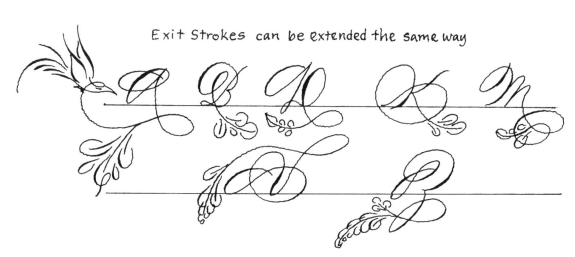

There are many creative ways of extending lines into flourishes. To begin this journey, it is helpful to consider the direction of the entry and ending strokes in the letter you will be flourishing. This will help in deciding what curvature your flourish must end in if you wish to make a flourished entry into the letter, or what curvature you must start with if you wish the ending stroke of a letter to be where your flourish begins. In the examples on the previous page, note the various entry strokes (x) and ending strokes (#).

Shown below are extended flourishes that have been used by penmen for over a century. In writing these flourishes in any textual composition, it is wise to use your judgment and not overindulge by creating them at the beginning and/or ending of every entry and ending letter of an abundance of words.

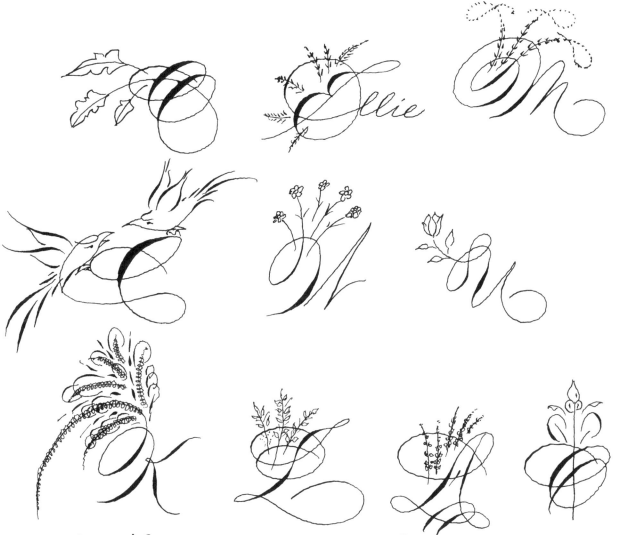

Extended Flourishes with ornamental accents of flowers, birds, leaves and Flourishing were often used on the leading capital of a body of text, such as poetry, Scripture, quotations, or for titles. The flowers and other accents were done in colors or gold for a stunning effect.

Through your own study and practice, and once you have gained the ability to envision the basic extended curves such as those shown in the examples, it will become easier for you to imagine extending the curves and curved patterns even further. In this way, the curves in the capitals become reference curves and serve as the basis for further flourishing of curves and patterns. Then, like water flowing around pebbles in a stream, you can create the flourishing designs that can fill the negative spaces in the empty areas of the margin spaces in between lines of writing or at the end of words. The margin spaces will usually be at the top, bottom, left, or right of your written composition. Learn how to create beautiful, flourished borders surrounding your text in the Flourishing chapter on page 100.

I am quite fond of a particular American Folk song from 1975 by artist Gordon Bok. The title of the song is "Turning Toward the Morning." With his kind permission, I wish to share it with you as an example of the process I use to write it as a composition in ornamental penmanship. Please note that whether you choose to center the written lines on your paper is completely up to you; it is a personal choice. I have chosen to center the lines so that I can explain the process to you. For all projects in which you decide to center the lines, I recommend that you purchase a center-finding ruler; a twelve-inch model will be fine. These can usually be ordered through your local art supply store or through JohnNealBooks.com. The chorus of the song I wish to write is:

"And if I had a thing to give you,
I would tell you one more time
That the world is always turning
Toward the morning."

The first thing I do is simply write the words in basic traditional Spencerian. This gives me a general idea of how the text looks in penmanship.

And if I had a thing to give you,

I would tell you one more time

That the world is always turning

Toward the morning.

Next, I decide how I would like the line breaks to be placed so that the finished composition will have a pleasing appearance and be easy to read. It should be mentioned that there is nothing wrong with altering the length of the words on a line from a composition to creatively compose a given composition in an artistic manner. Of course, if the poem, song, or quotation is not in the public domain, you should always ask permission of the artist or copyright holder to reproduce their work. If you wish to alter the lengths of the original composition, it would be prudent to ask their permission as well.

In the case of this chorus, I chose to break the lines in such a manner that the complete text would still be easy to read and each line would convey a thought, action, or word that is significant to the text.

The lines I chose did not have to visually appear to be of the same approximate length because I altered line lengths as I deemed necessary with extended flourishes.

And if I had a thing | to give you,
I would tell you | one more time
that the world is | always Turning
Toward the morning

Then, I rewrote the text in the format of the line breaks. I didn't try to center each line at this time; I simply wrote the lines under each other. Once I wrote all the lines, I used a center-finding ruler and marked the center of each line with a red pencil.

And if I had a thing
to give you
I would tell you
one more time
that the world is
always Turning
Toward the morning

For this step, I used a sheet of graph paper (I prefer ⅛" grid graph paper, as the scale of the grid pattern is similar to the size of my lowercase letters), a ruler, and a red colored pencil. The graph paper served as my layout paper for this composition. Using the pencil and straight edge, I drew a centerline in the middle of the paper. With a light table, I placed the worksheet with the marked centerlines under my graph (layout) paper and visually aligned the center of the first line with the centerline of the graph paper. I wrote the first line using the centered written line beneath as a guide. I continued in this manner, aligning each line's center with the marked centerline on the graph paper.

If you do not have a light table, it is no problem at all. You would take scissors and cut each line that you placed a centerline mark on. When you have completed this stage, you should have seven cut strips of paper, each one having a single line of text with the centerline marked in red pencil.

Next, lay the strip of paper with the first line on top of the graph paper above the actual line where you are now going to rewrite the first line. Make sure the centerline mark on your strip of paper is lying on top of the centerline marked on your graph paper. Now, look at where the writing's first capital letter is, then drop your focus directly down to the same position on the graph paper. Once you have begun this process, you can

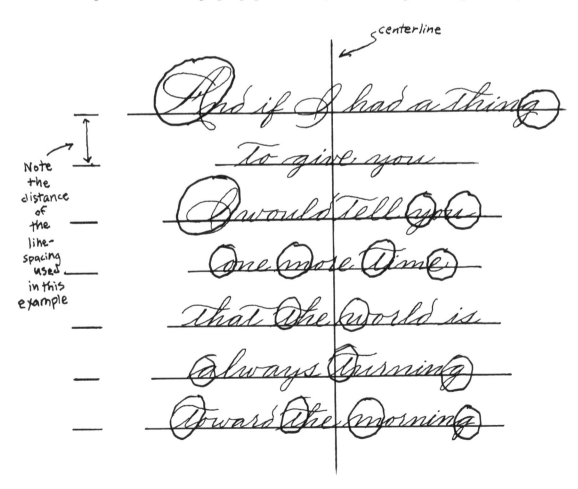

adjust your focus from the writing on the paper strip to the same area on the graph paper and continue writing the line. When you are done, use the second line paper strip the same way. Position the second strip of paper above your writing of the first line, with its centerline lying on top of the red centerline mark. Now, drop your focus and write the second line on the graph paper. Continue until you have written all the lines. (Remember that when your composition is completed and other people read it, no one is going to take out a center-finding ruler to check the accuracy of your centering!) As you will see shortly with the extended letter flourishes and ornamental capitals you will add to your lettering, your completed composition will appear balanced. That is what is important.

The next step is to look at your newly centered layout and decide which letters you wish to capitalize and which lowercase letters you wish to flourish. As indicated on the previous page, circle these letters in red. Now, rewrite with capitals and flourishes.

Notice the increased line spacing that is necessary for writing large, flourished Capital letters and ending flourishes

And if I had a Thing
To Give You
I would tell You
One More Time
that The World is
Always Turning
Toward the Morning.

63

This is my last rough layout, and my last opportunity to make any changes before the next and last step to do the final finished artwork. Note the indications I've written below. It is important that this rough is NOT written directly on graph paper, but instead, it should be written on a sheet of white paper that is taped over the graph paper. The reason for this is so that once this rough is completed, you need to see it without guidelines. Only then can you best decide any changes you wish to make, and what type of flourishing designs or patterns you wish to add, and where your flourishes to be placed in the layout.

Reference curves for flourish

I wish to make this A more prominent by starting the letter with two ovals instead of one

I wish to shade the cross bars on capital T's.

On this A and the one below, I wish to shade the bottom curve indicated by the arrow

This ending flourish is a change from the previous layout rough.

This crossbar is a minor design change I made from the one on the previous layout rough

And if I had a Thing

To Give You

I would tell You

One More Time

That The World is

Always Turning

Toward the Morning.

Reference lines for added flourishes.

64

At this point, use a new sheet of graph paper. Draw in new baselines, making them approximately ³⁄₁₆" or ½ centimeters further apart from each other than the previous baselines. This will allow room for the large ornamental capitals and line flourishes in this final stage of your composition. I wrote the seven lines of the chorus on these using the ornamental capitals and flourished line endings I desired. Once this was done, again using the center-finding ruler, I re-marked the center of each line.

On another new sheet of graph paper, I drew a centerline and carefully rewrote the text's seven lines in the same manner I did before. This became my final rough layout, and I used this as my guide to write the completed composition on my art paper.

If you don't have/want to use a light table to complete your composition, read on for the following alternative methods:

1. I carefully measure where each baseline will be and, very lightly in pencil but just dark enough so that I can see them, I put a pencil mark on the left and right edge of my art paper indicating where each baseline begins and where it ends. Then, I lay the top left edge of a ruler just slightly below the pencil mark on the left edge of the paper, and the top right edge of the ruler just below the pencil mark on the right edge of the paper. Now, pressing down on the ruler with the fingers of my left hand, I place the thumbnail of my right thumb against the top edge of the ruler and rest it on my art paper. Exerting just a little downward pressure on the paper, using my forearm muscle I move my thumb from the left edge of the paper to the right edge of the paper. In this way, my thumbnail scores an indented line on my paper as I move from left to right, thus marks my baseline. I continue this procedure with the remaining six lines. Using these marked baselines to write on, I do not have to erase my penciled baselines after the ink is dry. Also, being careful to exert just a slight amount of pressure on the paper with my thumbnail, the resulting indented line I create will be visible for me to see and do my writing on, but not too deep to trap the ink from my pen or catch the tip of my point as I write. If you prefer not to use your thumbnail for this, you can use any scoring tool which you source at an art supply store or a hobby store, order online from JohnNealBooks.com, or use any non-sharp tool such as a dull letter opener, fine-pointed knitting needle, or crochet hook. Any of these will work well. When all your writing is done, the slightly indented baselines will be visible, but instead of detracting from the appearance of your composition, they will tend to add a touch of dimension to the overall flat appearance of your ink-on-paper artwork. I encourage you to try this with your next penmanship project.

2. Regarding the laying of your cut paper strips on top of your art paper that allows you to determine where you will start to write your lines of text, you must be

careful. After writing your first line, the ink might not be dry before you are ready to write your next line. I recommend that you place each paper strip, line by line as you need them, on your art paper's surface immediately above your first line of writing. Then, as you begin to write each line, you will need to focus your eyesight on the first letter or word on the paper strip, then move your sight down to the similar position on your art paper and start writing. Once again, remember that no one is going to measure your centering of the text, and with any flourishes you may add, only the appearance of your artwork is what matters. The more often you perform this procedure, the more comfortable and skilled you will become at doing it.

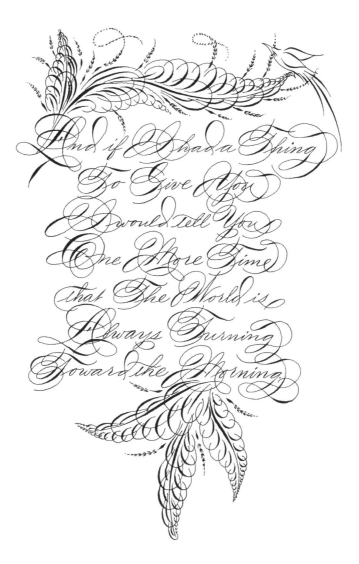

Notice the line ending flourishes in my completed design, my choice of flourish capitals, and the off-hand flourishing patterned designs at the top and bottom of the text. All these elements work together to create an attractive composition.

Composition Writing

At this point in your studies, I wish to introduce a penmanship technique that I address by the name of composition writing. It is a simple technique that changes the overall appearance of a finished composition from "Nice penmanship!" to a "Wow! That's beautiful!" comment from whoever sees the text. It all began for me some years in my past when I received a commission to write a well-known excerpt of poetry: Alfred, Lord Tennyson's "Crossing the Bar." Only four lines in length, it reads:

> *"Sunset and evening star,*
> *And one clear call for me!*
> *And may there be no moaning of the bar,*
> *When I put out to sea."*

While reading these four lines, I felt a sense of emotion, as the author shares his personal reflections about the future when, someday, his life will come to an end. I was familiar with the rest of the poem, as it was required reading for all students of my generation. So, with thoughts of the verse from my past, I wrote it in Spencerian:

Sunset and evening star,
And one clear call for me!
And may there be no moaning of the bar,
When I put out to sea.

Upon finishing this task, I looked at my penmanship and read the lines I had written. Something seemed wrong. I felt that, although my penmanship looked nice and I had spelled all the words correctly, the visual appearance of the excerpt conveyed no sense of emotion inferred by the words themselves. Focusing on the words the way they were typed and how I had written them, it seemed if read aloud, some unknown voice would recite the lines in a complete monotone, with no inflection of feeling, conscience, or belief. I began to sense that despite my skill of the Spencerian style, I had committed an injustice to these four lines and to the poem itself.

I previously mentioned that I consider penmanship to be visual language. As such, this verse should ideally be read as if being spoken by the author himself, with any verbal or physical intonations that would be natural in a spoken conversation. I soon realized that the silence of my handwriting could be changed if capitalization, flourishing, size, and shade alterations were allowed to visually emphasize any word or phrases of significance. After all, there is no legality that explicitly states you must only use capitalizations for the first word in a sentence and for all proper nouns. I then began rewriting the four lines as I felt they should appear.

In focusing again on my written text, I thought that the third line looked out of place because it was so much longer than lines 1, 2, and 4. Therefore, I chose to separate the third line into two lines, thus making the verse a total of five lines in length. My next step was having fun trying capitalization and ending flourishes to bring forth the imaginary "voice" of the words. In the end, my completed composition looked like this:

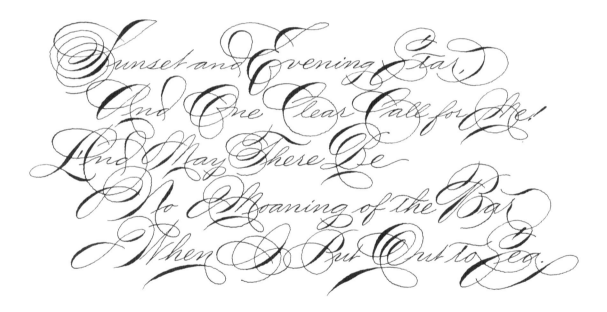

I was pleased with the result and felt that, in essence, I had taken four lines of text and, with the changes I mentioned, turned the written text into a more expressive form of composition. I decided to name this technique composition writing.

I encourage you to experiment with the methods I have suggested the next time you have the occasion to write any length of text. Just like your own body language reflects your emotions when you speak, write the words of your composition in such a way that will add emphasis, excitement, or special significance to its meaning or context. Do not hesitate to:

- Capitalize any word significance to give it visual emphasis.
- Create a layout that can focus meaningful words or phrases.
- Add flourishes where you feel they will add a degree of visual emphasis to the language of the text.
- For any special words, do not be afraid to use exaggerated capitals such as twisters, super twisters, or ornate majuscules, and perhaps make these capitals and their shaded strokes noticeably larger and more dramatic than the rest of your text.
- Last, try such concepts as writing any particularly expressive word or phrase on a curved or angled baseline. Sometimes, just a single word can be emphasized by writing it large and/or in color on an inclined baseline. Give it a try!

Negative Space and Flourish Density

In the process and our enthusiasm of adding ornate capitals and line ending flourishes to our work, it is wise to exercise the quality of common sense and forethought in what the final piece will look like. It is well to extend ovals and entry and exit strokes that artfully cross each other to create a visual network of ornamental letters and words within a body of text, but we must be careful not to create an overabundance of lines and shades that can draw the reader's attention completely away from the meaning of the text itself. Flourishing in particular is such an enjoyable technique that it is very easy to become so enthusiastic that you can easily over-flourish your text. We must always consider what should be the primary focus of our written composition. With this in mind, I have found that the concepts of negative spacing and flourish density are most helpful to keep in mind when working on a body of text.

Negative space does not only refer to the empty space within and surrounding letters and words. In composition writing, it also refers to the interline spacing. This is the wide, horizontal, open space between the bottom of a baseline of writing and the waistline or top height of the small lowercase letters from the line of writing immediately below. In the following example, the dotted areas occupy the interline spacing between the two lines of lettering.

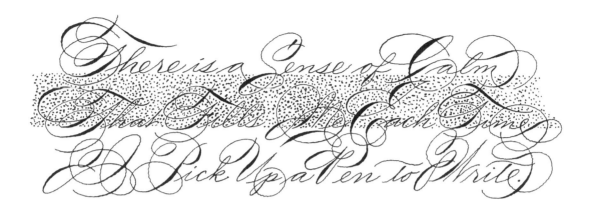

In simple terms, the open or negative space between two lines of writing should not become so filled with crossed flourished strokes that both lines of writing appear to be heavily stitched together. Generally speaking, there should still be more empty, open space to view rather than a complex mass of non-legible flourished lines. I refer to this aspect as flourish density. This term refers to how much space is occupied or filled with fancy extra lines and strokes you create by extending entry ovals, flourishes, exit strokes, elongated ascenders, and descenders. My best advice is to constantly be observant of your entire composition as you write. Remember also that any excess flourishing usually results in a body of text becoming difficult for most people to read. Always keep this thought in mind.

There are several people I've known for many years whose friendships are more dear to me than I can express. I thought of them recently and what "friendship" really means. I tried to explain it in one sentence and came up with the following text which I wish to share with you as Composition Writing in both a horizontal and vertical format. Often a body of text will have a more dramatic, sensitive, striking, or meaningful appearance in a vertical format than in a horizontal format, or the other way around. I encourage you to try both ways; it is surprising that one of these formats will inevitably "speak" to you while the other format will not. I suggest that you photocopy these two examples so that you can see both images side by side. Note that the line breaks and line spacing differ from each other. I purposely did not add any flourishing to either image so that you can determine your preference based on the lettering alone. Which do you prefer? Then answer the important question: Why do you prefer one format over the other?

The Emotions of
Love and Trust
Found In A
Personal Friendship
Enrich Our Lives
Beyond Wealth
and are Truly the
Most Worthy Legacies
that Anyone
Can Leave Behind.

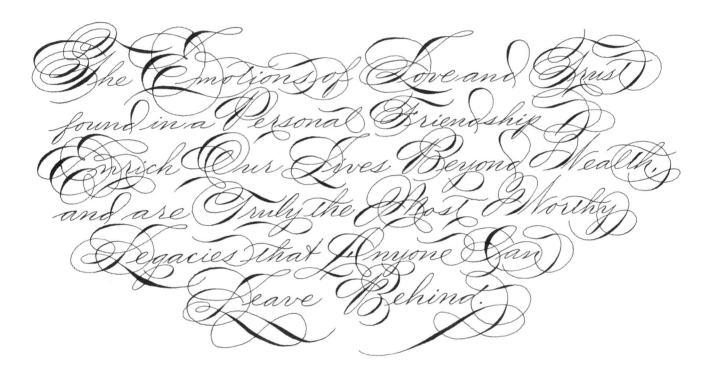

The Emotions of Love and Trust
found in a Personal Friendship
Enrich Our Lives Beyond Wealth,
and are Truly the Most Worthy
Legacies that Anyone Can
Leave Behind.

Superscription

Defined by the Merriam-Webster dictionary, the word superscription means "something written or engraved on the surface of, outside, or above something else." In penmanship, this term refers to capital writing and signature writing—two vintage disciplines of the penman's art that are rarely taught or practiced today. I must confess, however, that with this publication, I hope in at least some measure to change this state of artistic disuse. Plainly speaking, I find these forms of penmanship so much fun to do. The results can be simply beautiful to see. During America's Golden Age of Penmanship more than a century ago, these art forms of ornamental writing were crafted with the handheld penholder being propelled on the paper surface by movement from the larger shoulder muscle. It was an incredible feat to achieve the necessary skill that frequently took years of determined practice to acquire. In this current age of penmanship, however, handwriting is written through *combination movement* of the forearm, wrist, and finger muscles. By using these three muscle groups, it is easy and faster for students of ornamental penmanship to acquire dexterity in the use of the pen in much less time than the legendary penmen of old. You still must practice as often as you can, every day, if possible. With such diligent practice, your learning curve to acquire at least a beginner's level of skill in these disciplines will most likely be a matter of eight to ten months rather than several years. With these thoughts in mind, let us begin.

Capital Writing

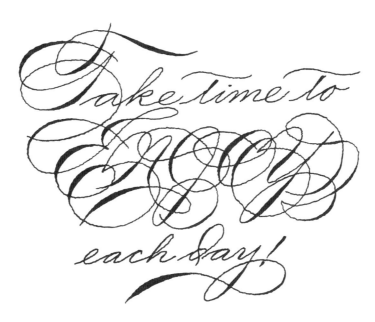

Take time to enjoy each day.

This is a technique that was rarely done during the penmanship era and is even more rarely practiced today. However, if you take your time, study both the traditional and alternate forms of capital letters, and choose your text selections wisely, you can create some amazing penmanship. Use discretion in selecting which capital forms will be best for coupling and begin practicing this lost writing technique. Writing a word in all capital letters can add a pleasing touch of visual drama to your text.

The technique for capital writing follows the same basic guidelines for writing capital letters: Do not cross two shaded strokes, maintain enough negative space surrounding all lines and ovals so that no arrangement of lines or shades appear crowded or cramped together, and ensure that all curves are smooth and graceful. The only exception I can offer to such advice is that, at times, it is prudent to make shaded strokes a bit wider and more pronounced to help achieve greater legibility for the word itself. The plain truth is that nobody is used to reading text that is completely written in Spencerian capitals. For this reason, most people find it quite difficult to read handwritten words in penmanship that are composed only in capitals. One method to help the legibility of your composition is to make the primary shades in your capitals a little heavier so that each letter is easier to read. My advice is this: Use capital writing primarily for short words that have a particular function in your composition such as words of emphasis, salutation, exclamation, or judgment. In addition, it is often helpful to write the first capital of a word somewhat larger in size than the remaining capital letters that finish spelling that word. This will help enhance the legibility of your capital writing. Also, do not use overly decorative capital forms such as twisters, super twisters, or other multi-oval ornate majuscules. You can certainly use alternate forms of capital letters, as sometimes the physical structure of such capitals will be easier to overlap a portion of the preceding capital in a word. As a general rule, use only the basic forms of both traditional and alternate capital letterforms. Last, always strive to maintain consistent letter spacing and letter angle in all your capitals; this will certainly help maintain legibility as well.

Technique

When writing a word in all capital letters, the results generally appear more graceful and coordinated if the non-legible entry oval of a letter overlaps a portion of the preceding letter. Since there are an infinite number of possible letter combinations among the English alphabet's twenty-six letters and additional alternate letter forms, this method does not always work. Simply overlapping a letter with the entry oval from one letter to the previous letter is not always possible nor would appear graceful. In such a case, if an overlapping join between two letters is not the best or most attractive solution, it is still preferable that adjacent letters be visibly joined.

There are three traditional techniques of joining letters. None of these choices are better than or preferred over another. They each work, although with practice of using words with various letter combinations, you will surely see that one technique may work better, or easier, than the other two methods from time to time. Also, there will be letter combinations where any of the three methods will be effective in joining capitals. In such instances, your own preferences will make the choice of which method to use. The selections are as follows:

1. Overlapping Joins

 As previously mentioned, to join two capitals, you simply extend the horizontal entry oval of one letter to such a width that a portion of this large oval will overlap or cross through a portion of the preceding capital. This is the most common method for joining two letters. You should have no fear of this method causing any loss of legibility to either of the letters involved. Remember that the extended oval should remain a hairline. Since it is an *entry* oval and not part of the visible letter's structure, the extended oval possesses no legibility itself.

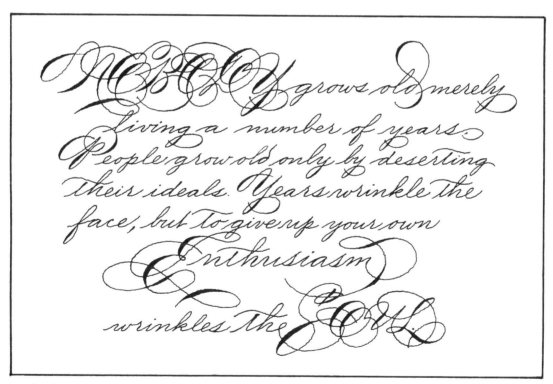

Nobody quote.

2. Natural Joins

In this method, as one capital is written, the ending stroke of this capital exits the letter, extends downward below the baseline to the right, then curves upward in a large arc to the left over the letter from which it came, changes direction, and moves through its own letter. Then, extending and arching up, the line becomes the large entry oval that begins the next letter. This method is referred to as a *natural* join because in a colloquial sense, an ending stroke exits a letter, then curves around, over, or through this same letter, and moves to the right to begin forming the next letter. This entire process happens naturally without lifting the pen from the paper.

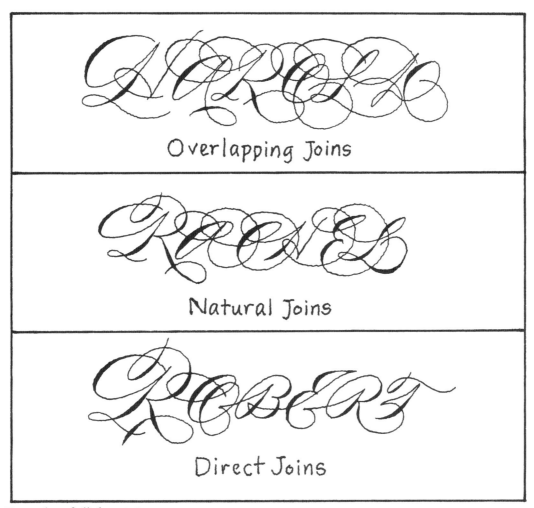

Examples of all three joins.

3. Direct Joins

This is a very brief method and is the easiest technique to join two capitals. The process is quite straightforward and can actually be considered as a somewhat

76

abbreviated form of natural joins since the pen remains on the paper during the process of connecting both letters. In this method, upon exiting a letter with a downstroke that crosses through the baseline, the stroke curves back up almost immediately. Then just after crossing up through the baseline, the exiting stroke abruptly changes direction and proceeds directly into making the next letter. Another version of the direct join occurs with letters that end with an upstroke such as V, W and the alternate form of a capital S. Capital P can fall into this category as well since the letter ends at the midpoint height of the form, approximately where the capital stem shade begins. After the ending stroke finishes making its own letter, the line simply extends a little further to the right and immediately begins making the next capital letter.

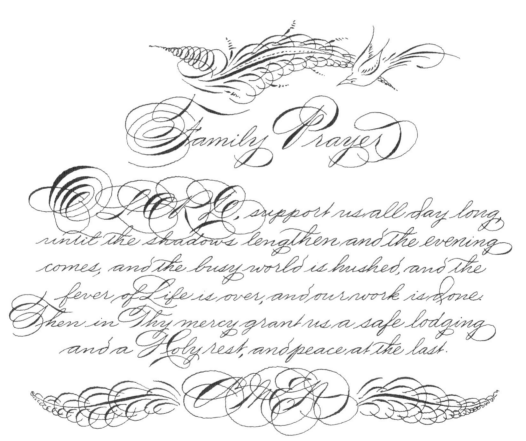

Family prayer.

Signature Writing

Signature Writing was always considered to be one of the defining examples of a penman's skill. No other form of penmanship was as personal or iconic as the way in which a penman wrote his or her name. ("Penman" was commonly regarded as a term neutral in gender, although during Platt Rogers Spencer's lifetime, female scribes were often

referred to as "lady writers.") The same rules that govern capital writing apply here as well, particularly such as the sage advice of never crossing two shaded strokes. However, signature writing also involves the use of lowercase letters, which capital writing does not. This feature, plus the most unique element of personalization, allows for more creativity in signature writing than is possible in capital writing. It is because of these distinct characteristics that it is prudent at this time to mention several additional subjects to consider before we delve into the more specific techniques of this art.

1. Shade Control

 Due to the use of lowercase letters in signature writing, it is wise to refine your ability to deftly use hand and finger muscles as you write to produce perfect shaded strokes of the smallest size possible. Strive to make well-formed, distinct shades of less than 1/16" or approximately 1.5 millimeters in size. Practice with various pen points on smooth paper. I recommend Canson ProMarker layout paper, Clairefontaine, Mnemosyne, or Rhodia papers. Another brand that I like to use is Ayush paper (see Ayushpaper.com). Regarding pen points, I suggest you experiment with any of the following to practice your skill at writing small shades: Gillett 170, 290, 291, 303, 1950; Hunt 99, 100, 101, 103; Zebra G; Leonardo EF; or Brause 66F.

2. Understanding the Use of Curves

 It is not enough that all your curves should be smooth. You must be familiar with the nature of curvature. This means that curves endlessly change direction, repeat themselves, and produce unique visual effects by diverging, converging, paralleling, and crossing each other. By shading curves, you can add emphasis to the curves and/or to the entire composition in countless ways. Knowing these characteristics of the curves you make is a skill set that will allow your work to be quite singular and visibly have a life of its own!

3. Balancing of Letters and Flourishing

 Flourishing does not only refer to off-hand flourishing where non-lettering penmanship results from creating attractive patterns of curves, hairlines, and shades. Flourishing exists in lettering as well as whenever any line is extended beyond the function of legibility. Thus, well-written flourished letters all contain the basic legible form of the alphabet they represent, yet their structure involves additional lines and curves whose sole purpose are *ornamentation*. The important point to realize is that these extra curves must not obscure the legibility of the letter. Too many lines, curves, or shades can easily make the letter confusing and difficult to read.

I am emphasizing this cautionary note because in signature writing, a penman is presented with a relatively small number of letters, most of which are usually lowercase. At the same time, there appears to be an unlimited amount of space (the entire paper surface surrounding all the letters) to add whatever flourishes you can think of. The best way I have found to guard myself against the potential of overflourishing is to be cautious—very cautious—of shading extra flourishing lines that are very near letters. In capital letters, shaded strokes are a primary aspect of letter definition, so it is generally a good idea to keep some distance between the letters of a name and the beginning of shaded flourished curves. There are some exceptions to this:

1. You can usually add extra curves, ovals, and shades to capitals if these extra strokes parallel the primary curves of the letters, such as in twisters and super twisters.

2. You can add a moderate shade to the entry oval of most capital letters. I also make a habit of always adding a retouched shade to the left side of the top loop of a capital J. In a standard J, the only shade is on the right side of the descending loop. Adding a shade to the top loop makes the letter appear much more balanced. After I have written the standard J, I turn my paper upside down so that the letter itself is inverted to my sight. I touch my pen to the loop at the position indicated by the illustration, then I press down on my pen with just enough pressure to

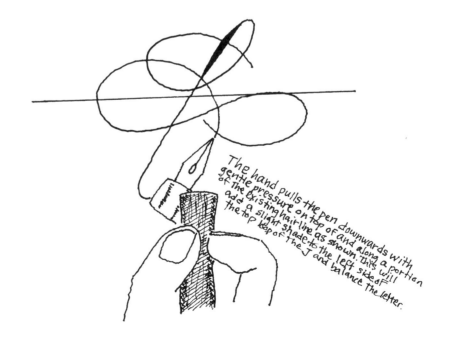

The hand pulls the pen downwards with gentle pressure on top of and along a portion of the existing hairline as shown. This will add a slight shade to the left side of the top loop of the J and balance the letter.

form a moderate shaded stroke. Using wrist (not finger) motion, I move the pen along the hairline of the loop, thus causing the length of the hairline to be transferred into a shade. The reason I do this with the letter upside down is because in this inverted position it is easiest to make the swell of the shade extend to the inside of the loop where it will appear most natural, as though it was written spontaneously. If the shade extended to the outside of the loop, the shade would look like an ungraceful bump on the letter.

3. False shades can be judiciously added to capitals. These are made by drawing the outline of the projecting portion of an imagined shade onto an existing curved line. Once this is done, you have an outline of the shade itself. The interior portion of the shade is now empty since the false side is in outlined form and not yet filled in with ink. The methods you can use to fill in the shades are numerous, depending upon your creativity. You can easily fill in the shade with several inked lines from your pen and then, before the ink dries, use a fine-pointed artist's brush (I suggest a No. 0, 1, or 2 size) to blend the lines together or use the brush itself, dipped in ink, to fill in the area. If you first draw the outline of your false shade in either pencil or a fine-line permanent Copic or Pigma Micron marker, you can fill in the false shade with colored pencil, marker, or acrylic ink. Pearlescent and iridescent acrylic inks are beautiful for this purpose, as are the Fine Tec pan colors.

False Shades
You draw the outline of a shape, and then fill it in.

I brush these onto my pen to color in small-sized flourishes. The choice is up to your imagination. Any of these techniques can be used to accent or augment the capital letters in a signature.

4. Balance the Use of Complex Forms with Text

If you enthusiastically use complex, fancy, or flourished letters too often, even if they are written well, your work can look too busy and confusing. It is the same idea as when a person wears too much jewelry. A few pieces of jewelry can become a beautiful accent to a person's appearance; too much jewelry appears gaudy and ostentatious. Reserve the use of ornate letters for special areas that you wish to emphasize in your composition. Don't put them everywhere without regard to their visual effect in your text. Remember the adage that just because you *can* do something, doesn't mean you *should* do it all the time. One general rule for lowercase letters is that you should only flourish entry or ending letters or ascending or descending strokes. Save the very ornate flourishing for the capital letters that are larger and can, therefore, handle extra shades and curves. Lowercases letters should remain consistent in the text which, in this chapter, refer primarily to a person's name. Unflourished lowercase letters in a signature are far easier to read and can serve as a contrast to more dramatic capitals.

Always strive to balance your ingenuity with common sense and, above all, make your strokes and shades graceful, smooth, and attractive. The more lines and shades you add to your letter or composition, the more vital it is that your work is clean, correct, and graceful. Never sacrifice legibility for ornamentation, for when all is said and done, if the results are difficult to read, you might as well hang it on your wall upside down!

Techniques of Signature Writing

Although much attention in this chapter has been given to methods of writing ornate capital letters, standard capital letters can also be used to write a signature. Even the simplest of examples can be exceptionally graceful, attractive, and certainly legible. No one should think that a super-scribed signature must be complicated with a multitude of lines and curves crisscrossing each other. Perhaps the best examples of attractive simply joined signatures are from Platt R. Spencer, known as the father of American handwriting, and former President of the United States, Abraham Lincoln. Note the following examples:

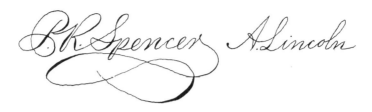

The beauty of these examples is that, from start to end, they are each written with one continuous movement of the pen, with the pen never being lifted off the paper except for the periods after P, R, and S for Spencer and A and L for President Lincoln. And, of course, the periods after the initials were added *after* the signatures were written. An aspect worth noting is that none of the initial letters, the P, R, S, and the A and L, end in a flourish. After each letter is written, the pen is simply moved directly to the next letter. Thus, all the capitals are joined and there appears to be natural flow of movement throughout the signatures. These are each notable examples of signature writing and are worth your study. No one needs the skill of a Master Penman to write an attractive and graceful signature.

Ornate Signature Writing
In the examples that follow, pay close attention to the various ways that capitals are joined, and the structure of the ending flourish written by extending the final ending stroke of the last lowercase letter in each name.

Overlapping Joined Signatures

Natural Joined Signatures

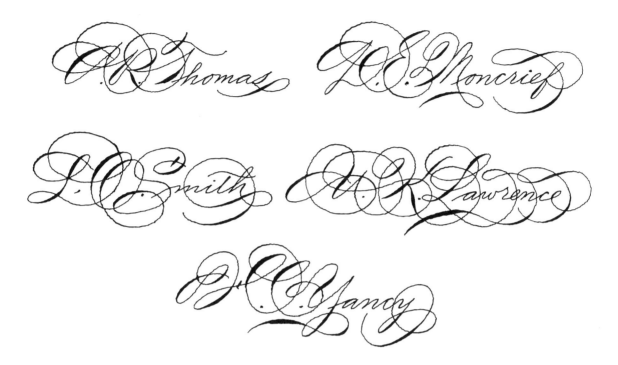

Direct Joined Signatures

Traditional Format and Full Name Signatures

Since capital letters are large and visually pronounced compared to lowercase letters, the traditional design of signature writing is to write and join the two or three capital initials of a person's name followed by the lowercase letters of the surname. Then, to make the right side of the signature visually balance the large capitals on the left side of the signature, the ending stroke of the last lowercase letter on the right is extended into a curving flourish. If an individual with a professional title such as Dr., Prof., Rev., Esq., etc. wishes to include their abbreviated title into their ornamental signature, it is no problem.

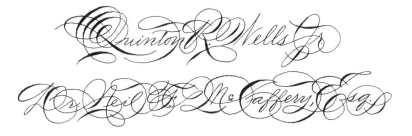

Full name signatures are also no problem to write. The only limitation is that you might not be able to join the capitals because they will normally be separated from each other by the lowercase letters. One technique that works is to extend the ending stroke of the first name's ending letter into a large curve that becomes the entry stroke of the surname's capital.

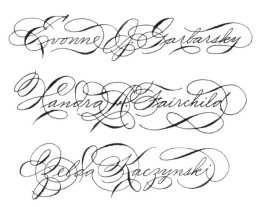

Creative Signatures

Perhaps the most creative and certainly iconic signature from the penmanship era was the pride of Master Penman Charles Paxton Zaner (1864–1918), widely regarded as one of the most talented penmen America ever produced. I have a special fondness for professor Zaner because he personally trained my mentor, Master Penman Paul H. O'Hara (1889–1990), at the famed Zanerian College of Penmanship from 1907–1908. Then, too, professor Zaner's business partner, Elmer Ward Bloser (1865–1929), had a most distinguished signature that featured a very large capital E. With my deepest respect, I wish to share my mentor's signature as well. He wrote his signature several times when he was training me; he was ninety-one years old at that time in 1980. As I watched his hand move with his oblique penholder, I can still remember how much I was inspired. Every stroke he made looked like magic to me.

In wring my own signature, I begin with an ornamental M that I enjoy, then I add a P instead of an R (my middle initial). I finish with an S and extend the ending stroke of the S into becoming the leg of my R. I then add the u, l, and l and complete the signature with an ending flourish to balance the design.

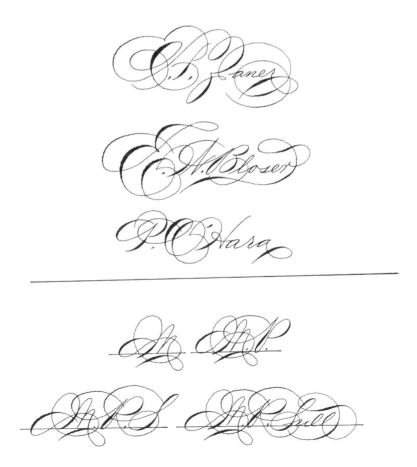

Signature writing can become an open canvas for off-hand flourishing patterns and design. The following are examples that illustrate how I enjoy adding flourishing to signatures. (Chapter 3 on page 100 describes the techniques and variations of pattern designs in off-hand flourishing.)

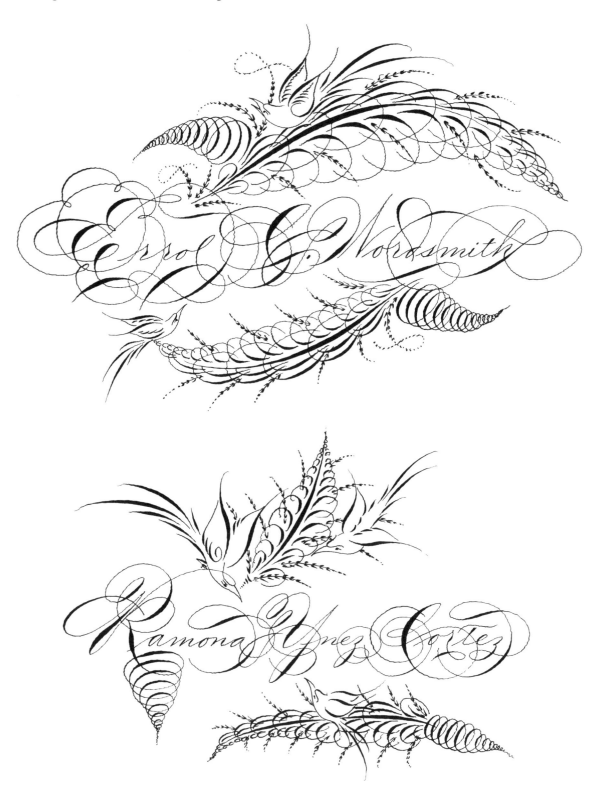

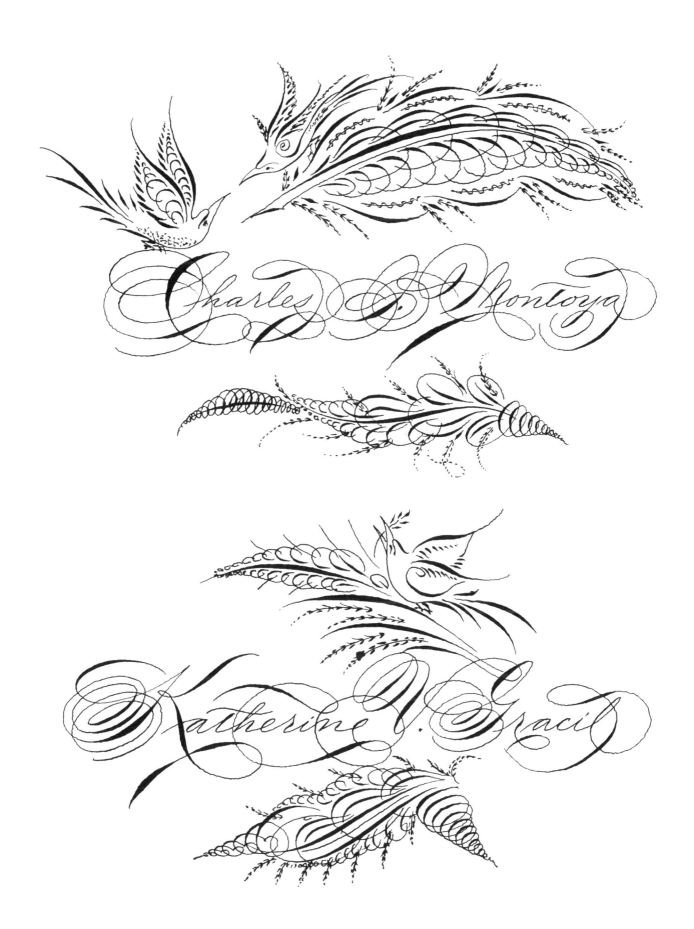

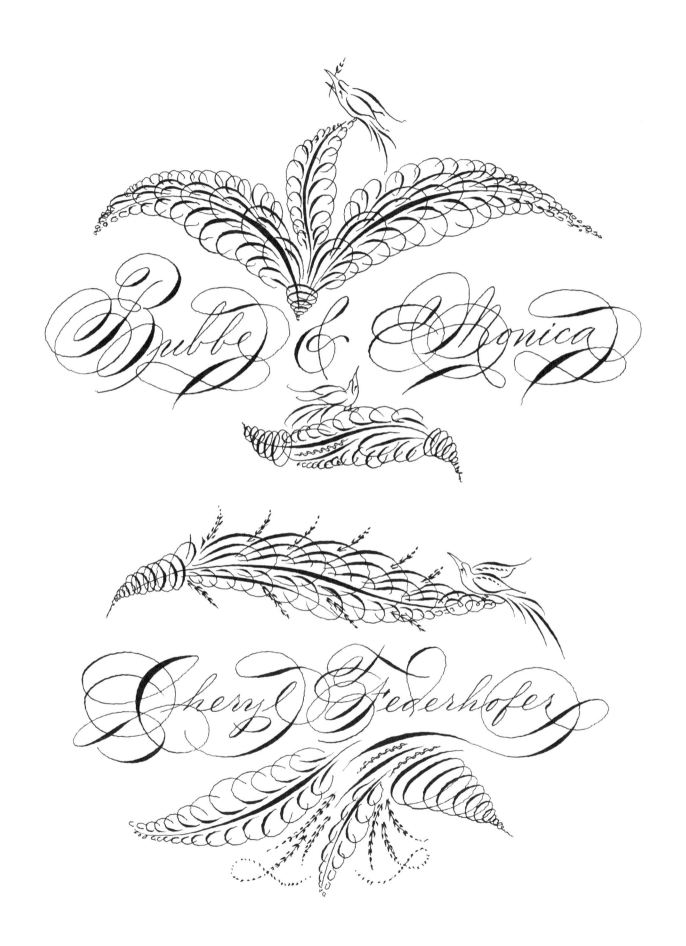

Spencerian Monograms

Monogram design has a very long history in mankind's efforts to celebrate the names of distinguished people, places, and events. During the nineteenth century, ornamental capital letters were often further embellished with patterns of vines, flowers, and even figures of angelic representations from scripture. Many of the monograms from that period featured broad pen letters on a stylized background such as a shield, banner, or scroll. Florid alphabets such as Lombardic Uncial, gothicized black letter variations of styles commonly known as "Olde English," and Roman lettering with portions of the letters and serifs designed into shapes of leaves and vines were common and admired.

These alphabets and the monograms composed of such letters reflect the English and European cultures of the Victorian era, which celebrated ornamentation in art, architecture, design, and literature. The Spencerian style of handwriting was also celebrated in America during this time, but it was developed for pedestrian use in common handwriting. The Master Penmen from that era raised P. R. Spencer's writing style to a cherished art form that we celebrate today.

During my career as a penman, many of my engaged clients expressed a desire for a representation of their union as a married couple in some form based on the handwriting I had done for others who had hired me over the years. Once they became better acquainted with the beauty of Spencerian, they would ask for some form of Spencerian that would be of more permanence than their invitation, ceremony program, or envelope addressing. They wanted something that could represent them always. Since I was very familiar with signature writing, creating Spencerian monograms seemed to be the answer.

In my earlier vocation as a staff lettering artist for Hallmark Cards, I learned methods of interesting lettering solutions for titles, captions, and text content for greeting cards. Using these skills with my knowledge of Spencerian was a perfect combination, and the monograms I have created over the years have become extremely popular.

With each monogram I create, I feel a sense of pride in knowing that, even in a small way, I am contributing to our penmanship heritage. I am excited to share the following techniques with you. In the beginning, coming up with an ornamental design may seem like a mystery puzzle that needs to be solved, but you will find that it is not that difficult to do with practice.

Monograms are a great deal of fun to create, and a most practical application of Spencerian script's fundamental principles: movement, curvature, contrast, and variability. If you already have competency in Spencerian, ornamental penmanship, or flourishing, you will find that the curve and line techniques in working with letters can be used in both similar and creative ways to create beautiful monograms. I know you

can do this; I think of it as another form of signature writing, and it can be just as much fun to accomplish!

Some Basic Information

1. Monograms are simply a combination of capital letters composed in such a fashion that an ornamental design is created from the letters themselves. The important word here is *composed!* The design solution is not spontaneous in this application, but is, instead, thought out, planned, and carefully rendered. This is not done with an oblique penholder, pen point, and ink, but with a combination of both black lead and colored pencils, fine-pointed markers, tracing paper, and graph paper.

2. Since a monogram is composed of capital letters, and capitals are made from a combination of curved lines, you are making a capital letter combination that follows the same rules that govern ornamental penmanship. Lines should cross other lines at right angles as much as possible to effect clarity in the distinct visual appearance of each line. In the process of doing this, the design will look best if the crossings occur between either two hairlines or a shade and a hairline. As a general rule, two shaded strokes should not cross one another unless they are of such a noticeable difference in width that they present a very strong visual contrast against each other.

3. Understanding the concept of curvature is the magic ingredient of a person's ability to create a combination of flourished letters with lines that cross, blend, encircle, or flare out (diverge), yet appear graceful, elegant, subtle, or dramatic. The rules of curvature are:

 a) Every curved line is part of an imaginary oval. If you can envision the parent oval of the curve you are making, you will have a better mental image of the line quality that you desire to produce. Quality in this context refers to smoothness of line, gracefulness of curvature, taper, and width of shade. You control each of these as you move your pencil or marker.

b) Curves must always be smooth, but they can extend in any direction at any time. They can also be of any degree of curvature, from tight, narrow changes of direction to open, gentle, round curves of a circling nature.

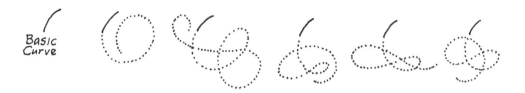

Various options of extending the same curve:

c) Shades: The purpose of shaded strokes in ornamental writing and flourishing is to provide a desired degree of *contrast* to the thin hairlines. Through a combination of the width of the shade, degree of taper from a hairline to the thickest width and then back to a hairline, and the length of the tapering portions of the shade, visual emphasis can be achieved. This apparent perception, whether subtle or dramatic, can turn the design into a stunning monogram that appears to be three-dimensional.

Points to Remember

A bold shade is composed of three curves: The left and right (A and B) edges of the shade itself, and the central axis (C) of the shaded curve. Note that all three curves must be as graceful as possible.

You are carefully drawing the shades in a monogram. Because of this, shades can appear on any line in any direction. In the designing of a monogram, shades are not only added to provide emphasis of contrast, but also to increase the legibility of the letters themselves. The fancier a monogram becomes with flourishing lines that surround or cross through the letters, the more complex the monogram will appear. To the untrained eye, the finished monogram can indeed be beautiful, but entirely illegible. Too many lines and ill-placed shades can make the letterforms disappear. Adding strong shades to the letters and shades of a more subtle appearance to the remainder of

the design will make the letters visually prominent. In this way, the letters will provide a strong contrast to the overall line work.

Letter placement can be quite varied. Letters chosen for a monogram can be adjacent to each other in any direction. Although letters are normally placed in a horizontal format (ABC), they may be placed in any position such as:

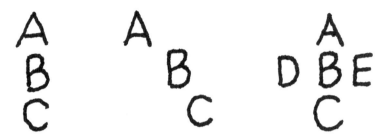

and so on. Also, monograms are not limited to only two or three letters. For example, a monogram for two people, Mary Smith and Thomas Jones, could be composed as:

For all practical purposes, there are three basic styles of monograms:

1. *Family Monograms.* If the husband and wife share the same last name, the surname initial is typically located in the middle of the monogram and noticeably larger than the other two initials. Mary and Tom Jones become mJt. Traditionally, the female's first name initial is placed to the right of the surname initial; the male's first name initial is placed to the left of the surname initial. However, this vintage practice certainly has no precedence or importance today. Any positioning is entirely appropriate and is the sole decision of the people involved.

2. *Personal Monograms.* Sometimes referred to as signature monograms, if an individual wishes to have a monogram that includes their first, middle, and last name initials, the letters would appear in the normal sequence of the person's name, and all the same size. Thomas Andrew Jones would be TAJ. In the case of multiple initial surnames, it is a matter of propriety and respect to include all initials, unless the person wishes to omit the middle initial. Thomas John McDonald could be TMcD or TJMcD. Mary Elaine Fry-Smith could be MFS or MEFS (the hyphen is typically omitted); Roger Paul Drake Jr. could be RPDJr; Alan James Drake II could be AJDII or AJD2.

3. *Artistic or Creative Monograms* can be designed in any format or sequence desired by the individual. Such monograms could be in any sequence, contain a combination of English and foreign language initials, letters in different alphabet styles, or a combination of letters with a graphic symbol. A person who loves a certain pet such as a cat could include a graphic image of a cat's face somewhere in their monogram. A person enthusiastic about gardening could include a drawing of a leaf or flower such as a rose; a spiritual person or someone with a deeply religious conviction could include the image of a cross, the Star of David, or any symbol of their faith. Remember that a monogram should be of a very personal nature to the individual. It is their name, their desired representation, and their choice.

Use of Monograms

Normally, I design monograms that are meant to be reproduced by printing, thermography, or engraving on stationery, wedding invitations, programs, related marriage items, bookplates, etc. If my artwork is to be scanned, the artwork can be embroidered on linens, used on personal family holiday cards, and stationery embosser dies. For this last application, I recommend Southwest Rubber Stamp Company (swrubberstamp.com). They provide excellent products and service. I prefer ordering embossers that feature a two-inch brass die, as this allows the maximum amount of area for that monogram to be duplicated. If the person's surname is short, you can write their initials and surname for the embosser die or simply their flourished first or surname or even a flourished design by itself. Regarding the model of the embosser, I recommend the heavy long-reach embosser. It is the easiest to use with the least amount of hand pressure required. One of my monograms was carved into an ice sculpture for a client's celebratory event.

I render monogram design on smooth Bristol Board paper stock in a permanent black ink such as FW Black Artist's Ink or Speedball Super Black India Ink. If I need to retouch any line or portion of the design, I use a material known as PRO WHITE by Daler Rowney artist materials. I source it for my own use from JohnNealBooks.com. If you desire to create a monogram that is a finished work of art suitable for framing, there must be no retouching. You simply have to be very careful to draw your finished design, then ink it in with a brush or use the fine-pointed markers as perfectly as possible.

Supplies

For creating your layout:
- Tracing paper and graph paper
- Standard No. 2 (HB) black lead pencil
- Three colored pencils (red, blue, and green)

- Soft plastic or vinyl pencil eraser
- Low-tack tape such as drafting tape
- Fine-pointed markers (Pigma Micron markers, sizes 01, 02, and 05 and Copic Multiliner markers, sizes 0.2, 0.25, and 0.5)

For the final finished art:
- Pigma Micron marker size 005 or any other similar sized very fine marker
- PRO WHITE
- No. 01 and 2 round-ferrule artist brushes (I prefer a top quality Kolinsky sable-hair brush) size available by Windsor & Newton (No. 7 series), Scharff, or Isabey (if you prefer to use a brush with wet ink, the FW Black Acrylic or Speedball Super Black India are the brands I use)
- Two open containers of water to rinse your brushes; one for the brush with black ink and one for your white ink brush
- Another small water container with an eyedropper or pipette for adding water to the PRO WHITE bottle as needed

Technique

1. On a piece of graph paper, draw the initials in black pencil approximately ¾–1" high. The letters should be simple, without flourish. If one letter is meant to be larger or taller than the other letter, make it so on the paper. This becomes your basic layout.

2. Tape a small piece of tracing paper over your pencil-drawn letters. Using a colored pencil, trace one of the letters (trace the center letter if it is for a three-letter monogram). Focusing your eyesight primarily on this letter, determine what modifications or additional curves would allow any portion of the letter to possibly encircle, cross, or flow into the other adjacent letters. With the same colored pencil, sketch these extra line extensions onto the taped piece of tracing paper.

3. Take the tracing paper off the graph paper and tape it separately onto a new piece of graph paper onto which you have drawn a baseline.

4. Using a new piece of tracing paper placed over one of the remaining initials, trace the next letter using a different colored pencil. When this is done, place this new tracing on the second piece of graph paper in its proper position relative to the first letter taped there from step 3. Using both of the colored pencils, add or modify the curves of both letters so that they blend, cross, or complement each other as you desire. To do this, you may have to move the letters a little further apart from each other to allow necessary space for any curves you have added. Focus on each letter individually at first, then on both letters in combination. Concentrate your eyesight on curvature, gracefulness, a pleasing balance of positive/negative spaces, and the visual effectiveness of shade versus hairline.

5. Using a new sheet of tracing paper and a third colored pencil, repeat step 4 on the next letter in the monogram. If the monogram contains more than these initial letters, alternate your colored pencils and continue until all the letters are done.

6. Your new sheet of graph paper should have all the letters of your monogram taped onto its surface, with each letter being in a different color of pencil. Next, place a new sheet of tracing paper over the taped letters. Using a sharply pointed black lead pencil, carefully trace the entire monogram, including the baseline. As you now look at your completed monogram design, if you determine that further modifications are desired, take additional time to rework the various pencil tracings until you are satisfied.

7. When this final black pencil tracing is completed, remove it from the graph paper and re-tape it onto a new piece of graph paper onto which you have drawn the baseline.

8. Place a new sheet of tracing paper over the final tracing and very carefully retrace the entire monogram with a fine-pointed marker. I suggest a size of 05 or 0.5.

9. Place this new tracing under a sheet of either Bristol Board or Canson Pro-Marker layout paper and tape it securely.

10. Using either a light table or a light pad, carefully redraw the finished monogram with your choice of the fine-pointed markers. You may wish to draw the outline of the letters and flourishes and fill the inside of the negative spaces with your brush and ink. Retouch as necessary with PRO WHITE. You're done!

I recommend that you carefully study the examples I've provided for their legibility, methods of letter joins, size of letters, and any extra designs such as the wheat flourishes in numbers 19, 22, and 38. The lines I have drawn in number 34 are there because after the monogram was printed onto a reception card for this client's wedding, I separately penned the gold wheat flourishes onto each card. Since the client scanned my original artwork, after the wedding it was no effort on his part to remove these lines on the scan, thus giving him a perfectly useful monogram for any future application. I added the leaves and grape design to number 13 because these clients' wedding was conducted in their favorite winery. Numbers 41, 42, 43, and 44 illustrate the design options I gave to two separate clients. Notice the slight difference between the two designs of each monogram.

It is important to note that in every case, I provided my client(s) with two such options for each monogram commission. If they request a third option, I charge an additional design fee. I feel I should mention that I live and work in Kansas so my fees are typically lower than artists who live in very large metropolitan areas. I also wish to note that every example of mine represents the finished design which the client approved.

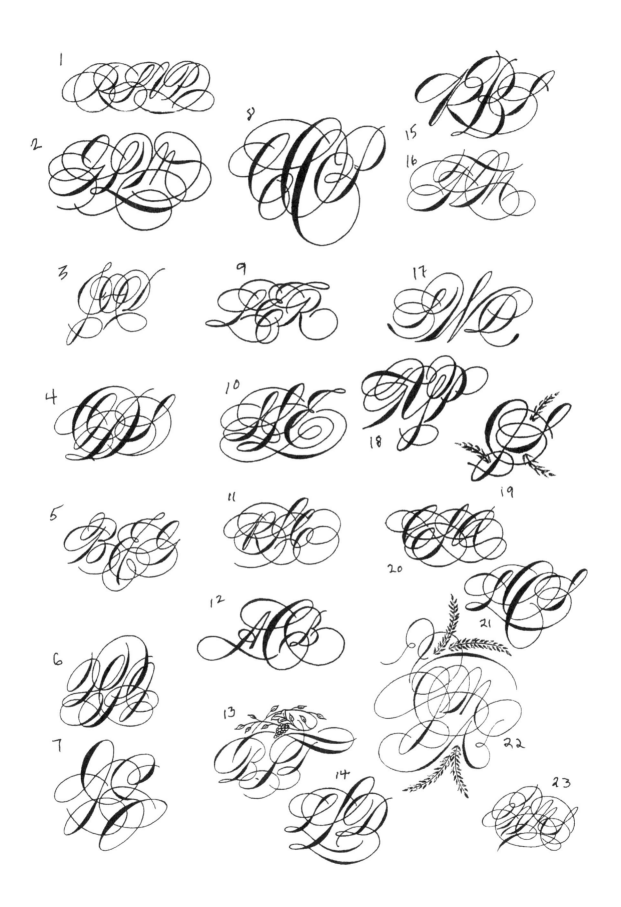

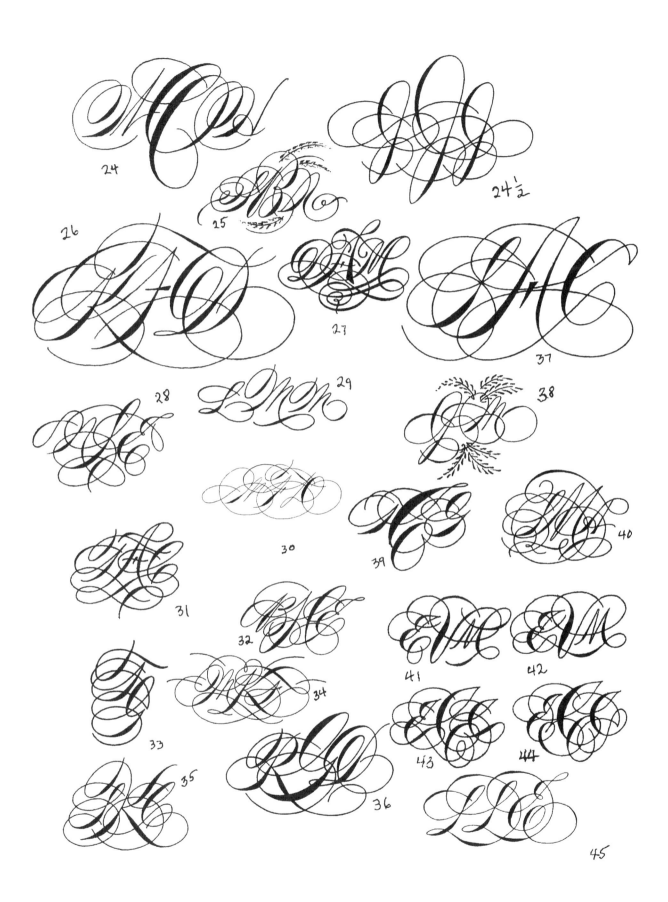

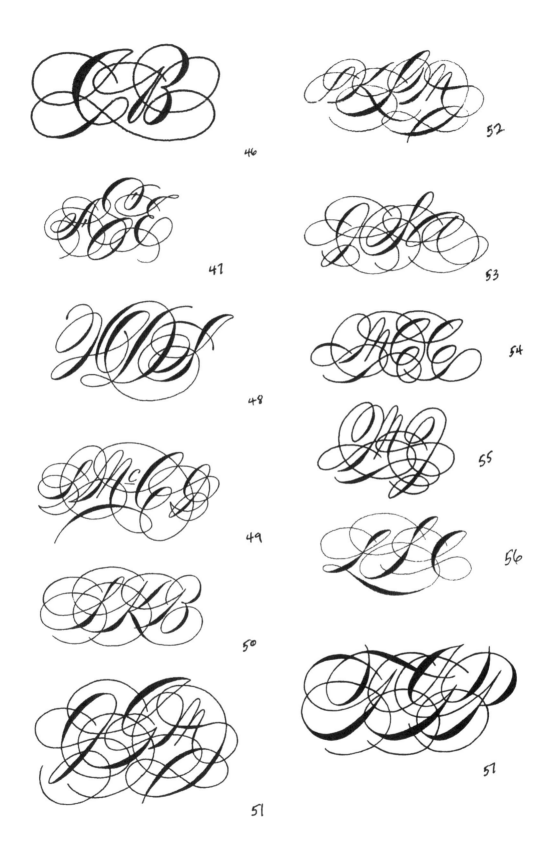

46

47

48

49

50

51

52

53

54

55

56

57

Step 1

I first draw the most basic monoline shape of each letter in a different color, but all on a common baseline. Then I carefully look at the beginning and ending strokes that can easily be extended, remembering that all curves are flexible in the designing process.

Step 2

Now I re-draw each letter in its own color (represented here by the dashed, solid, and dotted lines) on separate pieces of tracing paper. I position these close together as they will be in a monogram on a baseline.

Step 3

Studying these three letters that are taped close together, I take a new sheet of tracing paper, lay it on top of the three taped letters and with a pencil, I begin sketching rough ideas of how the curves could extend in a crossing manner to create a monogram design. Continue your designing ideas always in pencil, starting each new design upon a new sheet of tracing paper.

Step 4

When I am satisfied with a monogram design, I carefully re-draw it in black ink on a clean sheet of smooth Bristol Board paper.

Step 5

I now visually study my finished design and correct any visual inconsistencies or problems. When I am satisfied, my last step is to draw and fill in the shades.

Chapter 3: Flourishing

Flourishing is a non-lettering form of penmanship, and as such, there are no baselines, waistlines, capitals, or lowercase flourishes. The strokes and the flourished patterns themselves have no top or bottom. The patterns can, however, have a measurable height or width, and can serve as an ornamental accent at the top, bottom, or either side of a body of text. Flourishing can be accomplished with a wide variety of tools including straight and oblique penholders, black lead or colored pencils, fountain pens, colored or iridescent gel writers, and brushes. The use of materials such as colored or iridescent inks, water, gouache, and even metal leaf that can be precisely applied over written or drawn shades each have a distinctive accenting appearance.

The most common flourishing associated with ornamental penmanship is off-hand flourishing, which will be thoroughly explained in this chapter. You will also become acquainted with artistic linework, scrolling, filigree, and Masterpiece Flourishing. These are all forms of flourishing; contemporary methods are up to your imagination and creative efforts, and I encourage you to experiment in this direction if you wish. Always keep in mind what flourishing is and what functions it serves. There are two purposes, both of which are equally important. The first of these forms is to *fill negative space*. Off-hand flourishing patterns can do this very successfully, while still leaving ample negative space so that the inked patterns do not appear to be crowded or crammed together. Filigree can fill negative space even more completely than is possible with off-hand flourishing, and artistic linework can do this as well. Scrolling is commonly used to create or accent decorative borders and can be written spontaneously or carefully designed first and then written. Masterpiece Flourishing is the title that I give to a very different, yet exceedingly beautiful form of flourishing. Although Masterpiece Flourishing can be accomplished with a pen, I find that determining your design, carefully drawing, and accenting this form of non-lettering penmanship is much easier to do than charging ahead with your oblique penholder. Masterpiece Flourishing is the form of flourishing displayed in George Bickham's incredible volume, *The Universal Penman*. The stunning examples in that book were the results of a Master Engraver who laboriously perfected and engraved Bickham's flourished patterns so that the entire contents could be engraved onto paper, and thus be made into a book. The second purpose of flourishing is simply *ornamentation*. In such instances, the flourishing is filling a given amount of negative space. Although this is true, the foremost purpose of such flourished patterns or designs is to accent the text, thus helping to achieve a greater or more decorative appearance to the reader. If such work is rendered with skill, flourishing can be successful in making

certain forms of text such as titles, names, ranks, or credentials appear more meaningful or of greater significance than the remaining text to which it refers.

As you begin your study of flourishing and progress into practicing this art in its various forms, the following caution must be mentioned. While duly engaged in flourishing any body of text, from a signature to a multi-lined verse of poetry, it is often too easy for a condition my students refer to as Obsessive Compulsive Flourishing Disorder (OCFD) to develop with the writer. Once a person becomes skilled in this decorative art, flourishing can be so much fun that the penman is reluctant to stop or cease the movements of their pen. I mention this situation because it is important to always use flourishing wisely and not allow your enthusiasm to take control of your pen. If a composition becomes over-flourished, the decorative results are that the flourishing patterns become more visually prominent than the text itself. It must be remembered that the text should always be the most prominent image on a page, for it is the text that contains the visible language of what the composition states. Regardless of how attractive the flourishing may be, its purpose is to accent the written words, not to overpower them. Please keep this in mind.

Strokes, Paper Position, and Pen Manipulation

Strokes

The pen strokes used to create flourishing patterns are the same strokes we use to create our letters. The difference is that in flourishing, we will use many more strokes than in crafting letters. Also, in flourishing, many of the curves will be much longer and the shades often more prominent and bolder than they will be in letters. The Spencerian fundamentals of curvature, movement, contrast, and variability are the primary principles of flourishing; this precept of all our Spencerian-influenced writing never changes.

Paper Position

Off-hand flourishing is written spontaneously, meaning that the patterns and designs are created without preplanning. Typically, the penman does not draw the designs in pencil first and then go over them with a pen. Instead, the penman simply puts pen to paper and, with acquired knowledge and skill gained from extensive practice, creates the designs they wish to appear. The patterns are most often composed of repeating groups of ovals and curves that overlap, intersect, or diverge from each other. Such designs are graceful in appearance, often showing dramatic contrast of hairlines and shaded strokes that can be breathtaking in appearance.

Because the goal here is to produce patterns and designs instead of letters, no baselines are used. Shaded strokes can be made in any direction on the paper. To accomplish this, the penman needs only to turn the paper (prior to the pen touching the paper) in such a direction that will allow the shaded stroke to always be made as a downstroke toward the body and to appear in whatever position the penman choses. When creating a flourished design, I will often change my paper direction by turning the paper every three or four strokes. The paper is turned and held in this desired position by my nonwriting hand. Then, after I have completed the number of strokes that is possible in this position, my nonwriting hand moves the paper into the next desired position, stops and holds the paper in place, and I continue my writing. I continue in this manner constantly until I decide that my design is completed.

The caution that the penman must be aware of when writing a multitude of shaded strokes in various directions as he frequently turns the paper is the wet ink. In addition to creating many curving strokes to compose a design, the penman is also creating a vast area of shaded strokes that may require several minutes of time to dry. Therefore, although writing spontaneously, the writer must be careful not to allow either hand to touch or unconsciously smear the wet ink.

Pen Manipulation

Pen manipulation is not a mandatory technique to write flourished patterns or designs, but it is a helpful technique to master. As indicated in the following illustrations, by a combination of shifting your thumb in a forward movement that, in turn, moves the pen staff ahead of the large knuckle of the index finger, you can alter the writing position of the pen point. This motion will move the pen staff into a more vertical position, which will allow the point to produce either hairlines or shaded strokes in various directions.

PEN MANIPULATION

I find the ability to manipulate my penholder (and therefore, the point) is a very useful skill in the action of writing Capitals, and especially in Off-Hand Flourishing. Manipulating the penholder by "rolling" or "twisting" the pen as you write moves the pen point in various directions or positions. In this way when you must cross through an existing shade, your point will "slice through" the shade instead of "plowing through" it. The result of this will be a cleaner, more distinct appearance to the crossing lines. In these drawings, notice the position of the thumb as it moves forward thereby rolling the pen and changing the position of the point. Study the position of the point itself and the position of the penstaff relative to the large knuckle A of the hand from illustration to illustration.

When writing long, shaded curves, such pen manipulation of moving or rolling your thumb while you are moving can spontaneously alter the direction of the point. This action allows you to create pronounced shaded curves that are smooth and of great beauty.

102

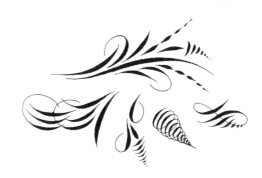

Patterns

There are two main groups of designs in off-hand flourishing known as primary designs and accent flourishes:

Primary designs are patterns that form a recognizable design. Traditional designs include the following: cartouche, plumes, quills, title flourishing, and birds. Traditional designs are often combined to create a more complex flourish such as a bird sitting on a plume or quill or the neck of one bird overlapping a portion of another bird to give the impression of the birds embracing one another.

Accent flourishes are small, decorative strokes added to primary designs to make them more decorative or ornamental. Accent flourishes are often rendered in attractive colored inks to further heighten their contrasting effect and make the entire primary design more attractive. These flourishes can appear in many forms such as wheat and leaf designs, false shades, flowers, small crescent or diamond shapes, rippled (waving) lines, spirals, and the traditional "zipper stitch."

ACCENT FLOURISHES

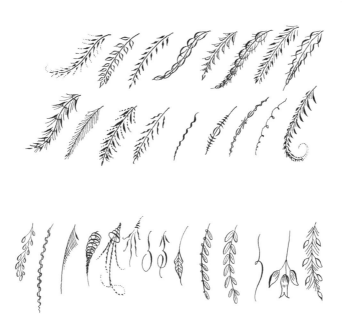

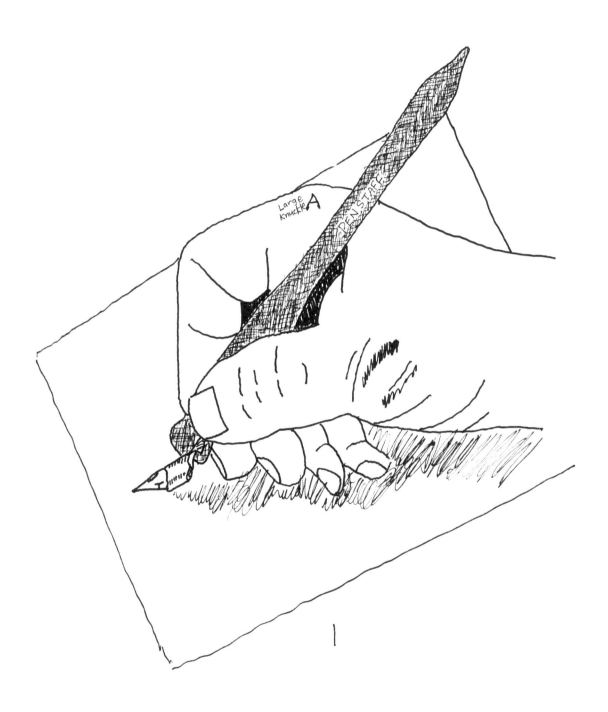

Large
Knuckle A

PEN STAFF

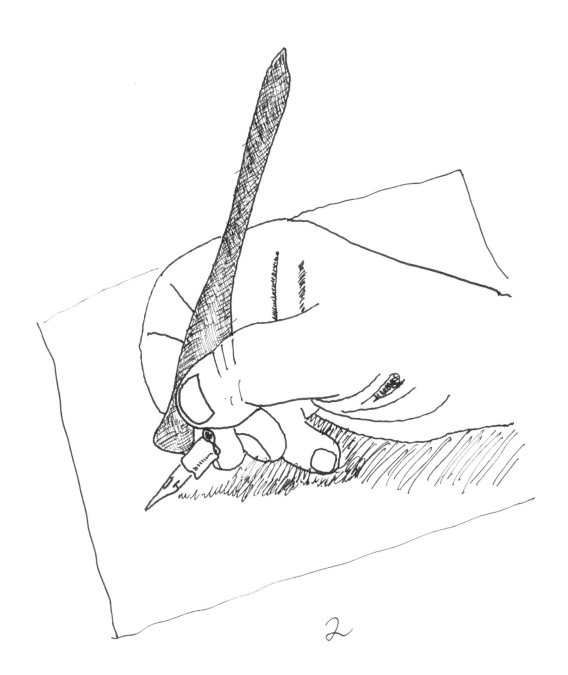

2

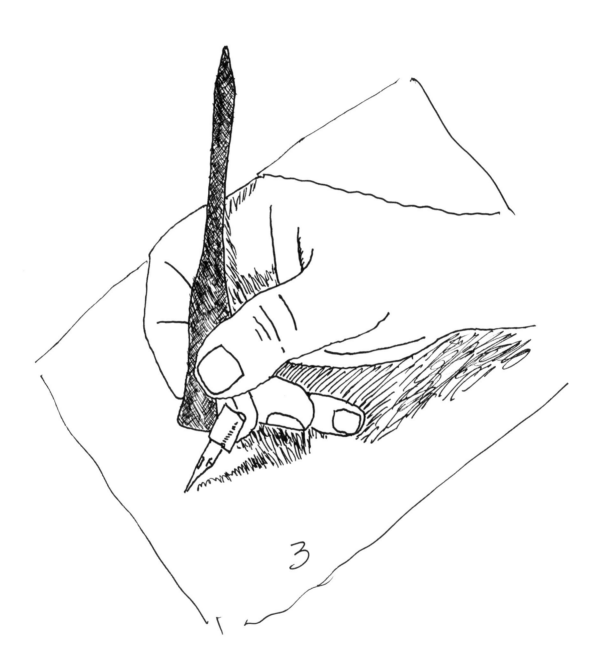

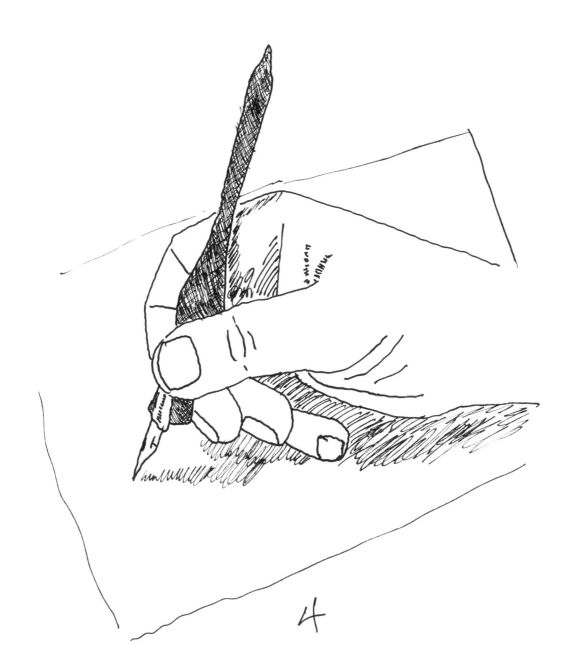

4

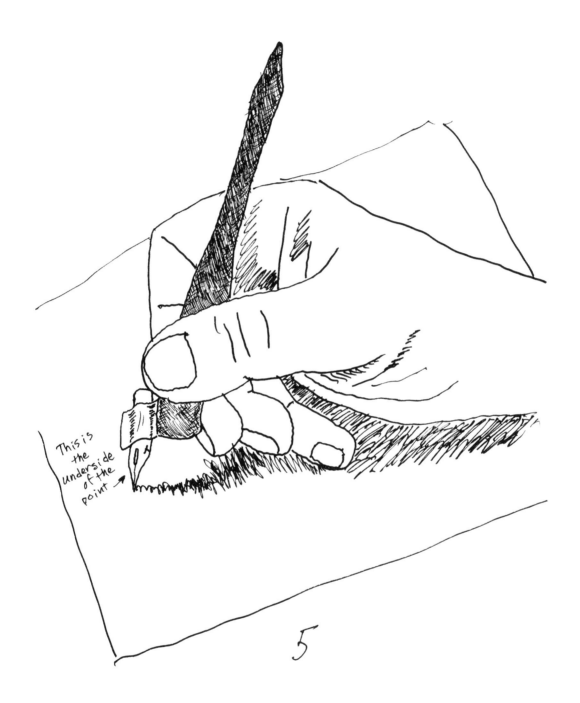

This is
the
underside
of the
point →

5

108

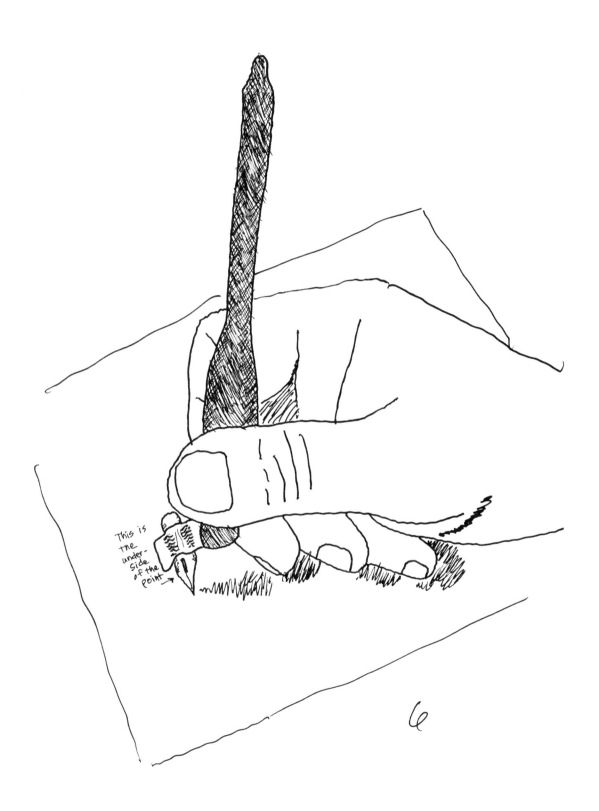

This is the underside of the point →

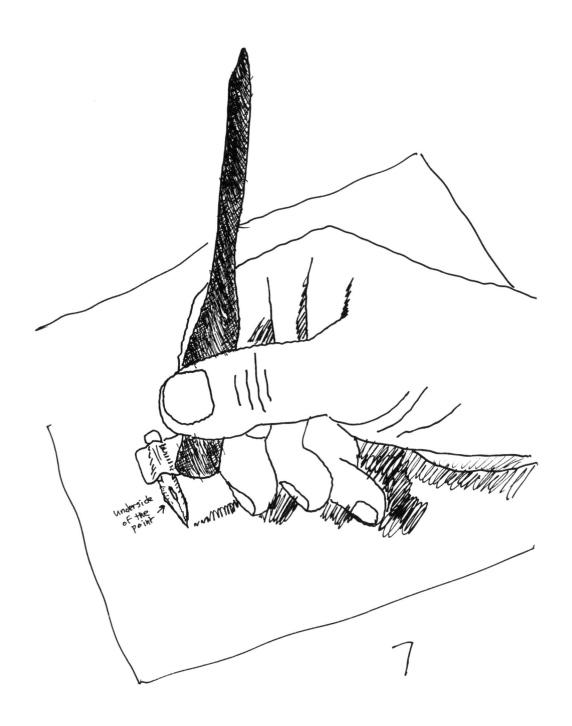

underside
of the
point →

7

Off-Hand Flourishing

The following off-hand flourishing strokes can be made with or without shade as the penman wishes. They can also be of any length, any degree of curvature, and combined in any pleasing configuration. These samples show the proper position of the shade. Keep in mind that every shade is made as a downstroke. Regardless of the degree, curvature, length, or position of the shade, all strokes and curves must be smooth and graceful. Also, every shade should have a distinct appearance of taper and swell, starting and ending as a hairline.

FLOURISHING BASIC STROKES

Cartouche

A cartouche is the easiest and simplest design in off-hand flourishing. It is a combination of curves that form a single design. They can be composed of as few as three strokes and up to hundreds of strokes in a large, complex design. In the several examples that follow, small arrows indicate the direction of movement.

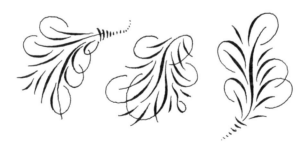

Plume Designs

A very easy design, plumes resemble a bird's feather and are composed of a long central shaded curve that serves as the primary stroke of the design. Overlapping curves or ovals of similar shape are placed along both sides of the primary stroke. The important aspect is that the spacing of curves or ovals must appear to be consistent with no bunching or noticeable gaps between the oval patterns that are apparent to the eye. In determining the consistency of the spacing, such judgment must be done by eyesight. To begin, in pencil, draw an outline of the shape(s) you wish to make.

Next, draw a curving line inside the shape that divides the design into two parts. The two sides do not have to be of equal width, but they must be of the same length from one end of the design to the other end.

Place a series of overlapping curves along the primary stroke, as shown. Important: The curves should come close, but not touch the primary stroke. Also, the size of the curves or ovals should not extend beyond the outline of the shape. Due to the natural form of feathers, the ovals and curves should all flow in one direction from one end of the design to the other. To accomplish this, the penman must decide which direction or position of the paper is relative to their body for them to place the curves and ovals correctly. Three different combinations of curves and ovals are shown below to illustrate the style of plume design.

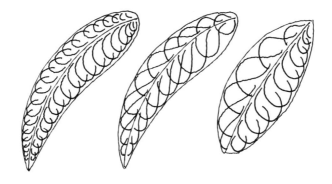

These samples are shown with simple, unshaded lines for the purpose of illustration. When done in ink with an oblique penholder and flexible pen point, and with the outside line removed, they will appear as follows:

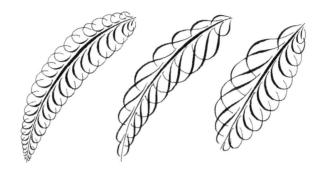

The plume design is my favorite form of flourishing because it is linear and can extend to any length. Thus, it works perfectly to be written above or below a signature. I will often pen a plume design to "float" above a signature, and a shorter plume design that I pen below a signature. Various forms of plume designs work excellently as border designs for certificates, forms of ornamental penmanship such as poetry and scripture, or any other body of text.

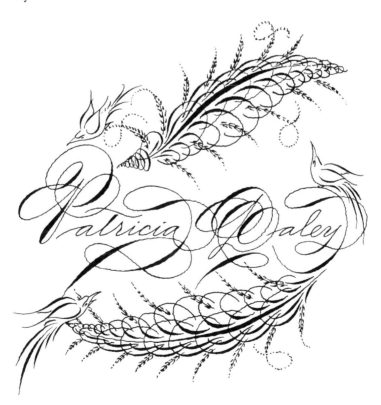

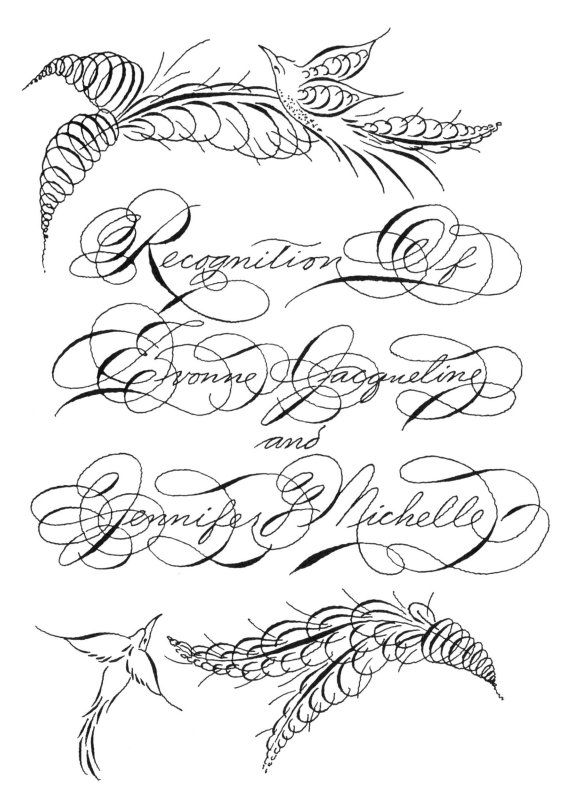

In addition, fairly short or abbreviated plume designs have been used by penmen and engrossers for over a century as symmetrical plume designs positioned equal distances left and right of a name, title, or other significant text. Here's how to create such a design:

Draw a plume design on a sheet of graph paper. The design looks best if it is based on a compound curve.

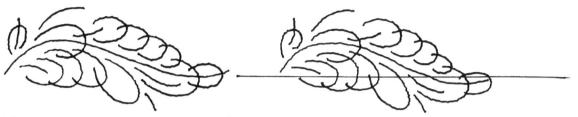

I do all my sketch and design work with a fine-line Micron marker.

Same design, traced on tracing paper, but looking at it on the reverse side of the tracing paper.

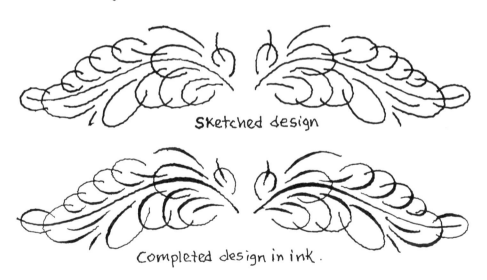

Sketched design

Completed design in ink.

Next, draw a reference line on the graph paper design using a horizontal grid line.

Using a piece of tracing paper, put the paper over your design and with pen and ink carefully trace your design, including the reference line. When done, turn the tracing paper over and tape it next to your design on the graph paper. Be sure to place the reference line on the tracing paper directly aligned with the same reference line you originally drew. As you can see, you now have your symmetrical plume designs. These

are also referred to as scroll designs, which are different than "scrolling" relating to border treatments. You can now use your symmetrical designs as you wish by tracing them carefully on each side of a name or title.

Quills

Quills are a writing tool made from a feather. As such, the design has a distinct writing point at one end. The main reference curve is made of two curves; one is a hairline, and one is shaded. The feathered portion of a quill can be done in several ways:

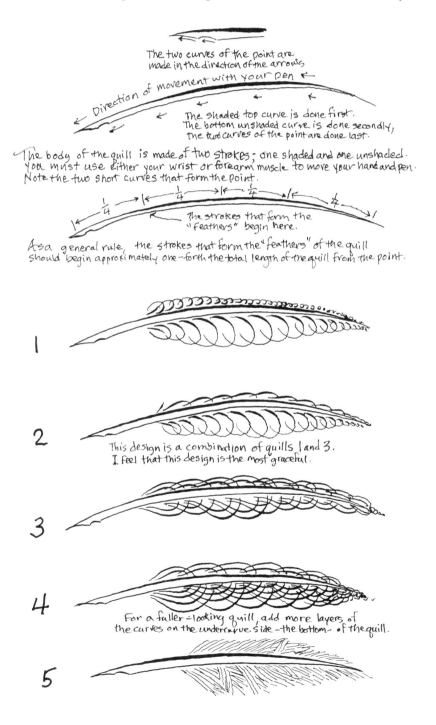

Title Flourishing

Perhaps the easiest way to learn this technique is to understand the similarity between plume designs and title flourishing. A plume design starts with a long, curving, shaded stroke. Then, you add a series of overlapping curves to the left and right sides of the primary curve. The result is a plume design. What you have actually done is symmetrically accented a long, shaded curve with a series of overlapping curves. The pattern of such a curvature on one side of the primary curve may be different than the shape of the curves and curved pattern on the other side, but they can be termed symmetrical in the sense that both start and end at the same points. In addition, between the curved patterns above and below the primary curve, the two curved patterns do indeed cover both sides of the entire primary curve with no gaps or irregular spacing.

Title flourishing is done in a similar way. Titles are simply words that occupy a certain length of space, just like the long, shaded primary curve of a plume. Think of a title, therefore, as the primary curve of a plume design. Your goal now is to flourish both sides (top and bottom) of the title with a series of overlapping ovals. The main difference here is that the primary curve of plume design is always curved and the oval proceeds from one end of the plume to the other. In title flourishing, the overlapping curves begin at the optical center of the title's width. The overlapping curves on the left side of the title proceed in a direction from the center of the title outward to the beginning first letter of the title on the left side. The curves on the right side start near the beginning of the left-side curves at the center of the title and proceed to the right, ending where the letters of the title end.

In writing the curves of both sides, left and right, you should either strive to make all the curves nearly the same size, with the curves on the two ends of the title being a little smaller than the larger curves in the middle section, or strive to make the curves in the center of the design, where both lines of curves begin, a noticeably larger and more pronounced size. Also, make the ending ovals, to the far left and right, somewhat smaller than the midsection largest ovals. By doing this, your title will have a graceful, pleasing appearance.

Once you have completed the top flourishing patterns of either option, turn your paper completely upside down (180 degrees) and repeat the curves you have already completed on top of the title. When this final step is completed, turn your paper upside down again so that you can read the title and see how your flourishing efforts truly ornament the title or name. The titles themselves are most often written in any style of broad pen calligraphy. As such, the graceful and delicate title flourishing brings a most pleasing contrast of design to the title itself, and simply looks attractive. You can also add smaller secondary curves if you wish to make your flourished pattern more delicate or complex in appearance.

To perform Title Flourishing, my first step is to visually divide the length of the title or name into three or four sections of approximately the same length. If the title or name is quite long, you will need to visually divide it into five or more sections. I also note at this time where I judge the middle, or center of the title is. Train your eyes to make these judgments of approximate length.

Next, place a series of curves over the words based on the number of division lengths your eyesight has determined. Do the curves over the top of the title first. Once you have completed this, turn your paper upside down (180°) and place curves on the underside of the title. In this way, the curves you have placed above and below the title should be approximately symmetrical. If you wish to embellish your flourished title further, you can add more curves. Note the examples that are shown.

One of the most notable of the past Master Penmen was Daniel Ames. He was especially fond of title flourishing. Note the examples of his title flourishes that were in one of his scrapbooks. These are fine examples of ornamenting a title to an excessive degree. Upon seeing his wonderful work, your eye immediately focuses on the title flourishes instead of the person's name. And yet, his work and his skill was amazing.

Step 1

I wish to show the process that I use to create a title flourish of my daughter's name. I judge the division of her name into thirds and mark this spacing.

Jennifer Lynn Sull

Step 2

Next, I position a large curve above each one-third section of her name. I create these curves far enough away from her name to allow another smaller curve to fit into this negative space. I pen the flourishes (curves) above her name first.

Jennifer Lynn Sull

Then I turn the paper upside down (or sideways) and put in the curves below her name.

Step 3

I create an ending flourish that overlaps, and thus joins the left and right ending curve strokes of the top and bottom large curves.

Jennifer Lynn Sull

Step 4

I create a spiraling Flourish that overlaps the ending flourishes from Step 3, resulting in a flourished tapering appearance for both left and right sides of the entire design.

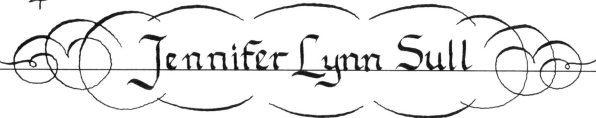

I put small curved shades within each of the three main flourishing areas, and extend one end of each, or at least a majority of these small shades into the lettering of Jennifer's name. This procedure of crossing some of the letters is important because it visually connects the title flourishing to the name. If no lines touched or crossed the letters, the completed design will often look like the name or title is floating within a flourished enclosure. Crossing through some of the letters gives a unifying perspective to the entire design.

Step 5

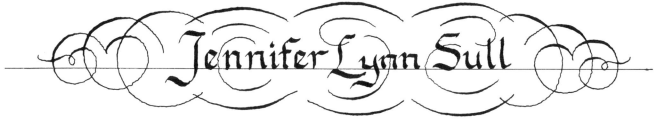

Introduce the finishing curved shaded strokes to give the design a completed, integral appearance.

Step 6

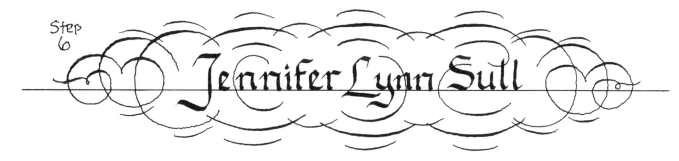

Optional: Add accent flourishes to ornament the design.

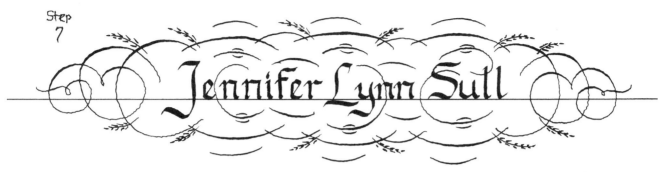

There are many other curves, lines, and ornamentation combinations that can be used to create attractive title flourishes, some examples of which you will see in the following specimens. The details of the one I have just explained are quite simple, but effective in giving an appearance of significance to a title or a name.

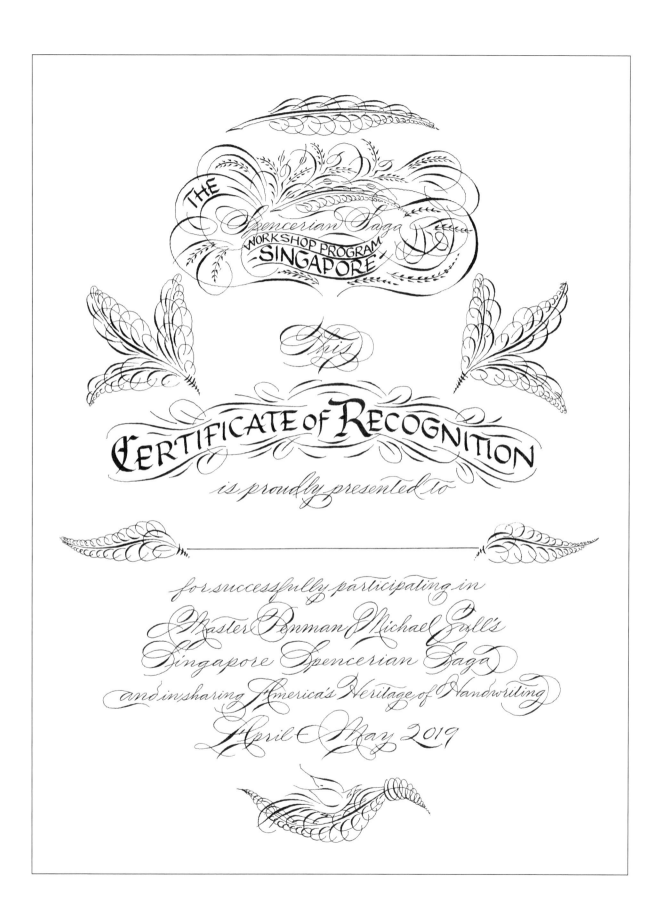

THE

Spencerian Saga

WORKSHOP PROGRAM
SINGAPORE

This

CERTIFICATE of RECOGNITION

is proudly presented to

for successfully participating in
Master Penman Michael Sull's
Singapore Spencerian Saga
and in sharing America's Heritage of Handwriting

April & May 2019

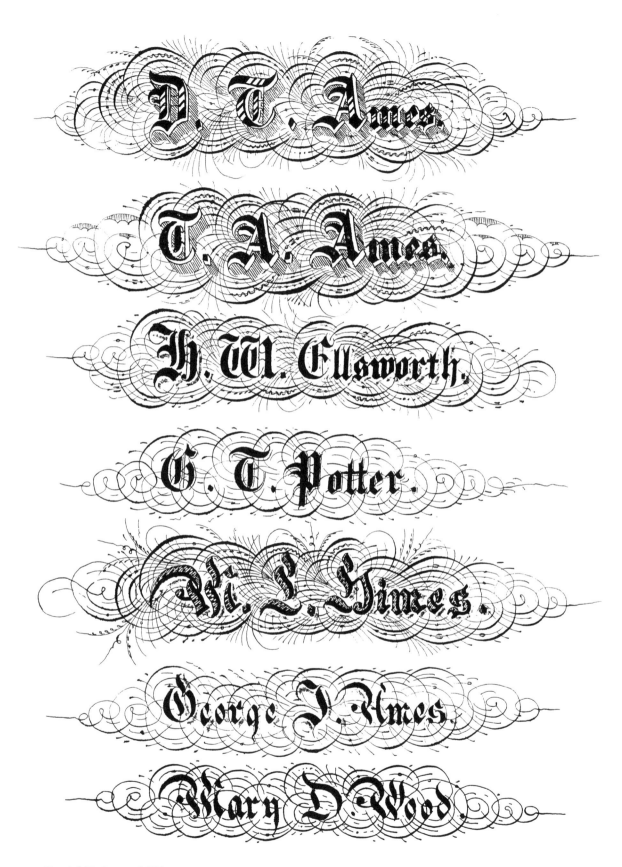

Daniel T. Ames, 1891

122

Title Signature Writing

The following technique is certainly not a necessary form of embellishment. Truthfully, if you are not careful, it can be very easy to over-flourish a signature. (I am guilty of this frequently. I can't help myself; it's just so much fun!) If you overdo the flourish, the flourishing takes center stage, and you must remind anyone looking at your work to read the name. With a certain amount of self-restraint, however, this can really make a signature jump off the paper and shout, "Everyone look at me!"

Technique: Once you have written a signature, all the outside curves become your guides. These are indicated by dotted lines:

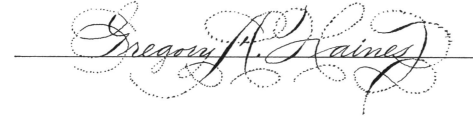

Observe the shapes of the negative paces indicated by the dot-filled areas:

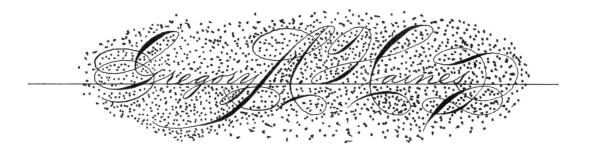

Keep in mind that every stroke you make will be a curve. It is important to remember that all curves near one another must have a discernible negative empty area next to their inked line or a shade. Your next step is to add large, curved, shaded strokes that appear to be growing out from the signature. These will serve as your reference curves from which the finer, more delicate flourishing patterns will be placed. In this way, the flourishing patterns that you are creating and the signature itself will look like a single, ornamental design. Since the signature is written in ornamental penmanship, the flourishing will not contrast with the written name, but will instead blend with it into one beautiful composition.

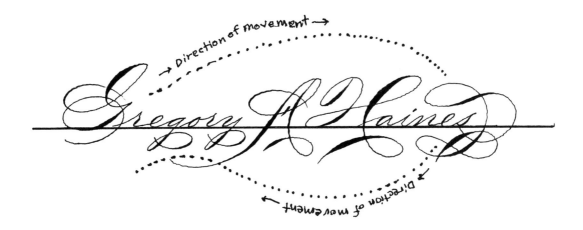

I have found that the completed signature will appear more balanced if the flourished pattern at the top of the signature and pattern beneath the bottom or underside of the signature are written in opposite directions. Therefore, one pattern appears to visually flow from left to right and the other pattern appears to flow from right to left. It does not matter which direction you choose to write the top and bottom flourishes. Either way, they appear to be presented in opposite directions and the result will still be a balanced appearance. Remember that you will have to turn the paper sideways or upside down to produce the flourished strokes, as in the completed signature:

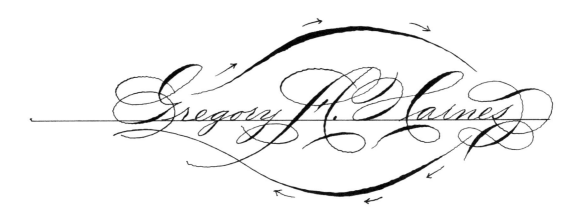

If you wish for the signature to appear even fancier, in the beginning, pen your two shaded reference curves further away at a greater distance from the actual signature. This will allow room for any accent flourishes or perhaps bird designs you wish to include. You can even add smaller, secondary curves and flourish those as well.

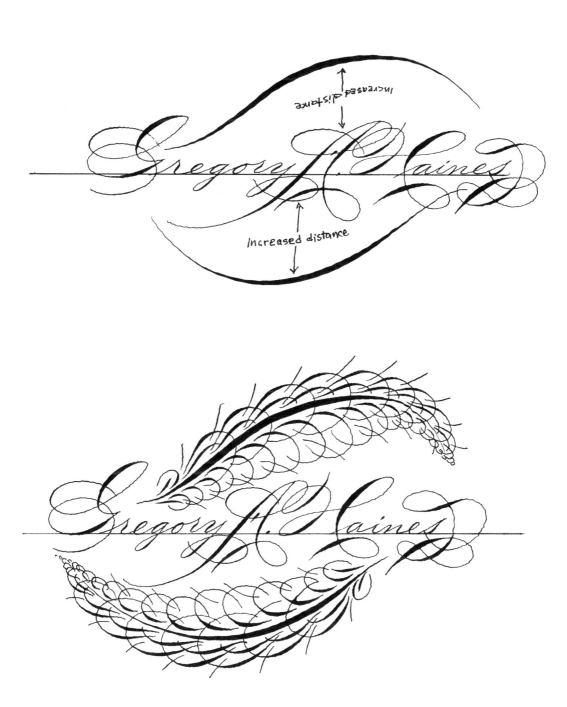

Birds

Bird designs have always been of special interest to penmen. Their feathers have historically been made into writing quills and always been a representative symbol of penmanship. The reasoning for this was expressed by Platt Rogers Spencer himself. In one of his monographs on penmanship for the Bryant & Stratton Business College in Buffalo, New York, Spencer wrote, "The bird is a gift to us from nature. It was this creature of flight who gave me from its body the quills that allowed me to write, and that thousands more have duly used to write throughout our land. Its image of grace and beauty represents all writing skill and will remain so always."

Unlike the stand-alone cartouches, plumes, title flourishing, and scrolls, birds are creatures of life that most people see every day. Also, birds are animated; they do not normally just sit still for any great length of time. As such, birds are very effective at bringing a natural sense of beauty, individuality, and expression to any form of penmanship. From the standpoint of structure, the shape of a bird is simply a series of several curves that, together and in the right proportion, produce a recognizable image. Additionally, because the vast number of species throughout the world exhibits every conceivable variety of color, shape, size, arrangement of feathers, length of beak, wings, and tail, you can create your own fanciful bird image and detail of these physical aspects in your rendering on paper.

There is, however, a caution to be aware of in your efforts to create a bird design flourish. You must be careful to make the curves that compose the bird's body in the right perspective and proportion, or else the poor creature you create will visually suffer. If you make the bird's bill or beak too long and rounded, it can look like a duck. If you make the large curve that defines the bird's breast too large or too curved, your bird can look like a chicken or a turkey! If the curve of the breast is made too long, your bird will appear, at best, to look unnatural. So, you must be careful. I strongly suggest that you obtain a book on identifying birds and study the images that show outlines of bird bodies in various positions such as flying, sitting, perching, and how their heads appear if they are looking up, ahead, or looking back over their wings.

During the Golden Age of Penmanship (1850–1925) bird designs were often the primary feature of a flourished composition. They were usually of a large, prominent size, and the body, wings, and tail were frequently quite detailed to give the impression of feathered patterns. Large swan designs were also popular with the best of the old Master Penmen.

Instead of such bold and dramatic designs, I've always designed simpler birds as notable accents to my penmanship. In this way, I can easily add several bird designs to my compositions, and by penning them in various positions and sizes, I can achieve as much visual animation as I wish. In fact, although it would over-flourish to excess, I

could add an entire flock of birds to appear on my paper! Such small bird designs may not appear as detailed or complex as the large-featured avian compositions from previous generations of penmen, but mine are easier to make and serve most effectively as lovely ornamental accents. If you are interested in the larger bird designs of the past, I highly recommend the publication *Ornate Pictorial Calligraphy* by Earl A. Lupfer. Originally published by the Zaner-Bloser Company under the title *Fascinating Pen Flourishing*, this book is a true classic from the past. Be advised, though, it instructs the reader by whole arm movement.

Technique

For the artistic penman, a bird's body is basically composed of only five primary parts: the head, including the beak, the wings, the breast, the tail, and the legs and feet. I usually start with the head. There were several head designs used during the penmanship era. The most popular design consists of only several strokes, as shown by the following example:

The pen makes this style of head in actually one stroke without lifting off the paper. In doing so, the pen makes two movements—one for the top of the head, and one for the beak and the bottom curve of the "throat" area.

This stroke can continue to form the breast of the bird and continue to form the first tail feather

1. The first stroke forms the top of the head and top of the beak. Follow the arrow for direction of movement.
2. Without lifting the pen, the second stroke forms the bottom of the beak and throat area. The small strokes that make up the eye are next. For very small bird designs such as sparrows, finches, chickadees, and juncos, only a small dot is needed. The extra brow lines that give larger bird presentations more expression are omitted. A modification of the second stroke is to continue the bottom of the lower beak stroke into making the large body curve that forms the breast line and, if you choose to do so, the first of the tail feathers.

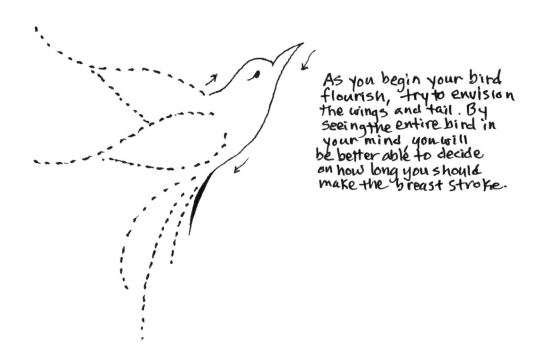

As you begin your bird flourish, try to envision the wings and tail. By seeing the entire bird in your mind you will be better able to decide on how long you should make the breast stroke.

A second way to draw the head is the method I use most often. You begin with the head by making a stroke that looks like a somewhat rounded upside-down V. The shade could be on the left or right side of the head, depending upon which side of the head you begin your stroke. Now, lift your pen. You may choose not to shade the head stroke at all or shade both sides by making each side of the head in a separate stroke.

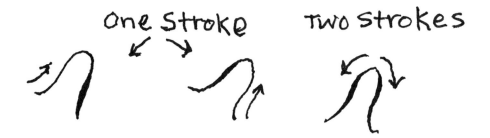

One Stroke Two Strokes

At the top of the head design, draw a slightly curved stroke that arches out a short distance to make the top of the beak. Then, without lifting your pen, change the direction of movement and continue the stroke to make the bottom of the lower beak. Do not stop; arch your curve outward just a little bit and make a large—but not too large or too long—curve. When you reach the point where, by your own judgment and eyesight, you determine how long the breast line and the length of the bird's body should be, without lifting your pen, continue the stroke to make the first shaded tail feather.

128

As a general guide, I strive to make the length of the breast line or bird's body no more than 1½–2 times longer than the head from the point of the top beak to behind the head.

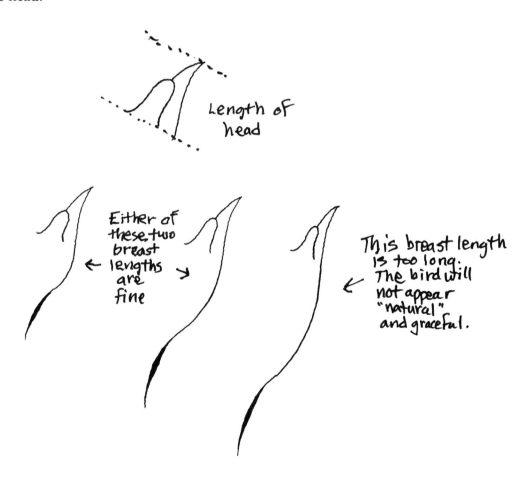

Length of head

Either of these two breast lengths are fine

This breast length is too long. The bird will not appear "natural" and graceful.

Keep in mind that "generic" bird designs are intended to represent small birds and, most generally, the shape of a dove. Only after you have gained a feeling of consistency in creating such bird designs should you experiment with making birds that are somewhat more interesting or complex.

At this time, I put in the small stroke that becomes the eye. If there is enough room, you may choose to add a stroke that becomes the extra brow line situated separately just above the eye.

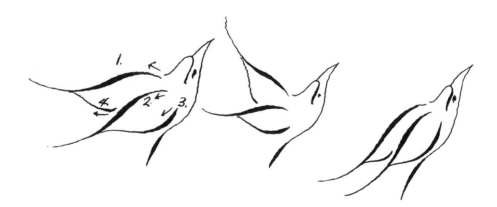

Putting in the stroke that is the eye of the bird is important. Up until now, you have been simply drawing several curves. By creating the eye, your design now actually looks like a bird. Your own sense of familiarity of what birds look like should help you immensely in envisioning realistic positions for the wings and finishing the tail.

3. The wings are next. They consist of four shaded compound curves. You are drawing your bird in perspective, which means that you are looking at a side view of the bird. The wings can be in various positions. This allows you to make birds appear in various positions.

4. Add the long, shaded curves that become the tail. I usually make three or four strokes for the tail in addition to the first tail feather stroke already made at the end of the breast line. The strokes that compose the tail are very easy to make and can even be extended into becoming an exaggerated flourish or border design.

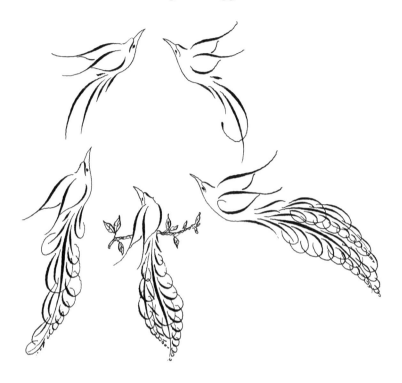

5. The last strokes are the legs and feet. They are not always necessary, but they do add a bit of realism so that the bird can appear as though it is perched upon some other portion of your design. The legs and feet are generally simple, unshaded strokes.

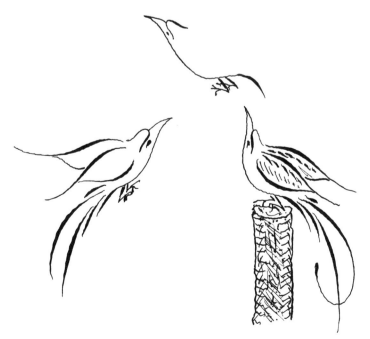

Other Options

A somewhat novel way of drawing a bird is by extending the making of an entrance stroke of the first capital letter of the first word in a title, paragraph, or on a line, or by extending the last lowercase letter in the last word of a title or a line of writing. Note the examples:

*And so it was, as
Time passed by,
the Conventions
came, and went,
And time, and again
the Master's Pen
was the Single
biggest event.*

It is natural for a bird to look back over its wings. To draw a bird in this position, the wing curves must originate from under the bird's neck. I find that the easiest way to do this is to draw the wings first.

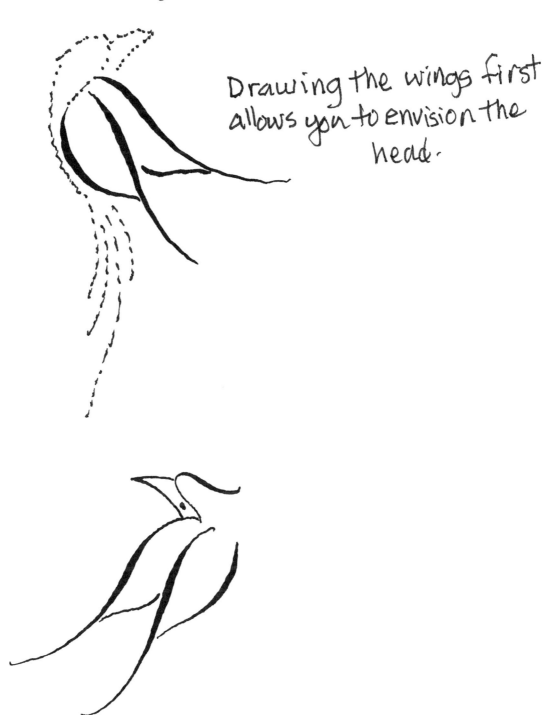

Drawing the wings first allows you to envision the head.

This gives you somewhat of a visual conception of where the head and body will be. It is now easier to envision the direction or position you desire the bird to be looking and, thus, the position of the head. Draw the head first, then the breast line, tail feathers, legs, and feet.

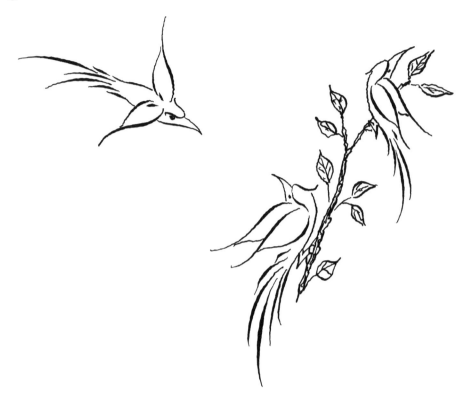

Flying birds are not difficult. You are now simply looking at the bird from above, a top view instead of a side view. I do the head and beak first and end the stroke making the underside of the beak at a point where it is even with the starting point of making the head.

Add the wing strokes, remembering that to look natural, both wings should appear to be the same length and width. Last, finish making the short strokes of the body and the longer tail feathers.

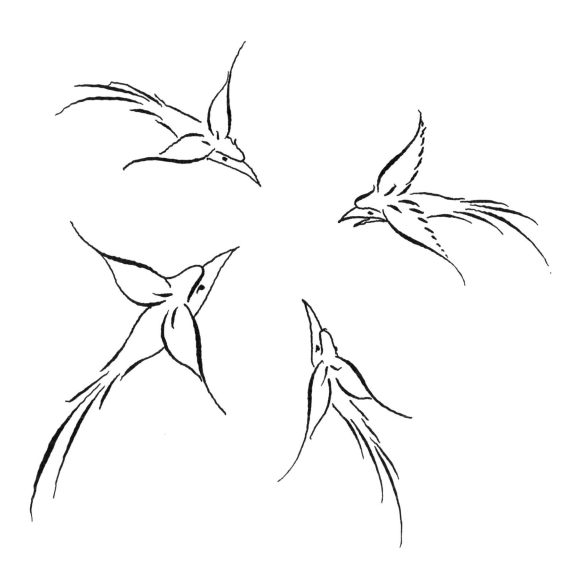

Extra Touches

You can make your birds a bit fancier or more artistic by adding small strokes to resemble feathers. The birds will also have a more animated appearance if you make two birds facing each other. If both birds have an upper and a lower beak, they will appear to be "talking" to each other. If one bird has an upper and lower beak and the other bird has one beak, it will look like one bird is "talking" and the other is listening. Another idea is to make one bird appear to be either beneath or in front of the other bird. This gives the impression that one bird is "cuddling" against the other bird in a somewhat endearing embrace. I do this design for holiday or anniversary correspondence to couples, and for client commissions written for the client's significant other or family member. Adding flourishing to bird designs can be most impressive.

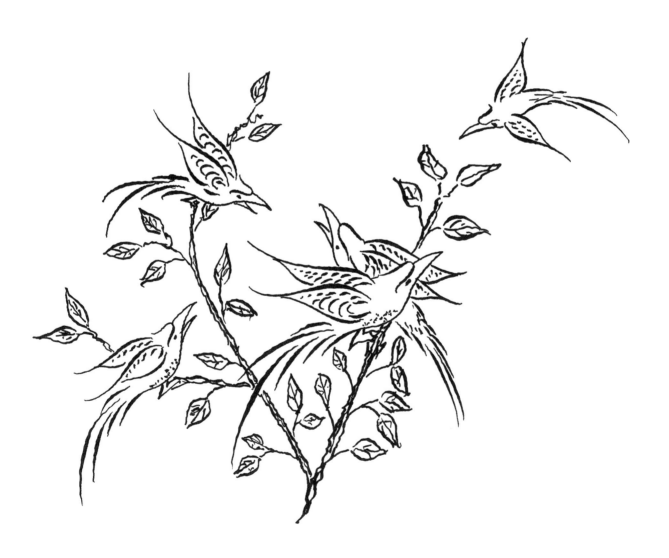

Filigree

Filigree is a simple design composed of thin, curving lines that can create delicate patterns around letters, leaves, floral elements, or become a background texture in any area on the paper. The styles of filigree that are most traditional in engrossing and illumination are curling, vine-like lines or delicate paisley shapes.

Tools

Filigree is done with the same fine-pointed pen that is used for Spencerian, engrosser's script, or copperplate. Extremely flexible points such a Brause 66EF, Leonard Principal EF, or Hunt 101 may be used but a very light touch with minimum pressure will yield the best results. As a common rule, filigree designs should not be shaded. Recommended points include Gillott 170, 303, 1950 (my mentor's favorite), Hunt 22, Nikko G, Zebra Z, and Tachikawa G. Many other pen points will work so if there are other points you like, simply try them for filigree to see the results.

Filigree can be drawn with either a straight or oblique penholder. Ink may be used, but to give the most attractive effect, colored inks are preferable. I do not recommend acrylic inks, as they dry too quickly on the pen. In any body of filigree work, hundreds of lines and filigree shapes will be drawn. Acrylic ink will dry so rapidly on the pen that a great deal of time will be spent consistently cleaning and removing the dry ink residue from the pen point. This is very frustrating and most engrossers, in my experience, including myself, do not feel it is worth the inconvenience. Most often, watercolors and gouache are used. Watercolors produce subtle patterns; gouache produces opaque patterns that can be somewhat more expressive or even strong in value. Watercolor or gouache is mixed with water using an artist's brush (I use either a #1 or #2 brush). Once

the brush is filled with either medium, the brush is used to paint the liquid watercolor or gouache onto the pen point.

Vine (Free-Form) Filigree

The delicate lines forming this filigree style can be any combination of simple over-curves, under-curves, compound curves, or ovals. These filigree patterns will often be drawn around other decorative elements such as leaves, flowers, colored circles, ovals, triangles, or other shapes. The designs are created by making groups of curving lines that usually accent a letter or other painted form. This is the simplest form of filigree.

Paisley (Patterned) Filigree

This is the filigree style favored by engrossing artists when it is desirable to fill in large or lengthy areas such as along borders and within, around, or between letters or painted designs. Paisley filigree is also used to fill in smaller areas such as outlined letters because of the defined and attractive patterns the shapes create.

Use the following steps to create paisley filigree:

1. Draw a thin line around or within the area to be filigreed using the same pen point, water or gouache, that will be used to do the actual filigree patterns. The purpose of this line is to contain the filigree and visually define and separate the filigree pattern from the letter of painted elements that the filigree is intended to accent. Basically, you do not want the filigree to look like it is merely an extended portion of the letter or painted element such as a leaf, floral design, or border. The thin line defines the filigree pattern as a separate and distinct form of ornamentation, giving it a sense of character and beauty unto itself.

2. The paisley shapes of filigree can form specific patterns or create patterns of a free-form nature. When done well, filigree patterns should appear graceful, well-defined (not bunched or squeezed together), and attractive to the eye. It will be easier to draw the filigree patterns in a variety of positions or directions on your paper if you turn your paper as you find it necessary.

Traditional Patterns

Free-form designs can be drawn in any direction and are usually composed of short rows of paisley shapes facing the same direction in a visual composition of other short rows of similar paisley groups facing different directions. It always looks best in all paisley patterns if the paisley shapes are nearly the same size.

Triangle designs can have all the paisley shapes going in the same direction or the designs can be symmetrically opposite with half the shapes arching to the left and the other half arching to the right. In the following example, note the shape of the center design.

Circle designs traditionally have the filigree patterns all facing the same direction.

Row designs can be done with the paisley shapes facing the same direction or with the paisley shapes facing alternate directions in adjacent rows.

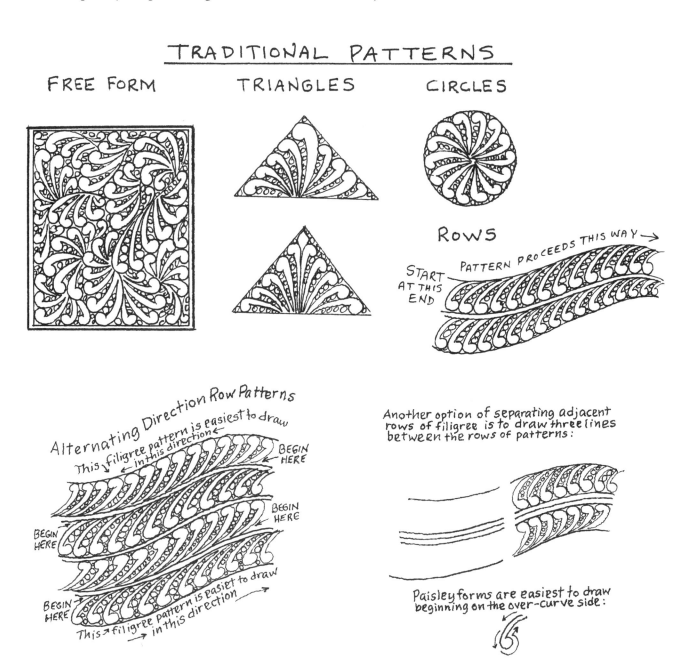

TRADITIONAL PATTERNS

FREE FORM TRIANGLES CIRCLES

ROWS

START AT THIS END PATTERN PROCEEDS THIS WAY →

Alternating Direction Row Patterns

This filigree pattern is easiest to draw in this direction ←

BEGIN HERE

BEGIN HERE

BEGIN HERE

BEGIN HERE

This filigree pattern is easiest to draw in this direction →

Another option of separating adjacent rows of filigree is to draw three lines between the rows of patterns:

Paisley forms are easiest to draw beginning on the over-curve side:

Symmetrical designs are similar to triangle designs where each of the two filigree patterns face opposite directions. However, symmetrical designs usually refer to a larger area of filigree where the reference line each filigree pattern sits on is curved. If there is an oval-shaped area that you wish to fill in with a symmetrical pattern, the following steps are recommended:

1. Look at the shape of the area or space to be filigreed.
2. Draw a thin line that will define the edge of the furthest boundary of the filigree patterns.
3. With a pencil, lightly draw in two closely spaced parallel curved lines that bisect the long dimension of the oval.
4. Beginning at the top of the right-side half of the oval area, draw evenly spaced filigree patterns. Begin your filigree patterns at the top portion of the oval, moving toward the bottom of the oval as your pattern of paisley progresses. Continue to the bottom of the oval shape.
5. Turn your paper 180 degrees so that your original oval shape is upside down and complete the other side of the oval area as before, beginning at the top and progressing toward the bottom.
6. Draw in the little "pearls" between the filigree shapes.
7. Decorate the letter with more filigree if you wish.

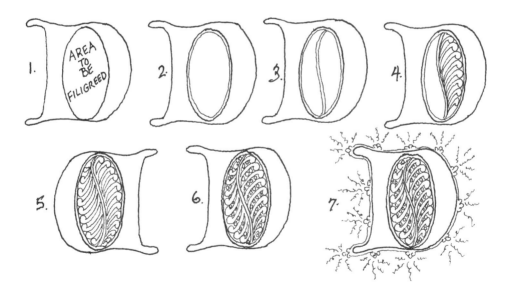

Inter-Spacing Circles or "Pearls"

Filigree patterns can consist of just the paisley shapes alone. Usually, however, as you draw your filigree patterns, you should stop every five minutes or so and take a few moments to draw small circles between the paisley shapes. These small circles are

important because they visually define the paisley shapes from each other. My engrossing mentor, Master Penman David Fairbanks, termed these circles as "pearls." Without them, the filigree patterns can appear to be confusing. This is because the negative spaces between the paisley shapes are as numerous as the paisley shapes themselves. The pearls fill in these negative spaces between the paisleys, thus giving the paisley forms a distinct appearance. For a colorful variation, the pearls may be of contrasting color from the filigree or they may be solid dots of an iridescent color such as gold, purple, blue, or green. Try it! Note the various filigree patterns in the following example. For superb examples of filigree, search for publications by Arthur Szyk, Alberto Sangorski, or purchase the wondrous *The Psalms of David* by Owen Jones.

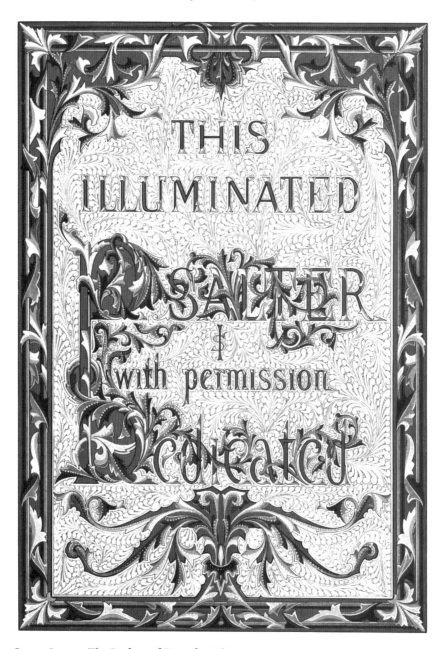

Owen Jones, *The Psalms of David*, 1860

Owen Jones, *The Psalms of David*, 1860

Owen Jones, *The Psalms of David*, 1860

Owen Jones, *The Psalms of David*, 1860

Artistic Line Work

The use of small strokes made by the pen (dots and short lines) and drawn in various combinations of shape, size, and design have been effective techniques of engrossers for many years. Artistic line work has often accompanied illustrative design among nineteenth and early twentieth-century penman artisans in the creation of certificates and documents of recognition. Its usages remained popular until shortly after World War II when the engrossing profession waned and nearly disappeared. As a result, instruction manuals, online work techniques, as well as engrossers to teach this subject were very scarce or no longer available. Yet, the remarkable ability of such simple pen strokes to create both the illusion of texture and the beauty of illustration still captivates enthusiasts of penmanship, engrossing, and calligraphy.

Among the many engrossers who frequently used line work during their careers were Patrick Costello, William Dennis, Willis Baird, G. S. Henderson, Frank W. Martin, J. B. Hogue, Stephen Malone, Arthur Meyers, Daniel Ames, and Charles Rollinson. Perhaps the engrosser best known for his extensive display of high-quality line work was Edwin Brown (1869–1958) of Rockland, Maine. Patrick Costello (1866–1935) from Scranton, Pennsylvania, was also a genius in line work design. By studying the work of these individuals, the student can gain insight into the wide variety of styles, techniques, patterns, and designs that were so effective in adding a sense of realism and dimension to a sheet of Bristol Board.

Technique

The technique to produce line work is quite simple. The artist uses a steel pen dipped in ink to make dots or lines on paper. A wide variety of pen points may be used. The style of pinpoint, stiff or flexible, sharp or round pointed, will determine the type of mark that can be made. Today, fine-pointed markers are also excellent tools for line work. The line work can be used in several ways. One such use is to create stand-alone designs such as letters, leaves, vines, borders, or detailed illustrations.

More often, however, line work was the engrosser's tool to create images of texture, tone, and pattern for backgrounds and dimensional accent around or within all manner of designs. It was also liberally used on top of watercolor washes to add the appearance of depth in the color. Artistic line work is a most versatile technique that is easy to create and limited in its use only by the needs and imagination of the artist, engrosser, or penman.

Tools

Paper

The most common paper used for engrossing was smooth two- or three-ply Bristol boards. I have used this for my commission work. It is an excellent surface medium that accepts ink, watercolor, and gouache without feathering or bleeding. A higher quality paper is Arches hot press watercolor paper (90- or 140-pound pads). This is a lovely paper for engrossing. It has a smooth surface and accepts all mediums readily without problems. It is a creamy, off-white color with a slight soft yellow cast. Saunders Waterford 140-pound hot press watercolor paper is another great choice. Strathmore 400 Series Drawing Paper also works very well for all flourishing techniques.

Penholder

Normally, a straight penholder is the preferred tool, although a number of penmen are so comfortable using their oblique penholders that this works excellently for engrossing as well. Other tools such as ruling bars, center-finding rulers, and ruling pens are indispensable tools for an engrosser. Note: Ruling bars are a vintage engrossing tool from the Golden Age of Penmanship. My mentor Mr. O'Hara used them in his engrossing class at the Zanerian College of Penmanship in 1907–1908. It's a metal tool shaped like a ruler whose straight edges are curved. It's used as a straight edge for the use of a ruling pen or broad pen lettering.

The title illustration "The Master's Pen" is very simple line texture and serves to focus the reader on the image of the pen. I used a Gillott 170 lines and a Nikko G for the vintage poem, a good example of work that suggests dimension, and the eyesight of the pen. point for the fine for all remaining lines.

To create artistic linework, it is important to familiarize oneself with the capabilities and line widths of various pen points and fine-pointed markers. Although the flexibility of the Nikko G, Zebra G, Tachikawa G, Hunt 22, Imperial 101, Gillott 303, and Brause 66 EF are superior points (including the Leonardt Principal) for Ornamental writing, for decorative linework the pen artist selects points for their quality of making a single line or stroke without exerting much pressure. Thus, for very fine lines, using a <u>light touch</u>, the Leonardt Principal, Hunt Imperial 101, Hunt 22, Gillott 303, 170, and Gillott 1950 serve this purpose very well. For broad (heavy) strokes, many of the stub points still being made (check with your supplier or on the Internet) are excellent, as well as stub and Business vintage points by such brands as Esterbrook, Eagle, Palmer, Mussellman, Perry, Spencerian and George W. Hughes, among many others. I suggest that other vintage points known as "spoon points," "globe points," "Falcon points" and "radio points" can work very well for making heavy strokes. Besides sourcing these on the Internet, vintage points can sometimes be found at Flea Markets, Antique Malls, Antique Shops, and at Fountain Pen Shows. The points that I prefer are:

Heavy Strokes	Medium Strokes	Fine Strokes
vintage, stub points	Nikko G	Gillott 170
vintage globe & spoon points	Gillott 404	Gillott 303
Hunt 56		Gillott 1950

I also use fine-pointed markers a great deal. I prefer Pigma Micron markers for their excellent quality, range of sizes, and availability. The sizes that I use are:

003, 005, 01, 02, 03, 05, 08

Study the included examples of artistic line-work presented here and in the Plates section of the Appendices. They are excerpts from early 20th century copies of the Business Educator with the kind permission of the Zaner-Bloser Company. None of us may be as artistic as the great engrossing legends E. L. Brown or P. W. Costello, but with diligent practice, their simple techniques of creating texture and dimension are surely within our grasp. Start by using the Micron Markers, then when you gain a feeling for creating patterns, try your hand with pen and ink.

Pen Points

Almost any pen point will do, depending upon what stroke or mark you desire to make. Fine lines and thick strokes may be obtained by any of these pen points: Gillette 170, 303, 404, and the 1950; Hunt 22 and 101, Brause 66EF, Leonardt Principle EF, and the G points (Nikko, Zebra, and Tachikawa).

Markers

There is a wide variety of pigmented, waterproof, permanent markers available in an array of point sizes and colors that are entirely suitable for line work applications. Recommended brand names are Copic, Pigma Micron, and Zig markers.

Suggestions from a Master

Here are suggestions from Master Engrossing Artist E. L. Brown:

- Make a pencil drawing of your design or sketch in detail first. Then, with pencil, lightly note indications of color tones in the design before you proceed with ink.
- Remember to use as few lines as possible to produce the desired effect.
- When studying samples of existing work, carefully note the gradation of deep tones, half tones, and solid black tones to produce contrasting effects. Aim for strength, softness, and harmony in color values.
- In stipple work, where small dots or brief pen strokes are used, attention to detail is required to a similar degree as in line work. There are two kinds of stipple: random dots and dots uniformly spaced. The effect of light and shade is obtained by varying spacing and the size of the dots. The size of the dots may be large or small depending on the desired effect.
- Until you gain experience, try various stipple and other line work designs on tracing paper to determine your best or most pleasing design.

Plates

The following examples represent a selection of traditional patterns as they were used by engrossers from the past. Study each specimen for how the placement of lines are used to create the illusion of tone, weight, and dimension.

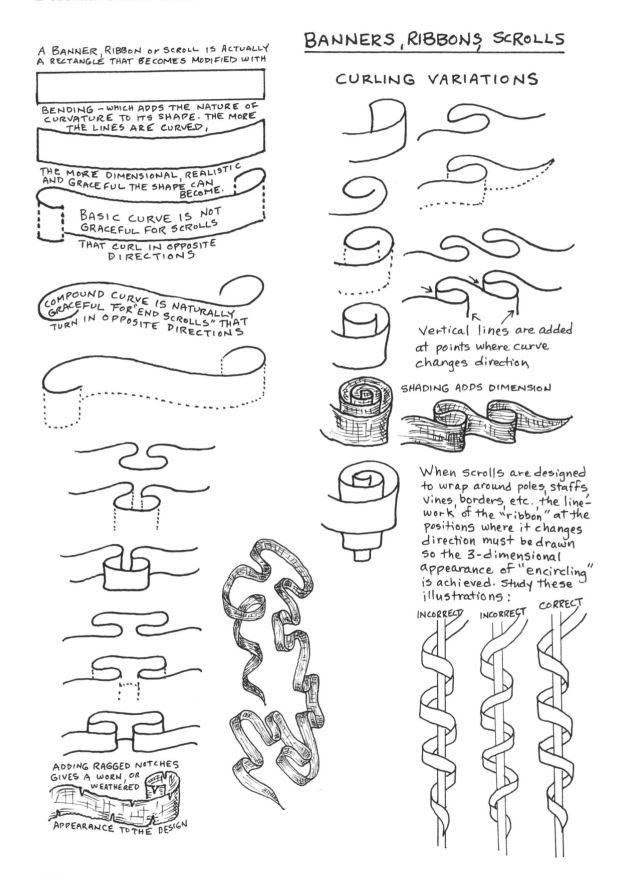

A BANNER, RIBBON or SCROLL IS ACTUALLY A RECTANGLE THAT BECOMES MODIFIED WITH

BENDING — WHICH ADDS THE NATURE OF CURVATURE TO ITS SHAPE. THE MORE THE LINES ARE CURVED,

THE MORE DIMENSIONAL, REALISTIC AND GRACEFUL THE SHAPE CAN BECOME.

BASIC CURVE IS NOT GRACEFUL FOR SCROLLS THAT CURL IN OPPOSITE DIRECTIONS

COMPOUND CURVE IS NATURALLY GRACEFUL FOR "END SCROLLS" THAT TURN IN OPPOSITE DIRECTIONS

ADDING RAGGED NOTCHES GIVES A WORN, OR WEATHERED APPEARANCE TO THE DESIGN

BANNERS, RIBBONS, SCROLLS

CURLING VARIATIONS

Vertical lines are added at points where curve changes direction

SHADING ADDS DIMENSION

When scrolls are designed to wrap around poles, staffs, vines, borders, etc. the line-work of the "ribbon" at the positions where it changes direction must be drawn so the 3-dimensional appearance of "encircling" is achieved. Study these illustrations:

INCORRECT INCORRECT CORRECT

America's Greatest Man

America's Greatest Man is one who heads a family, works steadily, pays bills promptly, is loyal to wife and country; for he typifies True Americanism

George E Smith

ABCDEFGHIJ
KLMNOPQ
RSTUVWX
YZ&c
12345
67890

BROWN'S ALPHABETS

152

HIGH GRADE

Diplomas

DESIGNS FOR CATALOGS AND GENERAL ADVERTISING PURPOSES ARE EVER IN DEMAND.

153

154

155

Commercial Designing of Every Description at Reasonable Prices.

SKETCHES AND ESTIMATES FURNISHED ON APPLICATION

156

Be Joyous for Merry Christmas is here

The Season's Greetings of the Business Educator, are hereby extended to its Readers

BROAD PEN STUNTS

ABCDEFGHIJKLM
NOPQRSTUVWXYZ&

ABCDEFGHIJKLMNO
PQRSTUVWXYZ~Co

ABCDEFGIJKLMNOP
QRSTUVWXYZ & SON

Styles for many purposes and
especially suited for window
cards and general marking

Brown 1921

158

Resolved, ——— That while we bow in humble submission to the Divine will, we shall miss him, but we hope and trust that the sorrow placed upon relatives and friends will be borne in the proper spirit, with realization that there is to be a meeting in the home beyond the grave where there is no sorrow and no parting. ———

And be it further

ART CALENDARS

WE MAKE ALL KINDS OF TRADE AND ART CALENDARS

BEST QUALITY ── RELIABLE SERVICE

Filigree

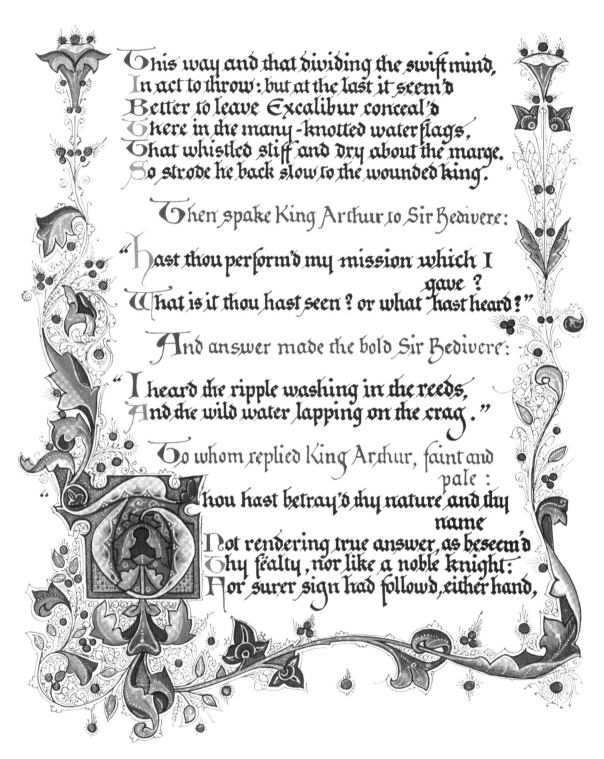

This way and that dividing the swift mind,
In act to throw: but at the last it seem'd
Better to leave Excalibur conceal'd
There in the many-knotted water flags,
That whistled stiff and dry about the marge.
So strode he back slow to the wounded king.

Then spake King Arthur to Sir Bedivere:

"Hast thou perform'd my mission which I
 gave?
What is it thou hast seen? or what hast heard?"

And answer made the bold Sir Bedivere:

"I heard the ripple washing in the reeds,
And the wild water lapping on the crag."

To whom replied King Arthur, faint and
 pale:
"Thou hast betray'd thy nature and thy
 name
Not rendering true answer, as beseem'd
Thy fealty, nor like a noble knight:
For surer sign had follow'd, either hand,

Alberto Sangorski, 1912

162

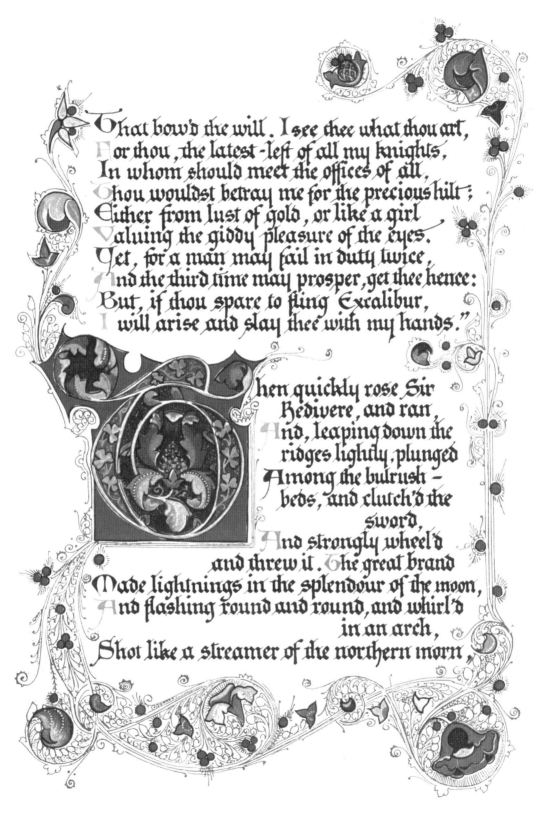

That bow'd the will. I see thee what thou art,
For thou, the latest-left of all my knights,
In whom should meet the offices of all,
Thou wouldst betray me for the precious hilt;
Either from lust of gold, or like a girl
Valuing the giddy pleasure of the eyes.
Yet, for a man may fail in duty twice,
And the third time may prosper, get thee hence:
But, if thou spare to fling Excalibur,
I will arise and slay thee with my hands."

Then quickly rose Sir Bedivere, and ran,
And, leaping down the ridges lightly, plunged
Among the bulrush-beds, and clutch'd the sword,
And strongly wheel'd and threw it. The great brand
Made lightnings in the splendour of the moon,
And flashing round and round, and whirl'd in an arch,
Shot like a streamer of the northern morn,

Alberto Sangorski, 1912

163

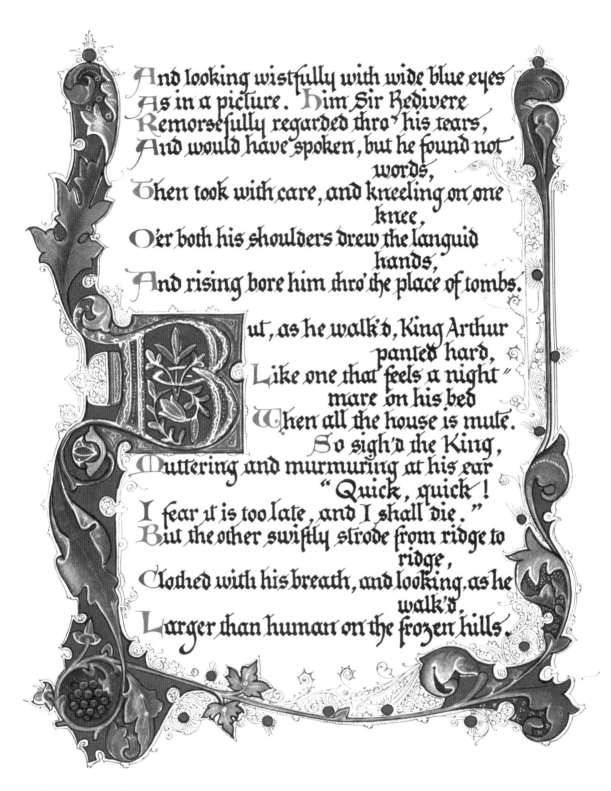

And looking wistfully with wide blue eyes
As in a picture. Him Sir Bedivere
Remorsefully regarded thro' his tears,
And would have spoken, but he found not
words,
Then took with care, and kneeling on one
knee,
O'er both his shoulders drew the languid
hands,
And rising bore him thro' the place of tombs.

But, as he walk'd, King Arthur
panted hard,
Like one that feels a night
mare on his bed
When all the house is mute. So sigh'd the King,
Muttering and murmuring at his ear
"Quick, quick!
I fear it is too late, and I shall die."
But the other swiftly strode from ridge to
ridge,
Clothed with his breath, and looking, as he
walk'd,
Larger than human on the frozen hills.

Alberto Sangorski, 1912

164

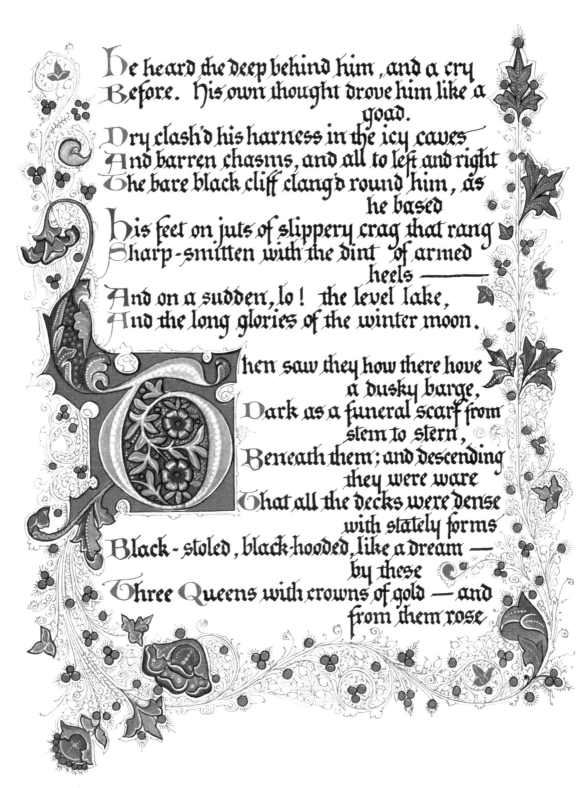

He heard the deep behind him, and a cry
Before. His own thought drove him like a
goad.
Dry clash'd his harness in the icy caves
And barren chasms, and all to left and right
The bare black cliff clang'd round him, as
he based
His feet on juts of slippery crag that rang
Sharp-smitten with the dint of armed
heels ——
And on a sudden, lo! the level lake,
And the long glories of the winter moon.

Then saw they how there hove
a dusky barge,
Dark as a funeral scarf from
stem to stern,
Beneath them; and descending
they were ware
That all the decks were dense
with stately forms
Black-stoled, black-hooded, like a dream —
by these
Three Queens with crowns of gold — and
from them rose

Alberto Sangorski, 1912

165

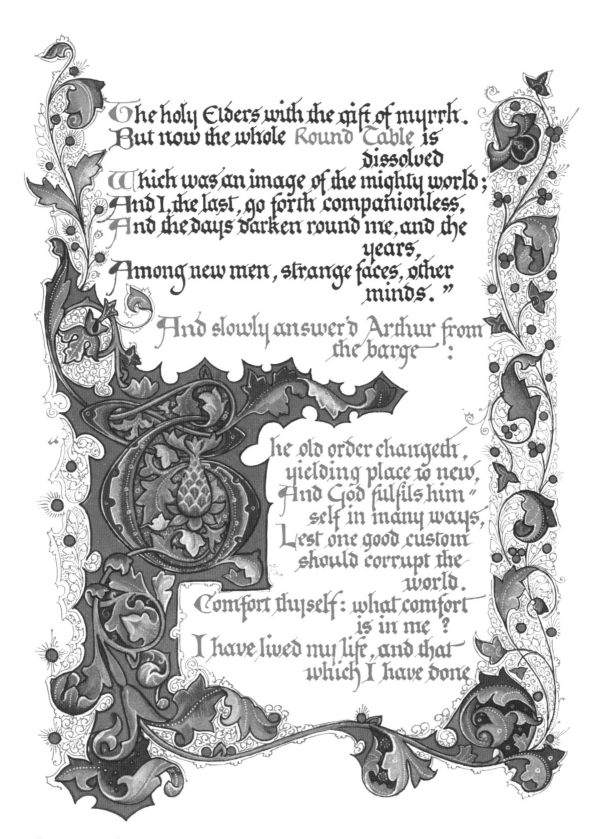

The holy Elders with the gift of myrrh.
But now the whole Round Table is
dissolved
Which was an image of the mighty world;
And I, the last, go forth companionless,
And the days darken round me, and the
years,
Among new men, strange faces, other
minds. "

And slowly answer'd Arthur from
the barge :

he old order changeth,
yielding place to new,
And God fulfils him "
self in many ways,
Lest one good custom
should corrupt the
world.
Comfort thyself: what comfort
is in me ?
I have lived my life, and that
which I have done

Alberto Sangorski, 1912

166

FOLIATION - DRAWING ACANTHUS LEAVES

In my studio I offer various lettering services to my clients, with one such service as that of being an Engrosser. In this work I enjoy incorporating acanthus leaf borders in my certificates. Painting the leaves in a blend of watercolors and accenting them further with decorative line-work, filigree, and flourishing produces an artistic composition that has been very popular with my clientele for many years. I mention this to assure you that you can certainly learn these skills and train yourself to become proficient in acanthus leaf design! It will take your own self-discipline and much practice, but you can do this! - even if you have never before drawn a leaf in your life. With this in mind, I offer the following suggestions on the time-honored design of architects, designers, artists, and dreamers for over two thousand years - the Acanthus leaf.

Designing simple and complex acanthus leaves for borders and accenting ornamental penmanship depends upon understanding the use and manipulation of curvature. The simplest explanation is that the acanthus is a leaf from the plant that is native to the Mediterranean countries. It has large leaves with toothed, or lobed edges.

To draw a Simple Acanthus leaf:

1. Draw a primary curve, such as a compound curve:

2. Draw a few "branches": one on each side
 These are also curves, but they should be either simple undercurves or overcurves:

I refer to this as the "skeleton" of the leaf.

Next - draw an outline around the skeleton, creating a lobed leaf such as this:

To make the design fancier, add more lobes:

3. To make a leaf look like it is curling, draw a primary curve that bends into another direction:

Now draw this into a simple skeleton:

Next, draw the outline beginning on the side where the primary curve becomes an overcurve as it changes direction:

This is the overcurve

At the very top of the curve where the curve changes direction have your outline cross through the primary curve and make an outline that ends where the end of the leaf would be.

Start the outline here

Next - start at the beginning of the leaf and make an outline on the right side of the leaf. Stop when the outline touches the overturned portion of the leaf (shown by the dotted line)

Now - starting at the top of the leaf design where it curls and goes into its change of direction, draw the remaining outline of the overturned portion of the leaf:

Complex acanthus leaves will usually have more lobes to the overall leaf shape. For finer detail, the outside edges of the lobes can have a number of small indentations, like a curved saw tooth. Study the examples.

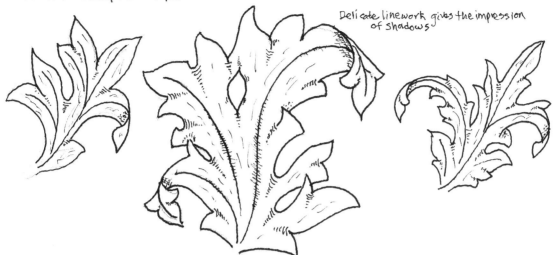

Delicate linework gives the impression of shadows

To make Acanthus leaves appear more realistic and add a sense of dimension to your illustration, a series of very fine lines can be placed where lines change direction such as in the areas shown in the samples above where the lobes branch out to form additional lobes.

To make a border of acanthus leaves for certificates or frameable Verse Scripture quotations etc., I draw a straight vertical line in pencil on graph paper. On top of this line I draw a compound curve that extends the same distance to the left of the line as it does to the right. If you want to have a non-symmetrical border, the compound curve should extend more in one direction than another. I like to alternate the position of these curves that extend left and right. This compound curve is the skeletal structure of this design. At a similar position on the portions of this curve the extends left and right, I draw a reference curve for the acanthus leaf. I now draw the acanthus leaves; they do not have to be similar to each other. If you wish a portion of a leaf to overlap the skeletal compound curve, this will add to the visual dimention of the design.

Using tracing paper upon which I have drawn my acanthus leaf repeating pattern, I can now trace my repeating pattern as many times as I need to so that my acanthus leaf border will be of the length that I desire. This entire border design can now be further accented on my art paper with flourishing, filigree, or other decorative line work techniques.

Foliation can also be useful at the base of a border, giving the impression that the acanthus border is growing out from a "bouquet" of acanthus leaves that overlap each other.

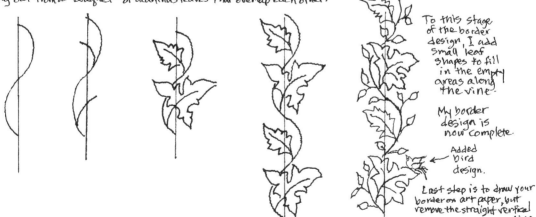

To this stage of the border design, I add small leaf shapes to fill in the empty areas along the vine.

My border design is now complete.

Added bird design.

Last step is to draw your border on art paper, but remove the straight vertical line.

There are many other ways to make border designs, and every artist who uses ornamental borders will have their own favorite design techniques. I like this method because it is quite easy to do, adding filigree designs is a lovely method to increase the ornamentation of the border band I am very fond of creating off-hand flourishing to sit upon some of the leaves. Because birds are living examples of Nature, perching birds on the leaves adds a sense of realism to the artwork.

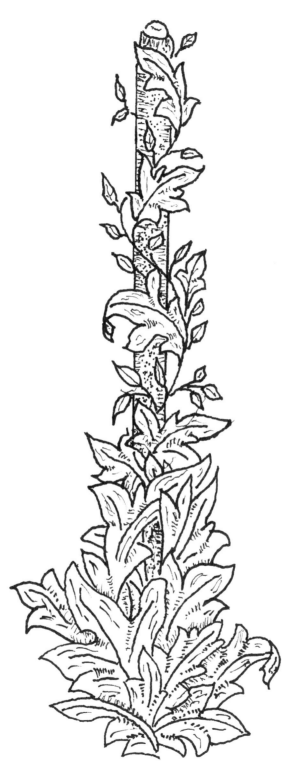

Example of using Foliation
to function as the base of
a border design.

Masterpiece Flourishing

The style of flourished patterns found throughout George Bickham's *The Universal Penman* have captivated me for over fifty years with their remarkable beauty, variety, and elegant grace. I have always considered them to be masterpieces of design. It has puzzled me why I have never seen their design process explained in publication. Perhaps I've missed the volume that shares his secret, but for everyone who, like me, admires and wonders at the appearance of Mr. Bickman's amazing flourishes, I wish to offer the following thoughts and techniques. These work for me every time and I am confident that they will also work for you.

Learning this art is not a difficult task. It is a great deal of fun! One may think of the process as figuring out a puzzle made of lines. There are concepts and rules that govern the procedure but they all make sense and are based on the fundamental aspects of nature that are the basis of all elaborate penmanship: curvature, movement, contrast, and variety. In homage to Mr. Bickham, I call this procedure Masterpiece Flourishing.

Basic Understanding

If you study the examples of off-hand flourishing made popular by American penmen of the late nineteenth and early twentieth centuries, it is easy to see that the four concepts of nature are the fundamental ideas in the design of cartouches, plumes, quills, scrolls, and birds. By making one design and repeating it in multiples, the overall effect looks more planned than spontaneous. Also, a graceful "flowing effect" is achieved that gives the impression of movement in each direction. Perhaps the most notable examples left to us by the great penmen were the elaborate title flourishes of William Dennis, Daniel Ames, Francis B. Courtney, Charles Zaner, and Edwin Brown, among others. The difference between off-hand flourishing and Masterpiece Flourishing is that, while both arts are closely related and involve an understanding of positive and negative space relationships, off-hand flourishing is primarily a free-form exercise while Masterpiece Flourishing is a planned exercise that exhibits a strong sense of apparent symmetry in the overall design. Remember that word: *apparent*.

Such symmetry in Masterpiece Flourishing is by no means precise. It is visually apparent rather than mathematical, which is achieved by preplanned, carefully placed line work. The sequence used by the artist in rendering one line after another is important, as always, but it is done in a methodical and controlled manner instead of spontaneously.

Where to Begin

Masterpiece Flourishing is basically a form of title flourishing that is planned, laid out, and first rendered on graph paper with a pencil. There is nothing magical about the details. Since it is a form of title flourishing, you begin with a letter, word, title, caption, or body of text such as a verse or quotation that you wish to surround with a delicate arrangement of lines. I choose to sketch my lettering layout directly on graph paper. Once this is done, the real fun begins. Using an assortment of several colored pencils and a standard black lead pencil, I proceed as follows:

1. Colored Pencil
I keep scissors, a vinyl eraser, tracing paper, and low-tack tape (such as drafting tape or painter's tape) on hand for sketching component designs to overlay as I create the flourishing pattern. Then, I outline the overall shape that I wish the flourishing pattern to occupy surrounding my block of text.

2. Tracing Paper
Taping a piece of tracing paper over the graph paper, I use a black lead pencil and usually start at the top of the first letter on the left side of the text and draw my first flourishing line. I draw this line with a series of curves so that it eventually proceeds in a direction to the right. It is at this stage that you decide what shape, curvature, and length this line will be. Keep in mind that as you proceed, there will be other flourishing lines that will intersect, cross, and overlap this line. No line in your pattern will ever be left alone without another line crossing through or over it. As other lines and curves begin to fill in the flourishing area, be careful not to make your curves in the line too small, tight, or awkward. Some standard forms of flourishing curves for Masterpiece Flourishing are shown on the next page:

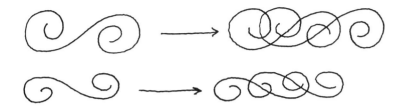

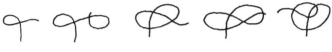

Ascending Line and Descending Line Flourishes

Turn these
upside down
for use as
descenders

These are effective for duplicating and overlapping to extend the patterning.

Ascending and descending lines extending out from lowercase letters are useful for becoming flourishing patterns. Note that if these ascending flourishes can be turned upside down, they become good flourishes to "grow" out of the descenders. I often turn my paper upside down and in all directions to sketch my flourishes in the smoothest manner.

If the text lettering is comprised of "Dutch Initials" or an angular blackletter such as the ubiquitous "Old English," the lines can be drawn so that they appear to be growing out of the capitals or extended portions of the lowercase letters.

Examples from George Bickham's *The Universal Penman*, 1740:

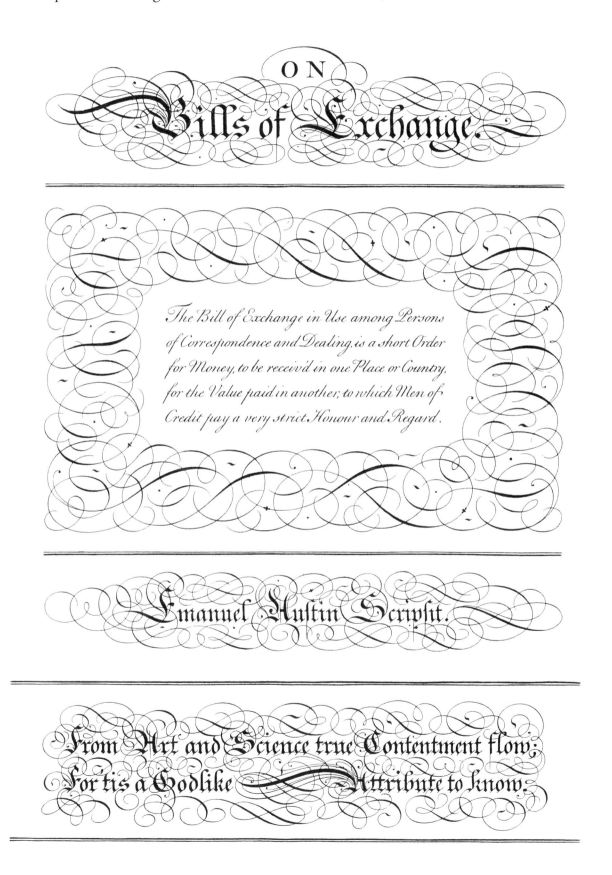

ON
Bills of Exchange.

The Bill of Exchange in Use among Persons of Correspondence and Dealing, is a short Order for Money, to be receiv'd in one Place or Country, for the Value paid in another, to which Men of Credit pay a very strict Honour and Regard.

Emanuel Austin Scripsit.

From Art and Science true Contentment flow; For tis a Godlike Attribute to know.

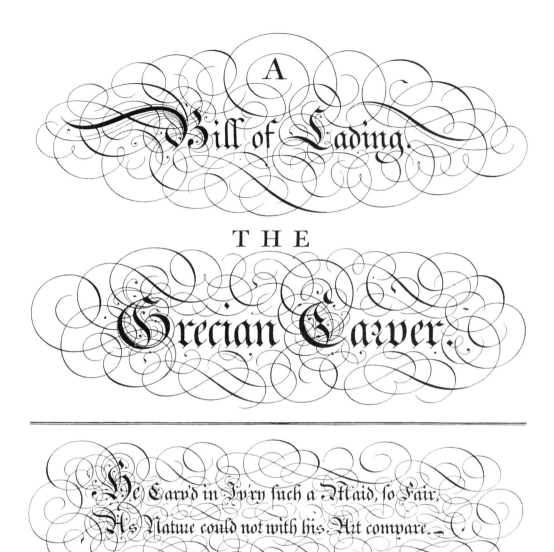

A

Bill of Lading.

THE

Grecian Carver.

He Carv'd in Iv'ry such a Maid, so Fair,
As Nature could not with his Art compare.

T. TREADWAY, Jun.

Scripsit.

174

W. Clark scrip.

William Brooks scrip.

I. Champion scrip.t

Labor Omnia Vincit.

B. Whilton scrip.

Emanuel Austin Scripsit 1736.

E. Austin Scripsit.

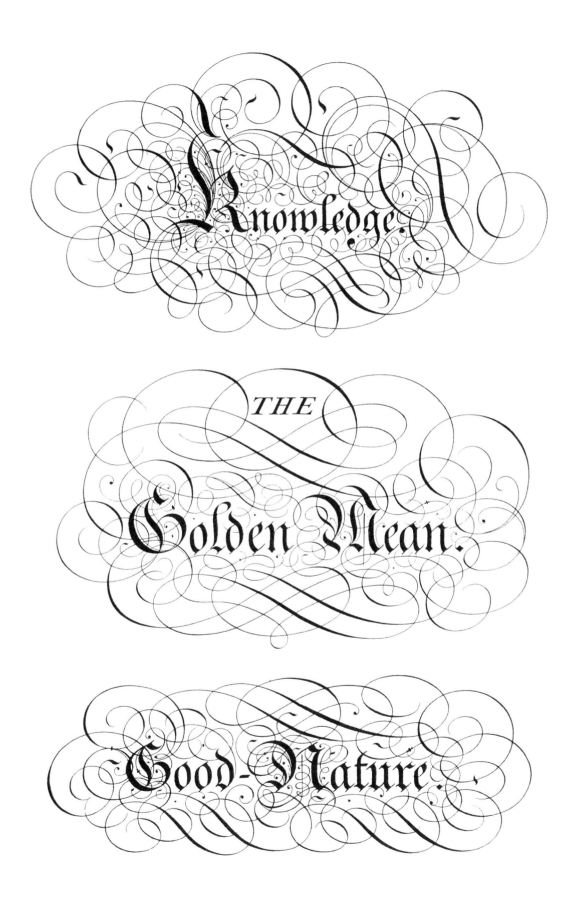

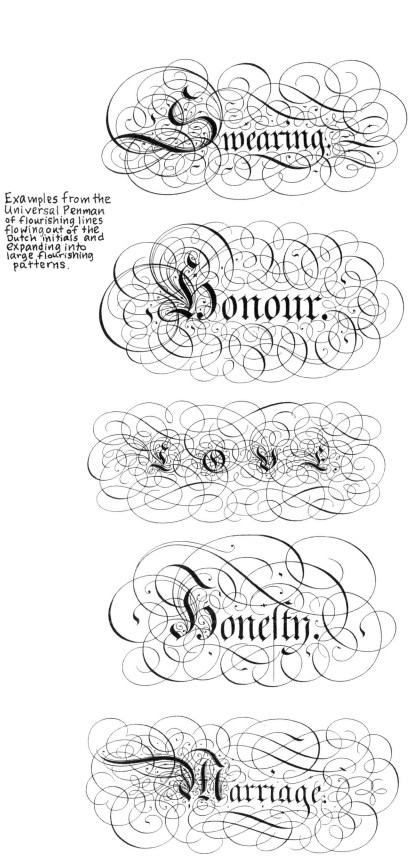

Examples from the Universal Penman of flourishing lines flowing out of the Dutch initials and expanding into large flourishing patterns.

177

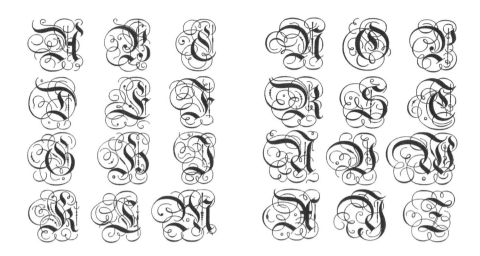

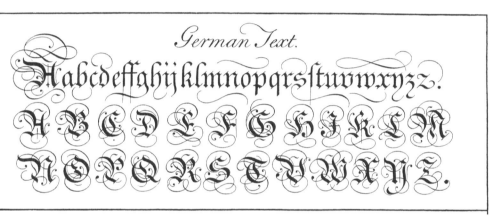

German Text.

178

Study.

A

Simile, or Comparison.

THE

Writing Masters

How to get Riches.

179

3. Intersecting Curvature Patterns

After studying the examples from my work and *The Universal Penman*, practice making such extended curving lines yourself. Tape a new sheet of tracing paper over a new sheet of graph paper. Then, with a colored pencil, practice drawing similar curves on the tracing paper. The graph paper will serve as a guide to maintain a perspective of how such curves can be positioned. Once you have created one or two extended curving lines, use a different colored pencil to practice drawing new extended curving lines that intersect or cross your first lines. When this step has been completed, use your third colored pencil to create a third set of lines, portions of which cross any of the lines you have already made. After this step is finished, study the composition. See how each colored line became a portion of the entire design. Turn your paper upside down and, again, study it for the intersection of lines and to see if there is a balance of negative spaces left to right and bottom to top.

Next, tape a new sheet of tracing paper over one of Mr. Bickham's flourishes and, with your three colored pencils, trace three lines of the flourish that intersect other lines. Lift your paper from the flourish and study the curvature of only the three lines. When I completed this portion of my practice, I took new sheets of tracing paper and repeated this exercise on five more of Mr. Bickham's flourished designs. I recommend this exercise for you. You must familiarize yourself with this format of intersecting curvature, for this is much different than curvature in off-hand flourishing.

A partial rough and simplified portion of a George Bickham example from The Universal Penman, showing the overlapping characteristics of three line flourishes. In place of colors to define the separate lines, note that one line is depicted by dots......, one by dashes ------, and one by a wavy line 〜〜〜〜. Students should trace over these with a different colored pencil for each line. The physical action of using your hand as you move the pencil to trace these flourishes is the best way to understand the physical concepts of curvature and motion necessary to create Masterpiece Flourishing designs. Remember to turn the paper frequently during the process of writing these patterns so that the paper is always in the best position for your hand and the pen to create the image of the curves smoothly in the easiest manner. The complete design of this example appears in the Universal Penman examples presented in this section.

4. Seeing Negative and Positive Areas

By constantly being observant of negative and positive spaces as your flourishing design progresses, you should strive to maintain an even balance of similar curves, curve lengths, and pattern density. It will take repeated practice to train your eyes to instantly see *both* negative and positive areas as you study the finished patterns from *The Universal Penman*. As you do this, turn the patterns upside down and study the curves as well as the negative and positive areas and pattern density.

After seeing several of the finished patterns in the manner just described, take a full sheet of tracing paper, then tape it over a full sheet of graph paper. With a lead pencil or any writing instrument, in large letters write the word "Calligraphy" on the graph paper in an alphabet style such as Old English, Italic, Bookhand, etc. Then, refer to the alphabets included in this chapter from *The Universal Penman* and study how the curves and flourishing lines appear to "grow out" from the capitals.

Basic Lettering:
Calligraphy

Designed Dutch Capital Letter:

Designed Flourishes:

"Calligraphy" in Masterpiece Flourishing:
Calligraphy

"Calligraphy" has three ascenders (l, l, h) and three descenders (g, p, y) among the lowercase, plus the capital C. In the designs from *The Universal Penman*, see how flourishing lines extend from various letters. The entire designs appear deceivingly fancy and complex, yet if we study their structure of where flourishing lines emerge and how the lines change direction, we can begin to understand the methods of curvature of which they are composed.

If you are successful in making a pleasing sense of visual harmony with your line work, the appearance of your negative areas will be balanced and attractive as well. You cannot achieve one without achieving the other. Positive and negative areas are intimately associated, for by their own existence they create one another. The trick is to train your visual perspective so that you can see both whenever you see anything containing letters.

5. Draw the Design

I proceed to draw my flourished pattern in a clockwise direction starting from left to right. You are *drawing* your design, not using an oblique penholder. Because of this, I find it easier to see the perspective of the design I am creating relative to the text letters if I turn my paper so that the portion I am working on is right in front of me. The following illustrations demonstrate this:

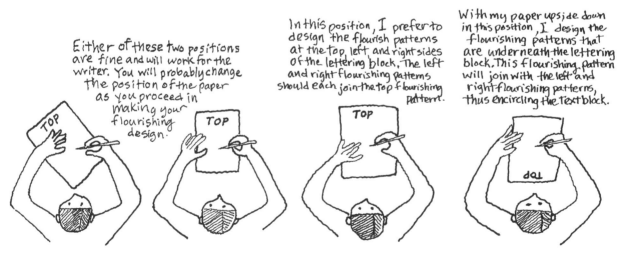

Because you are drawing your design, your visual perspective must not only focus on your flourishing pattern. Your vision should always be on both the lettering and the flourishing so that you can proceed by seeing how the flourishing size, complexity, and balance of negative-positive spaces relates to the lettering and the flourishes that you have already completed.

Either of these two positions are fine and will work for the writer. You will probably change the position of the paper as you proceed in making your flourishing design.

In this position, I prefer to design the flourish patterns at the top, left, and right sides of the lettering block. The left and right flourishing patterns should each join the top flourishing pattern.

With my paper upside down in this position, I design the flourishing patterns that are underneath the lettering block. This flourishing pattern will join with the left and right flourishing patterns, thus encircling the text block.

These illustrations are for a right-handed person. For a left-handed person, these illustrations would be in reverse as they would appear as seen in a mirror.

182

It is also a good idea every fifteen minutes or so to stop and turn your paper upside down. Looking at your design from this perspective can be quite revealing. Remember that if your design is truly graceful and elegant, it should appear that way regardless of what angle it is being viewed.

I do most of this preliminary work on tracing paper using a combination of pencil colors to help me see specific lines and patterns as I create them. It is still, however, a trial-and-error method. As with any endeavor, your speed and skill will improve with continued practice. *The Universal Penman* is your reference: Study! Study! Study! If you really wish to master this art, you *must* own Mr. Bickham's book. No other publication comes close.

6. Final Steps and Shading

When I am finally satisfied with my design, I place a clean sheet of tracing paper over my composite of tracing sketches and graph paper, remove all previous tracing sketches, then redraw the finished design in a monoline format without any shades. This is important because by drawing the sections of your design, you cannot know how the remaining portions and any shades they have will affect the shade density of your entire composition. Also, by observing your completed design in a monoline format, it is easier to see if the entire composition appears balanced. Once you decide that no further adjustment of curves, lines, and ovals need to be made, you can begin to design your shading. This is a most enjoyable portion of the complete procedure because the shades that you create will make the entire composition become visually alive! I recommend that you study your overall design and lightly draw in the outline of shades that you feel are the most significant or prominent curves or ovals in the left, right, top, and bottom of the design. These areas of direction are in the perspective of the area surrounding the text. If your design is a flourished pattern unto itself as a stand-alone composition without lettering, you should still decide the most significant curves in the four directional areas of your design. At this stage and every remaining stage of designing shades until it is completed, I turn my paper upside down and sideways to judge if the perspective of the shades I am creating appears to be balanced.

Your next step is to judge the secondary curves that you decide to shade. There will be many more of these than the number of primary shades. These shades should also be shorter or not as heavy as the primary ones. After deciding which curves you will shade, draw a small number of these outlined secondary shades—perhaps only six—and turn your paper. In the next section of your design, draw six more shades. Continue in this manner by turning your paper so that you can draw these secondary shades in all

directions. Once this is completed, study your composition again. Because you have drawn the outlines of your shades lightly in colored pencil, it will be much easier for your vision to focus on the shades alone. If you had drawn them with the same black lead pencil that you used to draw all your curves and ovals, the shades would blend in with the complete design and it would be difficult for your eyesight to focus only on the shaded outlines.

At this point in the procedure, study the overall appearance to judge if the entire masterpiece flourish you have created looks balanced. Make any adjustments that you feel are needed by erasing some outlined shades (continue turning your paper to do this). When you are satisfied that your artwork is complete, then (and only then!) with your black lead pencil or a fine-line marker, go over the colored pencil shade outlines in black. You do not need to fill in the shades.

The final step is to tape your final tracing, with all the shades outlined in black, to the backside of your art paper. Using a light pad or light table, reletter the words onto the art paper and allow the inked letters to dry. Then, carefully redraw your entire flourished composition. You are done!

A Few Thoughts to Keep in Mind

- Strive to keep your curves fairly simple. Please believe me that, after a while, the curves will seem to have a life of their own. Too many lines and too many curves will make your design look confusing, so be aware that your negative spaces are not too small or excessively large.

- It is perfectly fine to add short, simple, curved lines to fill in empty or excessively open areas; you do not have to redo the entire pattern time and again. Bickham shows many examples of this. As long as there is a pleasing visual balance in your design, the number of strokes and shades it takes to achieve this does not matter.

- Know when to stop. This is difficult to define. Train your eyes to recognize when visual harmony is achieved. Do not attempt to go further (you might want to repeat this each day!).

- Turn your paper frequently to observe the visual balance from all directions.

- Do not go overboard with shading. Remember that shading is an *accent* rather than a structural technique.

- Use capitals and ascending and descending lowercase letters as natural locations from which flourishing lines can "grow" and extend from the text.

- It is acceptable for an occasional flourishing line to cross through a lowercase letter. Note the following examples:

Design Layout Roughs showing flourishing lines crossing through lowercase letters

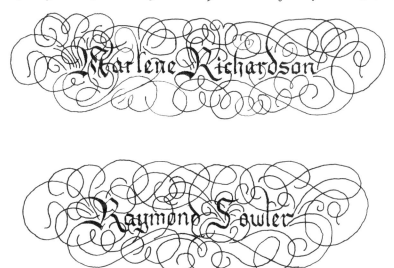

The text needs to be unencumbered by the line work so that it can be easily read. Be aware, however, that it can be very beneficial at times for a few of the unshaded hairline curves of the flourished design to cross through one or several of the lowercase letters. This serves to visually connect the flourished pattern to the text. Again, note this in the examples above. You do not want the flourished design to look like a complex arrangement of curves that float around the text. Crossing through a few of the lowercase letters will make the text and flourished design give the impression of a cohesive form of artwork. Just be cautious not to overdo this technique.

Extending Designs

The easiest method to extend a flourish or design is to "spiral out of it," much like a coiled spring that is stretched. This can be done in several ways. Additional curves and flourishes can then be built upon these. This technique can be useful for both off-hand flourishing and Masterpiece Flourishing.

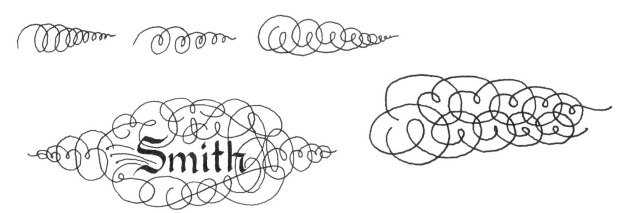

Masterpiece Flourishing - Shading Technique

You should always complete your Masterpiece Flourishing design first, and you should create it in a monoline format with no shades. Once you complete your design, there will be so many curves and crossed lines that it is often confusing to decide which are the best curves to shade, and where you should begin. In my own career as a penman and engrosser, many projects involving Masterpiece Flourishing came and went. As I learned from my mistakes which techniques did and did not work, I created a set of "rules" for myself that I wish to share with you. They have always been successful in guiding my efforts, and over time they will help you develop "an eye" for determining the shading density regardless of the overall shape or size of your flourishing composition. They are the following:

1. As noted, always create your entire Masterpiece Flourishing composition in a monoline unshaded form.

2. Use Drafting Tape to tape a sheet of tracing paper over your entire design.

3. With a colored pencil I divide my composition into sections. The number of sections depends upon the shape and how large the composition is.

 Example: if the composition size is approximately 8½ inches x 11 inches, or an A4 size, I divide the the composition into four sections:

 If the composition is approximately 11 inches x 14 inches, or 28 cm x 36 cm, I divide the composition into nine sections:

 Any size smaller than 8½" x 11" or A4, I divide the composition into two sections like this:

4. Take ten minutes or so to study the composition to determine which lines are the primary and secondary curves of importance. The remaining curves will usually be smaller or shorter. These will mostly serve the overall composition as space-fillers. Their function is to help make the finished design appear balanced.

5. Using another colored pencil of a different color, I start with Section 1 and begin to lightly outline the shades on your chosen letters. When you are done with Section 1, then go on to Section 2, and when you have completed outlining the shades of your Section 2, follow the remaining sections in sequence.

 Because many curves will cross two or more other curves as you proceed you will often find the need to re-adjust some of the shades in a previous section. I find myself needing to do this frequently. You will undoubtedly do this as well, but this will help you develop that "eye" for determining a proper shading density. Your ultimate goal is to have your completed composition appear evenly shaded. After you have added shades to your chosen primary and secondary shades, you will find that for the sake of balance, you will have to shade some of the smaller shades as well. As you work on each section, turn your paper around several times so that you can see all your efforts from different directions. An evenly shaded design should appear balanced from any direction.

6. Carefully fill in your outlined shades in ink, and you are done.

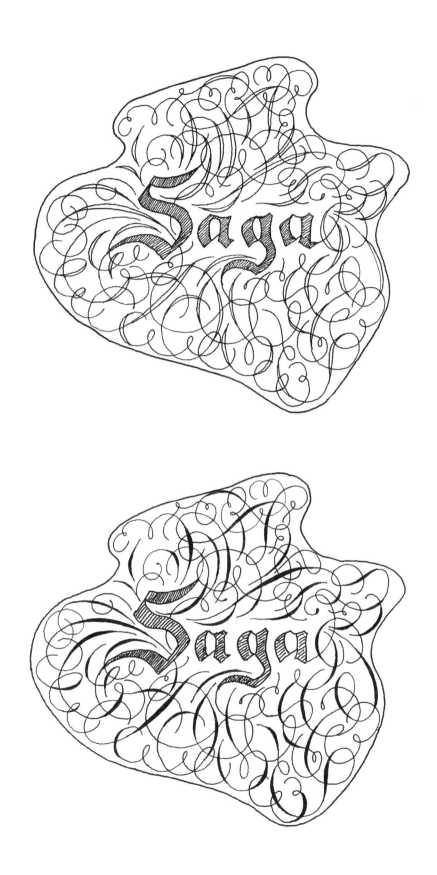

This technique is particularly useful for symmetrical flourish designs, often referred to as scrolls. A cartouche design is created, then traced and rewritten as the mirror image of the cartouche.

Designing Symmetrical "Scroll Flourishes" has been presented earlier in this Section on Flourishing. However, with the addition of a "stand alone cartouche" the use of this added design can be effective in creating an easily-formed version of Masterpiece Flourishing.

Step 1: Create a Cartouche design with an axis line running through the design's entire length.
Step 2: Trace the cartouche in reverse as previously described. Place the designs facing each other on the axis line. You have now created a symmetrical Scroll design.
Step 3: Create another cartouche design. It does not have to be symmetrical, but you will find that a stand-alone cartouche design will be quite useful in the future for other projects that you will have. A non-symmetrical cartouche should have both ends- left and right enclosed by an oval-styled flourishing stroke.
Step 4: Make multiple copies of your designs and use them to create an enclosed border design that will surround your text.

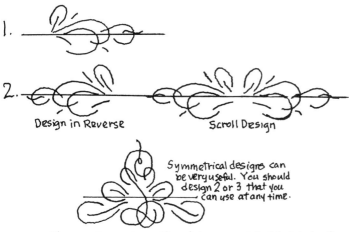

1.

2. Design in Reverse Scroll Design

Symmetrical designs can be very useful. You should design 2 or 3 that you can use at any time.

Your cartouche does not have to be symmetrical, but both left and right ends should be enclosed.

3. Non-Symmetrical Cartouche

This cartouche has enclosed ends with each end enclosed by a graceful curved design. This is the cartouche style you should create.

This cartouche has an open end and is not as graceful as the example on the left.

4. By making multiple copies of your Scroll design and stand-alone cartouche design, you can create a Masterpiece Flourishing design that can surround a body of text.

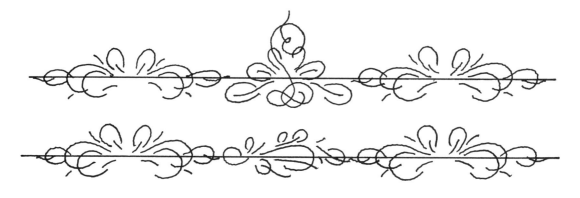

Letter Manipulation

Portions of letters that are traditional in shape and size can be extended and transformed into a source for further flourishing. Leaving more open space between the strokes of the letter will allow you to add more lines and flourishing touches if you desire.

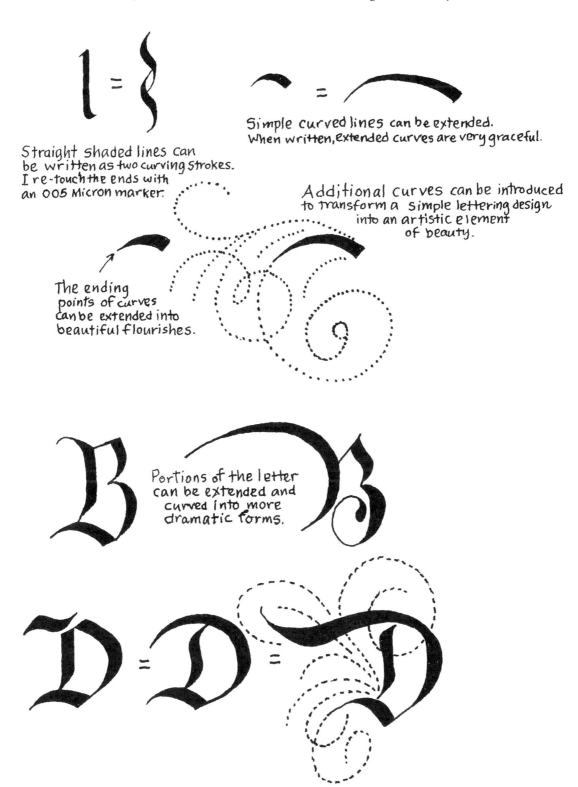

Straight shaded lines can be written as two curving strokes. I re-touch the ends with an 005 Micron marker.

Simple curved lines can be extended. When written, extended curves are very graceful.

Additional curves can be introduced to transform a simple lettering design into an artistic element of beauty.

The ending points of curves can be extended into beautiful flourishes.

Portions of the letter can be extended and curved into more dramatic forms.

189

Example from start to finish:

Step 1: Letter name or text in Broad-Pen alphabet.
Step 2: Modify letters to suit the alphabet style you desire.
Step 3: Re-letter with a broad-pen that is one size larger than the one used in steps 1 and 2, and expand capitals and any ascenders and descenders to allow ample room for additional flourishing lines. This larger size also allows you to further modify the letters if you desire to do so.
Step 4: Here is where your drawing skills come in and will require additional practice. Using tracing paper and a red colored pencil, lay the tracing paper over the Step 3 enlarged lettering design, and begin sketching possible flourishing solutions to the capitals, ascenders, and descenders. Continue using new sheets of tracing paper with red pencil until you create a flourished design that you find satisfactory. Then place the tracing paper with satisfactory design under the enlarged Step 3 design. With a fine-pointed marker, draw the flourishes onto the Step 3 artwork. This is also the final time to make any adjustments or modifications to lowercase letters and letter spacing.
Step 5: Using this as your final layout, re-letter and draw your finished composition on the art paper of your choice.

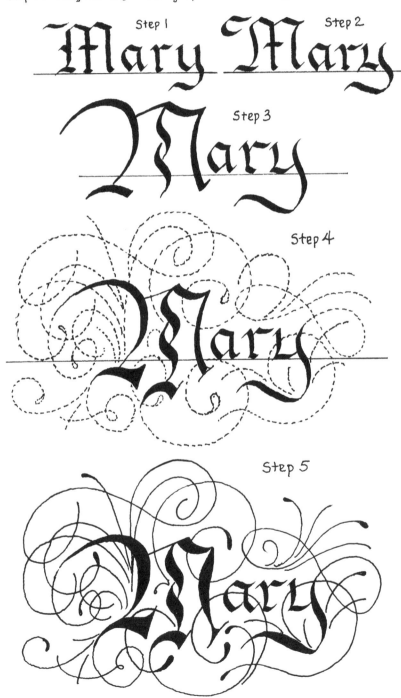

190

Conclusion

For many years it has been a personal goal of mine to write a manual for my students of the skills I was taught and those I have developed over time that can bring the writing of penmanship to a higher level than the traditional methods found in publications of the past. If even one of the techniques I have shared within these pages can prove helpful to you or further excite your interest in American penmanship, I will surely feel that my efforts have met with success. Remember, to acquire any degree of skill in the methods I have described, you must be patient with yourself, focused on your studies, and disciplined in your practice. I am fully confident that you can do all these aspects, but you must believe in yourself. It is essential to fully realize that you will make mistakes and that each mistake is a glorious learning opportunity you may have missed entirely if your mistake never happened. I earnestly hope that this volume will be helpful to you in your penmanship efforts and, as the years move on, it will become a friend you will turn to time and again.

I met my mentor, Paul O'Hara, in 1979. The way I heard about him before we met is a story unto itself. He was among the very last living bona fide Master Penmen to graduate from the Zanerian College of Penmanship with a gold seal—the highest grade possible—affixed to his diploma. His personal instructor in ornamental penmanship was the institution's founder, Charles Paxton Zaner.

There is little room here to tell the whole story. When I was introduced to Mr. O'Hara, he was ninety years of age. He asked why a young man like me (I was thirty years old at the time) wanted to talk to him about penmanship, as no one had spoken to him about "The Queen of the Arts" in fifty years! Because of my honest reply, he started believing in me. Because of his encouragement, I began to believe in myself. The last time I saw Mr. O'Hara was in 1990 when I handed him the first hot off-the-press copy of my first book, *Spencerian Script and Ornamental Penmanship*.

I had brought with me a dozen various penmanship samples of my work to show him. I also told him all about my teaching efforts in starting the Spencerian Saga workshop program in 1987. It was a most special moment for both of us. He was one hundred and one and I was forty-one, and we both realized we would never see each other again. Mr. O'Hara passed away six months later. To this day, I can feel his gaze over my shoulder as I write.

Each of us, in our own way, is part of the past through those who believed in us when we were younger. I am certain that the Master Penmen who came before me felt the same way. Through all the penmanship years, before and since, off-hand flourishing

became the visual symbol of American penmanship. In concluding this book and the information within its pages, I feel it only appropriate to place my work before you in the context of that special era from which it grew.

The Golden Age of Penmanship

Although the years 1850–1925 have generally been agreed upon as America's Golden Age of Penmanship, there were a number of American Writing Masters whose names and efforts led up to the mid-nineteenth century. This is but a brief glimpse into that history, but a most notable figure was John Jenkins (1755–1822), the American who is credited with authoring and publishing our nation's first handwriting manual, *The Art of Writing*, in 1791. Prior to him was the Honorable Thomas Matlock (1736–1829), whose penmanship was so highly regarded that he was selected to scribe the Declaration of Independence, as well as George Washington's commission as commander in chief of the Continental Army. He also served in the Continental Army and remained active in early American politics.

Perhaps most important of all, there was Platt Rogers Spencer (1800–1864). Known as the Father of American Handwriting, his Spencerian form of writing became America's national handwriting style at least a decade before the Civil War. Once Spencerian penmanship became widely known, many individuals followed his lead, but none became as nationally promoted to the same degree as Platt Rogers Spencer's original style until Austin Norman Palmer (1860–1927) in the early twentieth century. His innovation of combined muscular movement and Palmer method writing truly changed the way everyone wrote with their forearm, wrist, and fingers to become the personal "engine" of writing.

Up until this point, all penmen, except Palmer, used feather quill pens to write. A naturally soft and oftentimes brittle natural material, the shaded strokes of well written script writing were delicate and of a fairly light contrast to hairline strokes. Quills were fragile and very susceptible to breaking.

However, a decade before the desperate struggle of the Civil War, steel penpoints were being manufactured in England, and then in America by the Esterbrook Pen Company beginning in 1858. Coupled with the Industrial Revolution of the latter nineteenth century, business schools that focused on professional penmanship education were soon established throughout the United States. Chief among these was the Zanerian College of Penmanship in Columbus, Ohio, founded by Charles Paxton Zaner in 1888. Known as America's best all-around penman, Zaner's penmanship, in all styles, was legendary for its grace, beauty, and precision of line and shade.

Soon, many other penmen emerged who were also Masters of the Art and whose names are legendary to this day: Francis B. Courtney, known as the "Pen Wizard," William Dennis, referred to as the "Dean of Engrossing," and many, many more.

The roll call would be incomplete without our mentioning Henry Flickinger, Clinton Canan, John D. Williams, Elmer Bloser, Lloyd Kelchner, Louis Madarasz, Fielding Schofield, Willis Baird, George Gaskell, Daniel Ames, and Clinton Clark, among many others, including Paul O'Hara.

During the 1920s–1930s, the typewriter began to increasingly replace the need for such beautiful writing, causing the great penmanship era to draw to a close. As the twentieth century moved along, our cherished heritage of penmanship was soon forgotten. World War II, the Cold War, the Space Race, and the Vietnam War distracted us from the art of penmanship. No longer was there interest in Spencerian-related penmanship, and this wonderful part of America's history was forgotten.

Nearly all of the Master Penmen were gone, but at this point, I became lucky beyond my dreams for in a most magical series of happenings, I found Mr. O'Hara. During our time together, he shared many stories with me about his colleagues and friends from that era; about what it was like to be a professional penman in the years before the Titanic even put to sea; descriptions of the Penman Conventions; and his experiences personally training under the watchful eye of Professor Zaner. It was a remarkable journey back in time for me.

The days have vanished when business school circulars featuring exquisitely flourished specimens helped lure prospective penmanship students into joining the rolls of their institutions. From the veteran penmen of Mr. O'Hara's memory came many vintage stories that were told to him by his teachers and colleagues of the early twentieth century. One in particular eventually came to rest in my hand. The story was in the form of a legend about a very special pen.

This fabled instrument was made of amber and the point it carried was crafted of gold. It was called "The Master's Pen," referring to the Master Penmen who were selected to use it. According to legend, the highlight of the annual Penman's Convention was a penmanship demonstration like no other. At the end of the week's studies, the Convention concluded in a most solemn manner. The Masters who were in attendance each had a seat at a long table. Professor Zaner would hold the pen for everyone's view, explaining how the pen represented the genius of Platt Rogers Spencer and that his spirit of penmanship was within everyone gathered there. Then, he would pass the pen to the first seated Master who wrote with a grace that defied description. Then, he would pass it to the next Master Penman, who dipped it in ink anew and wrote; and thus, it continued to be passed on and on. Graceful, flourished birds would appear and seem to fly off the paper; fanciful quills would take shape, line by line, as the penmen's arms moved in a blurred succession of quick strokes, and ornamental letters of exquisite form almost danced off the golden point. It was said that everyone would look forward with great anticipation to the demonstration.

The Master's Pen became synonymous with the event and evolved into history as a penman's legend.

In the years since my mentor's time with me, I have crafted many of his stories into the form of narrative poetry which I share with my own students. I was the last penman to hear the stories firsthand from a penman of that era. In this way, it is my hope that the stories and legends of that remarkable era will not be forgotten or lost. Among those I have written in verse is "The Master's Pen." I published a book of these special poems which I gave to my students at the last Spencerian Saga I directed in 2012. In the years since, that poem and the legend it shares has found its way into many conventions and workshops.

In 2017, I had just returned from teaching in Moscow and St. Petersburg, Russia, and was attending the Colorado Pen Show. Two of my close friends, Ed Capizzi, the show's director, and Ryan Krusac, a phenomenal artist and craftsman (rkspens.com), confided in me that they wanted to craft the Master's Pen so that I could further share the story by actually demonstrating my own writing with it, continuing the legendary tradition. Their plans came up short because they could not obtain a large enough piece of amber, but while visiting St. Petersburg, I had seen an amber store that had large pieces for sale, and my workshop hosts had invited me to return the following summer. With the help of my two friends, I was able to purchase a large amber specimen during my next visit to Russia.

Months later, Ryan crafted the magnificent pen. The body is indeed made of forty-million-year-old Baltic amber, complete with the bodies of prehistoric ants that were buried in the tree resin before it became amber. The narrow tail of the pen is formed from five-thousand-year-old bog oak, the head is of fossilized megalodon tooth for strength, and the metal flange is 14-karat gold. The point is a vintage gilt Spencerian Velvet Point No. 46 from the Penmanship era. It is the incomparable Master's Pen of legend which I now use to demonstrate everywhere I have the opportunity to teach.

It is my earnest hope that this volume has been of assistance to you in your efforts. Thank you for becoming my student; I wish you every success along the penman's path!

Respectfully,

Michael Sull

Michael R. Sull

Appendices

McCaffery's Ink

Due to the chemical nature of iron-gall ink, McCaffery's black ink will actually appear as a grey-black or grey-blue when used from a new bottle. It will darken a bit as it dries. After a few weeks or so the ink will considerably darken, and a black precipitate of the ink will collect in the bottle. For best results, stir the liquid ink and precipitate for 20-30 seconds (a coffee-stirrer works well) before you dip your pen point to begin writing. When the surface of the ink in the jar lowers by 1/4" or so (due to usage or evaporation), add the equivalent of several full eyedroppers or 1 teaspoon of water to the ink. Stir thoroughly so the precipitate, ink and water will mix well. The ink is now ready to use again. A little water added to the ink once in a while is good maintenance. If, however, you neglect to do this for a number of months, the ink will thicken and it will be difficult to produce fine hairlines and smooth strokes. When the ink-level of the jar decreases to only one-half of the jar's depth, add enough fresh McCaffery's ink from another jar into the half full jar to bring the ink level back up to about 1/4" from the top of the jar.

McCaffery Inks Recreate Penmanship of the Golden Age
In this manner you are always mixing old and new ink together. Such care is well worth the effort; this ink is a faithful reproduction of the favored ink recipes used during the Golden Age of Penmanship. Once the ink has matured in the bottle (1-2 months on average), it is capable of producing exquisite hairlines and crisp, dramatic shades.

Normal Occurrences You May See
The pigments of McCaffery's inks are natural and organic in composition. As such, every so often it is not uncommon for you to find a slight growth of mold upon the surface of the ink inside the jar. Another "surprise" may be that when you open a jar, you notice that a dried "ink skin" has formed over the surface of the ink. I have also observed that from time to time when I open a bottle of Brown Ink, a thick, brown sludgy material seems to have settled in the ink. Take heart and don't panic! Your ink is fine. In fact, these occurrences are usually a sign that the ink itself is maturing. These phenomena are natural and do not harm, contaminate or dilute the ink. Just take a coffee stirrer, popsicle stick or similar item and lift the mold, dry skin or sludge out of the jar and into the trash. Once this is done, use a new stirring stick and stir the ink again. The ink is now ready to use.

When Restoration Efforts Fail
If you find that, due to neglect, evaporation, excessive dust or whatever, the ink in your jar is extremely thick, gooey, gritty or has a very unpleasant odor, it is probably best to throw the bottle away and start with a fresh bottle. Just do it – you will be glad you did.

Michael Sull '08

195

Cross-Drill Exercises

Movement exercises are designed to get your hand and arm "warmed up" and comfortably in motion. The purpose of *cross-drill exercises*, a type of movement exercise that was part of standard penmanship training for many years, is more specific. The exercises are designed to help the student develop a consistent movement as the hand glides from letter to letter. This is not the action of actually making the letter, but the movement from one letter to another, which determines the consistency of the spacing *between letters*.

The characteristic of consistent letter-spacing exhibited by American Cursive handwriting is a product of a combination of hand movement and arm movement that was referred to as the penman's *writing rhythm*. The cross-drill exercise (also known as *cross writing*) was the traditional method employed to train students to achieve this movement and the spacing between letters. The following Cross-Drill Practice Sheet is designed to assist the student in daily practice to acquire such letter-spacing (a blank sheet can be found on page 199). With diligent use (ten to fifteen minutes each day), the rhythmic arm movement necessary to produce this uniform letter-to-letter distance will become an automatic, nearly effortless technique.

How to Do Cross-Drill Exercises

Note that in opposite diagonal corners of the guide sheet are the following designations: VERTICAL FORMAT and HORIZONTAL FORMAT. With the sheet positioned in front of you so that the words VERTICAL FORMAT appear at the top left and bottom right corners, proceed to write continuously from left to right on the line marked by the letter X. The writing rhythm should be such that a single letter is written upon each X, and immediately after the letter is completed, the pencil or pen moves (without being lifted off the paper) to the next X on the right, where another letter is written.

In practicing cross writing, write at least five inches per line from left to right. After you finish this first line of writing, go to the next line of the letter X underneath the first line and repeat the writing as before. Continue in this fashion until a five-inch "block" of writing has been produced. Once this has been done, turn the sheet so that the words HORIZONTAL FORMAT appear at the top left and bottom right corners. Now proceed in the manner just explained, writing on the lines marked by the letter O until all the lines within the five-inch block have been used (see Figure O).

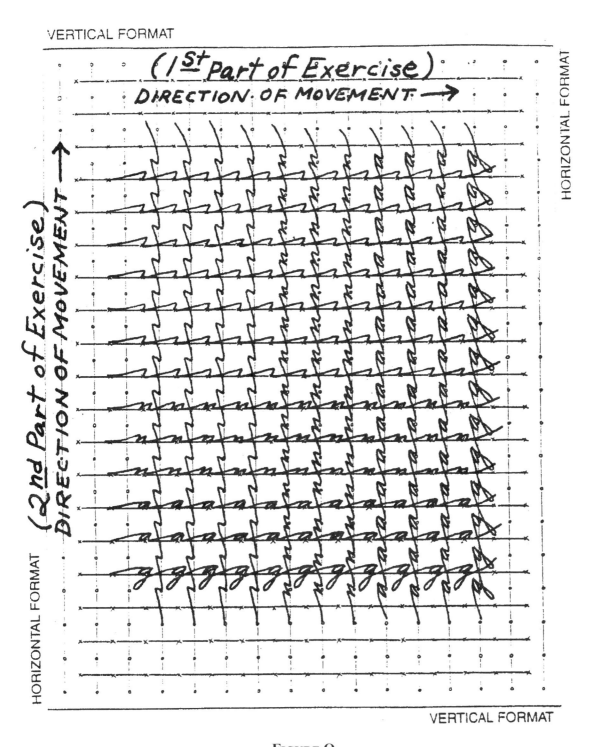

FIGURE O

HOW TO DO CROSS-DRILL EXERCISES

197

Speed of Writing During Cross-Drill Practice

Write at a comfortable speed: not too fast (at the sacrifice of good letter form) or too slowly (resulting in a stiff, ungraceful appearance of the letters). Remember that the lateral motion of moving from a finished letter to the point where the next letter will begin—that is, from one letter to another—is made with arm movement. This means that your arm moves by shifting slightly on your forearm muscles. Making the letters themselves is done with finger movement. It is essential that this combination of finger/arm movement is practiced to ensure proper writing habits (see Figure P).

FIGURE P
ARM AND FINGER MOVEMENT IN WRITING

Throughout your cross-drill exercises, maintain a light, comfortable grip on the pencil or pen with your hand. Do not tighten your grasp; your writing tool and your hand must have the freedom to move upon the paper with ease. Keep in mind the paper-shifting movement: after writing for two to three inches, stop writing for a moment and use your non-writing hand to briefly shift the paper two inches to the left. Then begin writing again. This will allow you to maintain correct posture as you write.

Cross-Drill Exercise Practice Sheet

VERTICAL FORMAT

HORIZONTAL FORMAT

HORIZONTAL FORMAT

VERTICAL FORMAT

199

CROSS WRITING GUIDE SHEET

GUIDE SHEET FOR ORNAMENTAL PENMANSHIP CAPITALS.
Strive to have all capitals sit a little bit below the Baseline, and keep the size of each capital within the SOLID lines above & below the Baseline.

Baseline for lower case are the dashed lines ↓

ENTIRE LETTER
SHOULD FIT BETWEEN
THESE TWO HEAVY
BLACK LINES
AS SHOWN

Capitals should sit on the ↗
solid lines marked by ■

Example

H C B Marvin Charles

Practice Ornamental Capitals

Anna Marie Benjamin

Spencerian Master Penmen

Cross Drill Exercises

These Samples Are For You

A B C D E F G H

I J K L M N O P

M.Sull '22

201

Guide Sheet for Ornamental Penmanship Capitals

Strive to have all capitals sit a little bit below the Baseline, and keep the size of each Capital within the dashed line above & below the Baseline.

Baseline for lower case
are the dashed lines ↲

Capitals should sit on the ↗
solid lines marked by ▪

MᶜSULV 22

How to Use the Spencerian Practice Guide Sheet

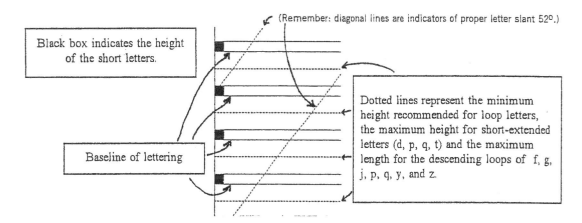

(Remember: diagonal lines are indicators of proper letter slant 52º.)

Black box indicates the height of the short letters.

Baseline of lettering

Dotted lines represent the minimum height recommended for loop letters, the maximum height for short-extended letters (d, p, q, t) and the maximum length for the descending loops of f, g, j, p, q, y, and z.

Explanation of the Use of Alternative Letter-Forms, Shading, and the Height Relationships of Letters in Spencerian Script

IN DEVELOPING the principles and letter-forms for Spencerian Script, Platt Rogers Spencer derived his inspiration from Nature. The beauty he saw in the world about him was everywhere. He reasoned that forms of *curves* were present in all things beautiful, from flowers, leaves, clouds, waves, and the wind, to even living creatures themselves (which had somewhat curved or rounded portions to their bodies).

He also noticed something else that was evident in everything he saw. This was the aspect of *variety*. The flowers he could see were not all the same flowers everywhere, but instead, many different types in different shapes, sizes, colors, and growing in different locations. There were many different types of trees as well, and clouds, birds, and all animal life. Even the waves changed shape continuously.

These concepts--that of *curvature* and *variation of appearance* became Mr. Spencer's key ingredients as he endeavored to emulate the beauty of Nature in the art of handwriting. As such, Spencerian penmanship is characterized by graceful curves, consistent letter-spacing (as the consistent curved spacing of waves on the sea) and, it its most pure, traditional form, a certain amount of variation in the letters themselves. This variation in the letter-forms occurs in three different ways. These are:

1. **The letter-form itself.** In studying Spencerian writing, the student will soon note that *alternate letter-forms* exist in addition to the traditional, or more "classic" letters. Alternate letters are noted on page 21 of the text "Learning to Write Spencerian Script" by M. Sull and D. Rapp and can be seen in nearly all vintage ornamental writing. These alternative forms, such as:

203

are not "better" than the standard letter-forms. They only exist as alternative options for the selection (by the penman) of which letters to use when words are written. In short, they exist purely for the sake of adding *an appearance of variety* to the writing. As a general rule, a variety of letter-forms can be used in sentences and in all writing, except within a single word. As an example, there are several variations of the lower-case **p** (*pppp*). You may use any of these variations when writing sentences, but within any single word having two or more **p's**, you should use one form of the **p** for all **p's** in the word (whichever one you choose). Using different forms of the same letter within a word can be visually confusing and adversely affect legibility. The only instance where you may use different forms of the same letter is when you use either of the ending *letter-forms;* that is, the **t** () or **d** ().

Because these letters are meant to be used only as the last letter in a word, if there are two or more **t's** or **d's** in a word including the last letter, then both the standard and alternate forms may be used:

That dabbled constraint ended Titt

2. **Shading:** Mr. Spencer felt that if the letters were all composed of thin pen-lines with no shading at all, they would tend to look somewhat uninteresting and dull, much like the flat surface of a lake when there are no waves. Similarly, he felt that if every letter was shaded, the writing would also look fairly uninteresting, since it would present the same, heavy appearance from one letter to the next.

So it was that, keeping in mind the beauty found in the variety of natural forms, Mr. Spencer developed this idea: If, when letters are written, all the curves that exist in each letter are written as smoothly and gracefully as possible, then the resulting letter will, of its own shape and form, be naturally pleasing to the eye, whether it is shaded or not. Therefore, the addition or omission of shade will not make the letter more correct or even beautiful, but it can make it more interesting in appearance when viewed, or read, in combination with other letters, some of which are shaded and some of which are not.

Normally, most lower-case letters in Spencerian are not shaded, except for the short-extended letters (*tdppq*). It is this infrequent shading of lowercase letters, together with the graceful curves of all letters, the joining strokes between letters and the dramatic shading of capital letters, that gives Spencerian Script its unique visual identity. No other form of penmanship is quite like it.

Remember: When you do decide to add shading to a lower-case letter, it should be merely a short and delicate shade, not bold and heavy. Note:

Unshaded Shaded

a h m n v w y z *a h m n v w y z*

204

3. Letter Height: As a general principle, the established height for the short lower-case letters is based on the letter **u.** However tall the penman decides to make the **u,** that becomes the height for all the other short letters. If we were to make a guidesheet based on the height of the **u** with even increments of height above and below the **u,** it would look like this:

Baseline

The rules for the height of the loop letters (*h k l b j y g z f*) again stem from Mr. Spencer's idea: if the curves that make up the letter are smooth and graceful, then whether one loop letter is a little taller or longer than another doesn't make any difference. The letter will still be attractive. Therefore, in Spencerian writing, it is not mandatory that all of the loop letters be exactly the same height. Because a human being is a creation of God and not a machine, it is natural that, in the momentum of the act of writing, there will be a slight variation in the height and width of each letter. This small variance in the letters is another feature that makes Spencerian somewhat unique among lettering styles, and is the reason why, despite the extraordinary skill of the master penmen, their beautiful writing looked a bit different from one penman to another.

Thus, the rules for the height of the loop letters are based on *proportion* rather than *precise measurement.* So, the rule is this: In order for a loop letter to truly give the appearance of an ascending, or tall, letter-form, the loop should be at least 2½ to 3 times the height of the short letter, such as **u, m, n, e,** and so on. However, since the actual loop of a loop letter consists of a thin, hair-line stroke *and possesses no shade,* the loop will not look too heavy or disproportionate if it is made somewhat taller than 2½ times the height of the short letters. Thus, it is permissible for loop letters to be written as much as 3½ times the height of the short letters.

The short-extended letters (*t d p q*) normally do have a small amount of shade on their ascenders or descenders. This shade does give the letters a certain amount of visual "weight" when compared with unshaded letters. This visual weight will increase (the letters look "heavier") as the letters are written larger. Because of this, the height and length of the shaded ascenders/descenders should not exceed 2-2½ times the height of the short letters.

How These Guidesheets Work

While all the information just mentioned is quite true, a problem develops when the lower-case letters are written somewhat taller than normal, as is usually the case for beginning students who start writing at a large size and gradually scale down the size of their writing as they become more skilled. It is easiest for beginning students to write Spencerian with a short letter letter-height of approximately 1⁄8 inch. This means, however, that the full height of a loop letter would be 3⁄8 inch. Writing at such a large scale makes it difficult for inexperienced

students to write with a smooth, graceful swing to their movement without having to frequently pick up their pens. Consequently, this guidesheet is designed as follows:

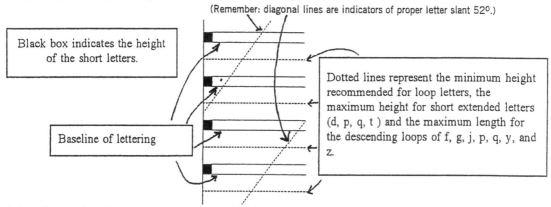

(Remember: diagonal lines are indicators of proper letter slant 52º.)

Black box indicates the height of the short letters.

Baseline of lettering

Dotted lines represent the minimum height recommended for loop letters, the maximum height for short extended letters (d, p, q, t) and the maximum length for the descending loops of f, g, j, p, q, y, and z.

After the student has developed some skill in writing Spencerian, he or she will find it more useful (and faster) to write with a short letter-height of about 1/16 inch. At this small size, it is much easier to write your loop letters three times (that is, 3/16 inch) the height of the small letters if you wish. But the 2½ height ratio of loop letters to small letters will always work, and your lettering will look as it should.

In due time and with continued diligent practice, maintaining the proper height relationship of letters as you write will become a nearly subconscious effort. You will actually see the correct letters in your mind as you write, and you will no longer need guidesheets to help you. When this happens, you'll be able to write using only a baseline to place your letters on. Congratulations! --you're a penman!

SAMPLE OF WRITING USING GUIDESHEET

Spencerian Practice Guide Sheet – Beginners

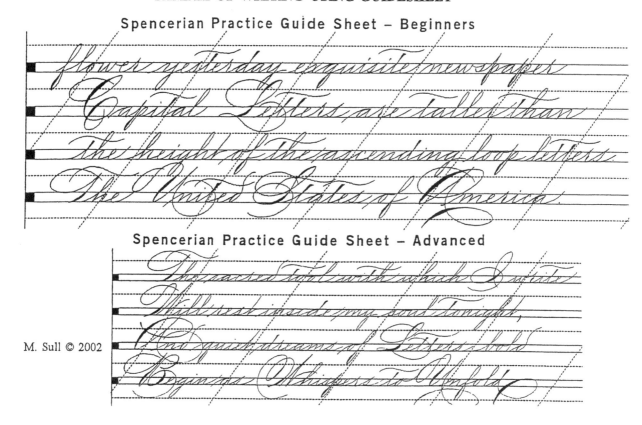

Spencerian Practice Guide Sheet – Advanced

M. Sull © 2002

206

Handwriting Practice Sheet A (Beginner's Guide Sheet)

Handwriting Practice Sheet A Name_____ Date_____

Remember: Diagonal lines are indicators of proper letter slant at 52°

Model

1

2

3

4

5

Model

1

2

3

4

5

6

Model

1

2

3

4

5

6

Suzi © 2000

Handwriting Practice Sheet B (Advanced Guide Sheet)

Handwriting Practice Sheet B Name_____ Date_____

Remember: Diagonal lines are indicators of proper letter slant at 52°

Additional Plates

Decorative Line Work

THE EDUCATOR

ENGROSSING
EDUCATION
HANDWRITING

DEMOCRACY

I believe in four things, as I believe in God—that democracy is the one hope of the world; that democracy without efficient common schools is impossible; that every school in the land should be made a home and a heaven for children; fourth, that when the ideal of the public school is realized, "the bloodshed by the blessed martyrs for freedom will not have been shed in vain."
—Colonel Francis W. Parker

ZANER BLOSER CO.
COLUMBUS, O.

210

THE EDUCATOR

EDUCATION HANDWRITING ENGROSSING

P. W. Costello

212

THE EDUCATOR

FEBRUARY 1936

EDUCATION
HANDWRITING
ENGROSSING

ZANER-BLOSER CO.
COLUMBUS, O.

1809
1865

Brown 1935

Diplomas and Certificates

For all kinds of schools furnished in blank form or neatly engrossed. Our facilities for designing and making special Diplomas are unexcelled. Sketches and estimates sent on request.

DESIGN FOR COVER
SIZE OF ORIGINAL 9 X 18

A. Brown 1916

214

THE EDUCATOR

Zaner-Bloser Co.
Columbus, Ohio.

The Educator

PENMANSHIP
BUSINESS
EDUCATION
ENGROSSING

Zaner-Bloser Co.
Columbus, Ohio

216

HIGH GRADE Diplomas AND Certificates

IN SHEET OR BOOKLET FORM
FOR ALL KINDS OF SCHOOLS.
OUR LINE OF STOCK DESIGNS
IS MOST COMPLETE.

ALL-HAND WORK **DIPLOMAS** ON
GENUINE SHEEPSKIN A SPECIALTY.

REAL AND IMITATION LEATHER
COVERS, MOIRE SILK LINED AND GOLD
SIDE STAMPED, FOR

BOOKLET DIPLOMAS

217

Flourishing

© Barbara Calzolari

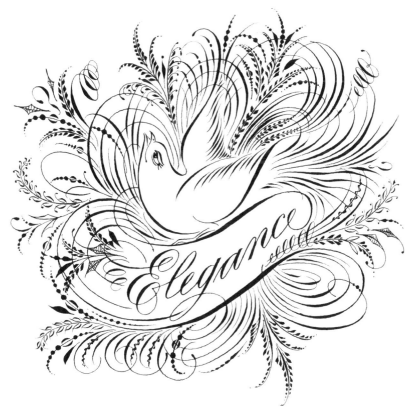

© Barbara Calzolari

Lindsey Gribble present:
THE
Great escape.
Spencerian FOR Beginners
WORKSHOP
Cornwall UK
Location: Bedruthan Hotel, Mawgan Porth, Cornwall, England
7TH AND 8TH MARCH 2020
With Barbara Calzolari

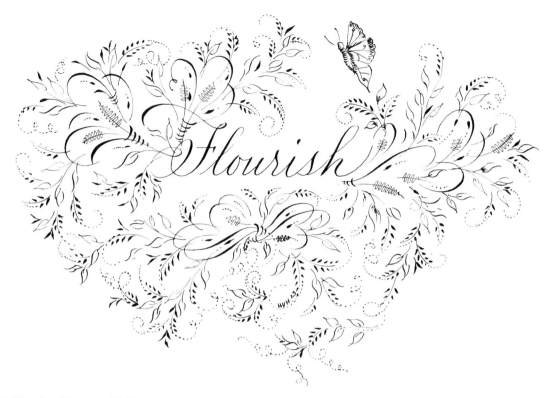

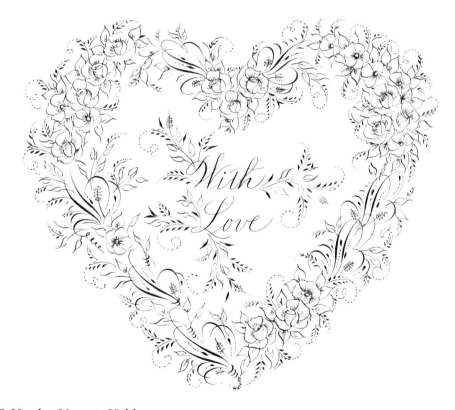

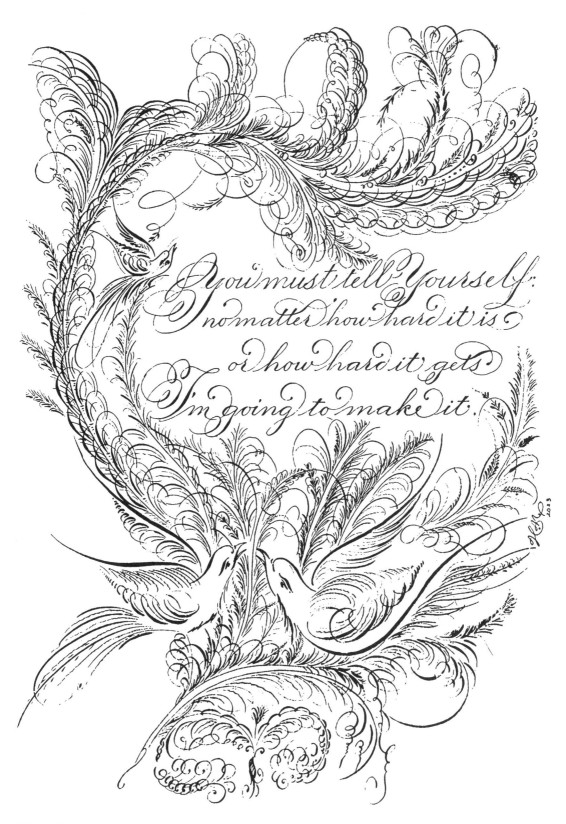

You must tell Yourself:
no matter how hard it is
or how hard it gets
I'm going to make it.

222

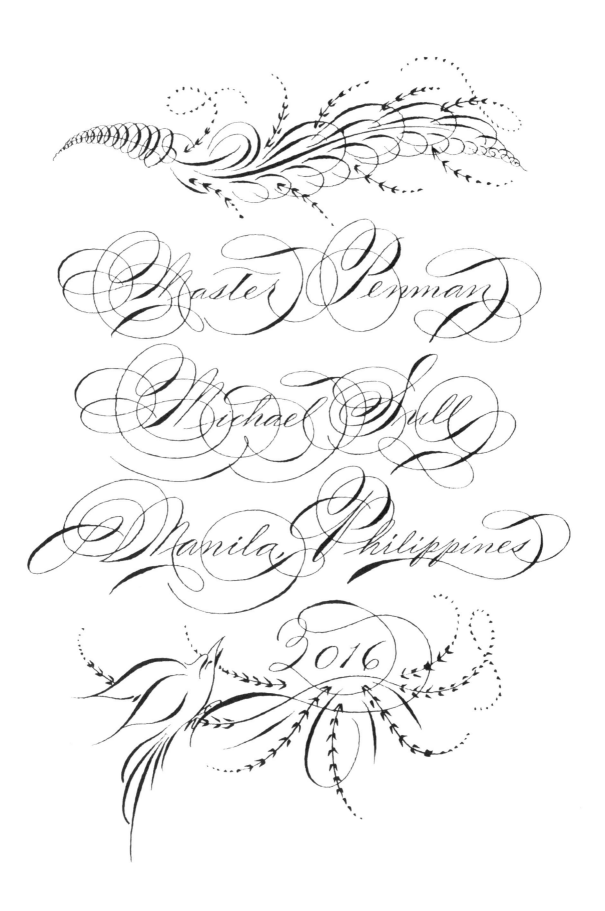

Master Penman

Michael Sull

Manila, Philippines

2016

Advanced

Spencerian Penmanship

a Special Workshop with

Michael Sull

Master Penman

Jakarta, Indonesia

April, 2017

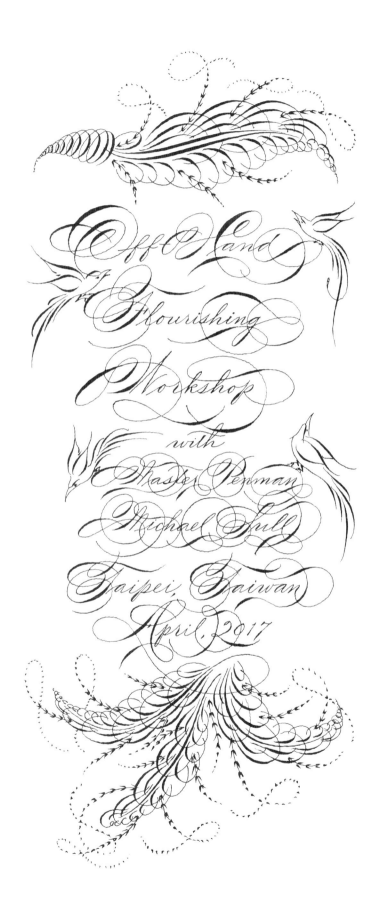

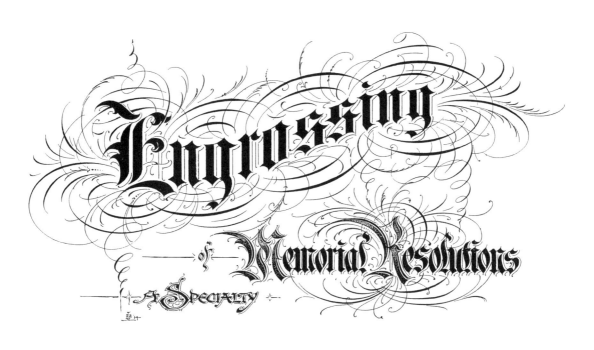

Engrossing
of Memorial Resolutions
A Specialty

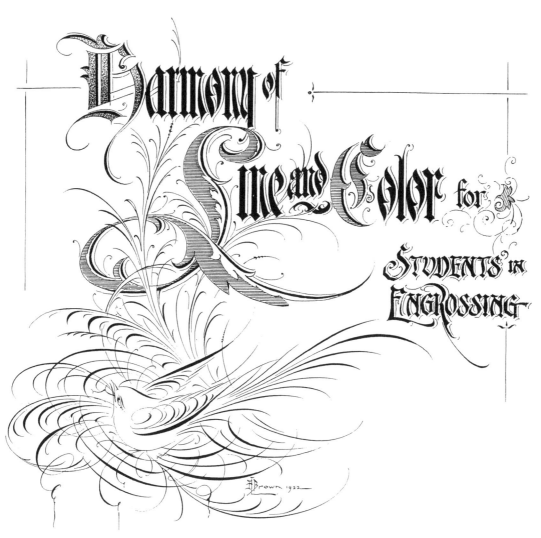

Harmony of
Line and Color for
Students in
Engrossing

226

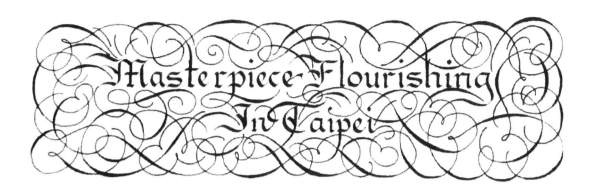

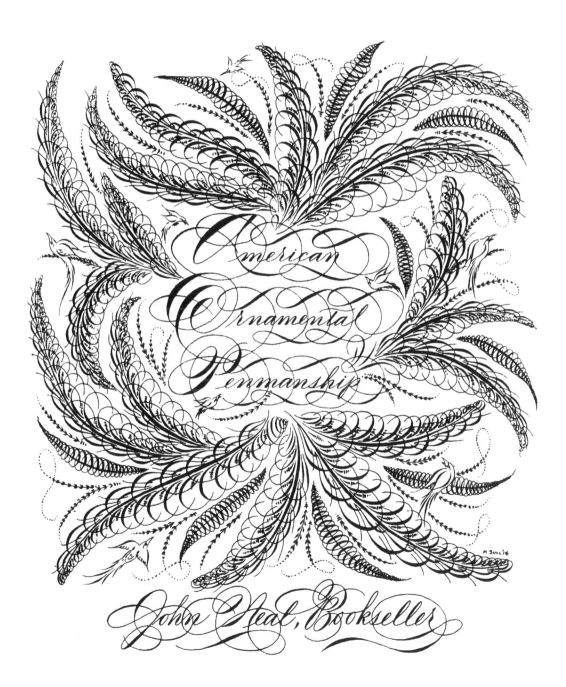

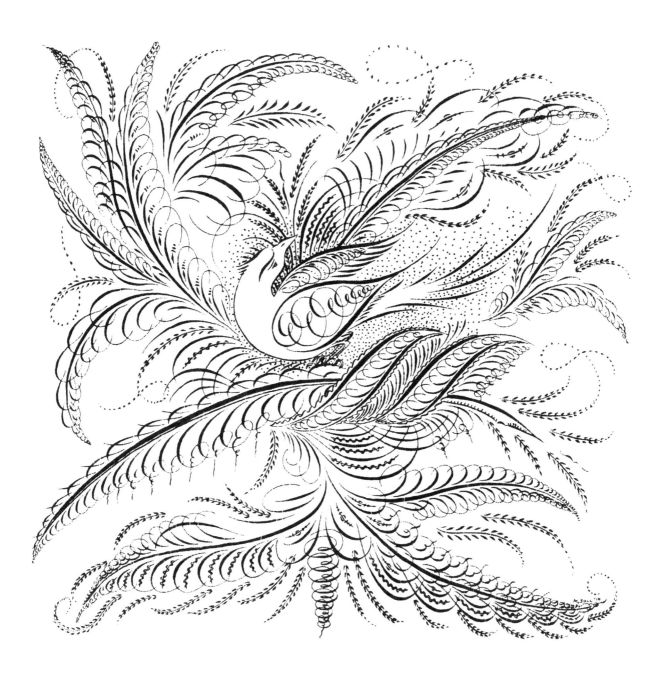

228

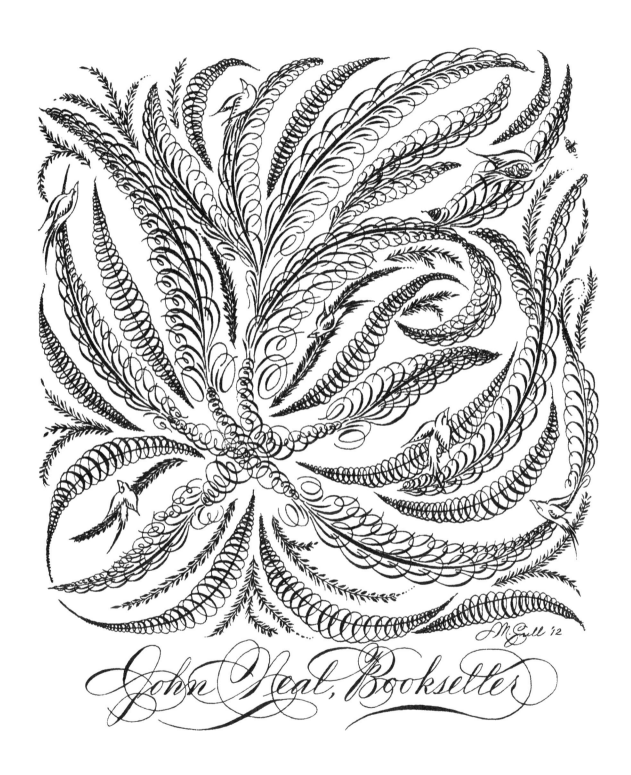

John Neal, Bookseller

NUMBERS

As a general rule, Advanced Ornamental Penmanship should only provide a minimal amount of embellishment to numbers whose purpose, as they appear in a text or visual communication, is to indicate a written amount of something, indicate a specific location of anything, or suggest a particular direction to follow, such as "Go 173 miles due West for 23 miles...". However, when numbers appear simply as a portion of a composition such as in a painting that includes the image of a clock or a numerical address displayed on some signage, or perhaps an image of displayed timepieces, if it is a person's responsibility to write the numbers involved, then ornamenting such numbers to an extent that propriety allows is completely acceptable. It is simple, actually. When numbers define or indicate anything specific, they must be legible and not partially hidden by any overlapping flourishes. With this thought in mind, here are the rules I adhere to and offer them for your consideration:

1. All numbers must consist of curved strokes in order to appear graceful. I use the following examples. Notice the baseline for each.

 1 2 2 3 3 4 4 5 5 6 7 7 8 8 9 0 0

2. When written, numbers should be at least twice as tall as the short lowercase letters. Numbers should be easily visible & not "blend in" with the small letters.

3. Ornamentation must not cross, overlap, or obscure the visibility of numbers.

4. All numbers should be easy to read unless the illustrated image of a number is intended to be obscured, such as the appearance of ivy vines growing over posted address numbers of an old building, cottage, property, house, etc.

5. When written in multiples where a grouping of more than a single number is involved, like letterspacing, number spacing should be visually consistent throughout the number grouping, so that no number appears disjointed from the grouping. Example:

 18491 S. Mulberry St.
 Good

 1 84 91 S. Mulberry St.
 BAD

Numbers in addresses and dates can have a bit more freedom of ornamentation than numbers specifying specific amounts, quanities, or dimensions of anything. Examples: 4236 Kelsey Lane

5392 Juniper Cr.

December 25, 1834

May 20, 2024

7008 Lake St.

230

THE SECRET OF THE OVALS

QUITE OFTEN, upon seeing a completed extra-flourished letter, as attractive as it may be to view, its sheer complexity of lines, curves, ovals, and shades is more than any student's self-confidence will allow. Thoughts such as "I could never do that!", "In my dreams..., maybe...", or "You've got to be kidding!" run through a person's mind with enough conviction that she or he gives up before even dipping the pen to put forth an honest effort at trying to write the letter. If this sounds at all familiar to you, I wish to offer the following technique for your consideration. As long as your curves and ovals are smooth and well-formed, and you enlarge the complete letter to allow for ample negative space for all your additional curves and ovals, this always works.

Every Capital letter largely consists of curves, ovals, or a combination of both. I suggest that you write a capital, and once completed, identify what the reference curves are that <u>begin</u> and <u>end</u> the letter. These should not be the primary curves that produce the legible form of the letter, but rather, the non-legible curves and ovals that are responsible for <u>ornamenting</u> the legible shape of the capital letter. Now, focusing your attention on these curves and ovals, write a basic, well-formed capital letter. If the entry or ending stroke is not an oval, it certainly should be a curve. Remembering the rule that every curve is part of an idealized oval, write the letter again, this time writing the entry and ending strokes as the idealized "parent oval" of the simple entry and ending curves shown in Example Step 1. When you have completed this Example Step 2, your letter should appear "more ornamental" than it was in Step 1.

What follows is the continuation of this process which I refer to as "The Secret of the Ovals". Continue re-writing your Capital letter, and with each successive example, add an extra oval to the entry and/or ending oval. This is done by either over-lapping ovals, or by spiraling ovals. This can be done with every traditional capital letter, and as far as my own experiments have shown, with every Alternate capital letter as well. Be advised that due to the different shapes of the letters, although many capitals — particularly the capital stem capitals and both the O and Q — can easily accomodate three sets of ovals in entry and ending strokes, other capitals may only work with two sets of ovals in these strokes. You must experiment yourself to become familiar with the oval limitations of each letter. The determining factor as to how many ovals look good or look bad is the legibility of the letter itself. If it becomes difficult to read with three extra entry or ending ovals, then make no more than two extra ovals. Also, some letters may be able to retain legibility with three entry ovals, but only two ending ovals, or vice versa. But here is the extra bonus: because the ending curve of a capital can be transformed into ending ovals that do not cover up, obscure, or reduce the legibility of the letter, the same idea can be said of the exit curved stroke of the last lowercase letter of a word. Please notice the ending e in Examples Steps 9, 10, and 11.

Thus, simply stated, "The Secret of the Ovals" is merely duplicating the entry and ending ovals of a capital, and also the ending lowercase letter of the last letter in a word if you desire to do so. In this way you can transform a standard capital (and perhaps, a title or a person's name where the ending lowercase letter can also be involved) into an amazing example of advanced Ornamental Penmanship. Try it!

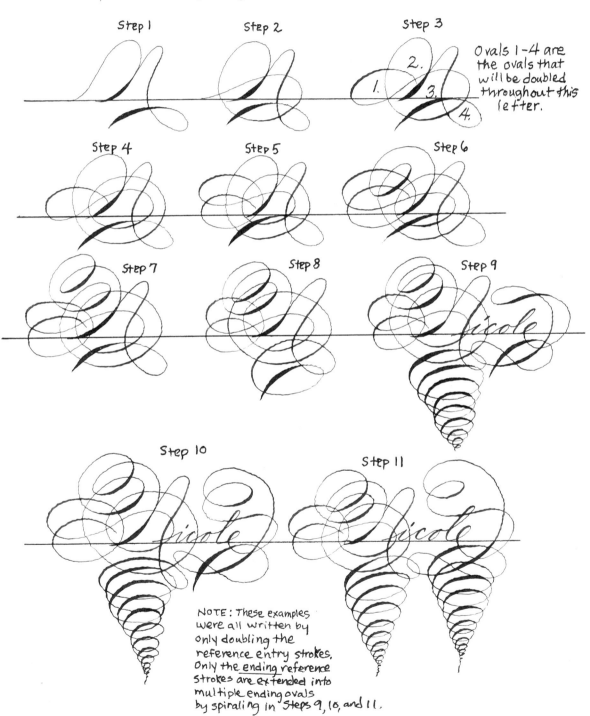

Step 1

Step 2

Step 3

Ovals 1-4 are the ovals that will be doubled throughout this letter.

Step 4

Step 5

Step 6

Step 7

Step 8

Step 9

Step 10

Step 11

NOTE: These examples were all written by only doubling the reference entry strokes. Only the ending reference strokes are extended into multiple ending ovals by spiraling in steps 9, 10, and 11.

232

Acknowledgments

Abook such as this does not happen overnight, and every author is only one part of a large team effort that brings a volume to life.

- Above all, I wish to thank my dear wife, Debra, for her enormous help in previewing my manuscript, often making valuable suggestions, typing the final drafts, and providing her devoted help in every possible way. She is truly "the wind beneath my wings." I love her with all my heart.
- I sincerely thank Sherry Shinogle for her invaluable efforts in making sense of my handwritten manuscript and typing the entire first draft. I am so very grateful to you for your advice, invaluable help, and support.
- To my dear and trusted friend of many years, Allan Shinogle, for his constant encouragement, support, and belief in me. Brother Al, I can never thank you enough. Our countless adventures are not over yet.
- To Nicole Mele, my amazing editor from Skyhorse Publishing, I will always be most grateful for extending to me this amazing opportunity for my students. Your skill and professionalism, your patience and kindness is on every page. Thank you most sincerely, from Paul O'Hara and me.
- To Gordon Bok, Ann Mayo Muir, and Ed Trickett, thank you for your most kind permission in allowing me to include your wonderful song, "Turning Toward The Morning" in this effort. Together, your songs have been a comfort and inspiration to generations of kindred souls who long for the sea, and I among them.
- To my colleague and friend, Jake Weidmann, thank you for your most kind considerations and fellowship of our history over the years. We have more times to share, and I look forward to every one.
- To Isaac Weldon Bullock, David Fairbanks, and Paul O'Hara; all that I am as a penman is because of you; you are each with me every day.
- To Adam and Jennifer Shipman for your much appreciated support that allowed special items of artwork to appear in this book. I am so very grateful to you.
- Last, I wish to thank my students around the world from my heart. You have always believed in me, and I will always believe in you. It is my most treasured honor that you have welcomed all that I can share.

About the Author

A native of Buffalo, New York, Michael R. Sull is an American Master Penman whose work in the field of traditional handwriting has extended over a forty-two-year career. He is internationally recognized as the most significant American Penman of the past sixty-five years for his penmanship skills, authorship, and teaching efforts. A devoted chirographer, Michael's activities have been innovative and instrumental in bringing back our handwriting heritage. He is widely regarded as the individual responsible for ushering in a new interest in American handwriting and reintroducing today's generation of students to Spencerian penmanship.

Michael's interest in calligraphy began shortly after he completed his service in the US Navy in 1973. He founded the Tidewater Calligraphy Guild in 1978 in Virginia Beach, Virginia, and subsequently met veteran Master Penmen Isaac Weldon Bullock, David Fairbanks, and Paul O'Hara. At age ninety, Mr. O'Hara at that was time was one of the last living Master Penmen from America's Golden Age of Penmanship (1850–1925). These individuals became Michael's mentors, and over the next few years they encouraged him to share his knowledge and skills with others so that America's history of penmanship would not remain forgotten. To this end, Michael has dedicated his career.

His achievements over the next several decades have been unprecedented and substantial: 1981–1986 staff lettering artist, Hallmark Cards; founder and director, Spencerian Workshop Program, 1987–2012; president, International Association of Master Penmen, Engrossers, and Teachers of Handwriting (IAMPETH), 2001; founder and director, IAMPETH Master Penman Program, 2001–2015; personal calligrapher to former president Ronald Reagan, 1990–2003; founder, the Spencerian Monument for American Handwriting, 2012; author: *Spencerian Script and Ornamental Penmanship*,

234

Learning to Write Spencerian Script, Spencerian Practice Set, Penmanship Poetry: Tales and Legends from a Lost Era, American Cursive Handwriting, and *The Art of Cursive Penmanship*; Zaner-Bloser corporate Master Penman, penmanship contributor to *We the People* (IMAX film, 2014).

Michael's teaching efforts have been extensive. Since 1985 he has taught American penmanship in over forty states and eighteen foreign countries; more than anyone in our country's history. He is also well-known for his handmade oblique penholders, personally crafting more than eight-thousand of these special writing instruments over thirty-five years. His writing skills are highly sought after as private commissions, and examples of his Spencerian script and ornamental penmanship can be found in personal collections around the world.

A renowned penman respected for his teaching ability and writing skill, Michael is a singular in today's renaissance of interest in American penmanship. With *Sull's Manual of Advanced Penmanship,* he focuses his attention on raising penmanship skills to an artistic level of the penmen from America's past.

Website: spencerian.com
Etsy: etsy.com/shop/MikeSullPenmanship
Instagram: @michaelrsull
Facebook: facebook.com/MichaelRSull

Author's Previous Works

Spencerian Script and Ornamental Penmanship (1989)
Spencerian Script Practice Set (1991)
Learning to Write Spencerian Script (1993)
Off-Hand Flourishing Techniques for Ornamental Penmanship (1993)
American Cursive Handwriting (2011)
Spencerian Saga: Poems of a Penman (2011)
The Art of Cursive Penmanship (2018)

Index